An American Legacy, A Gift to New York

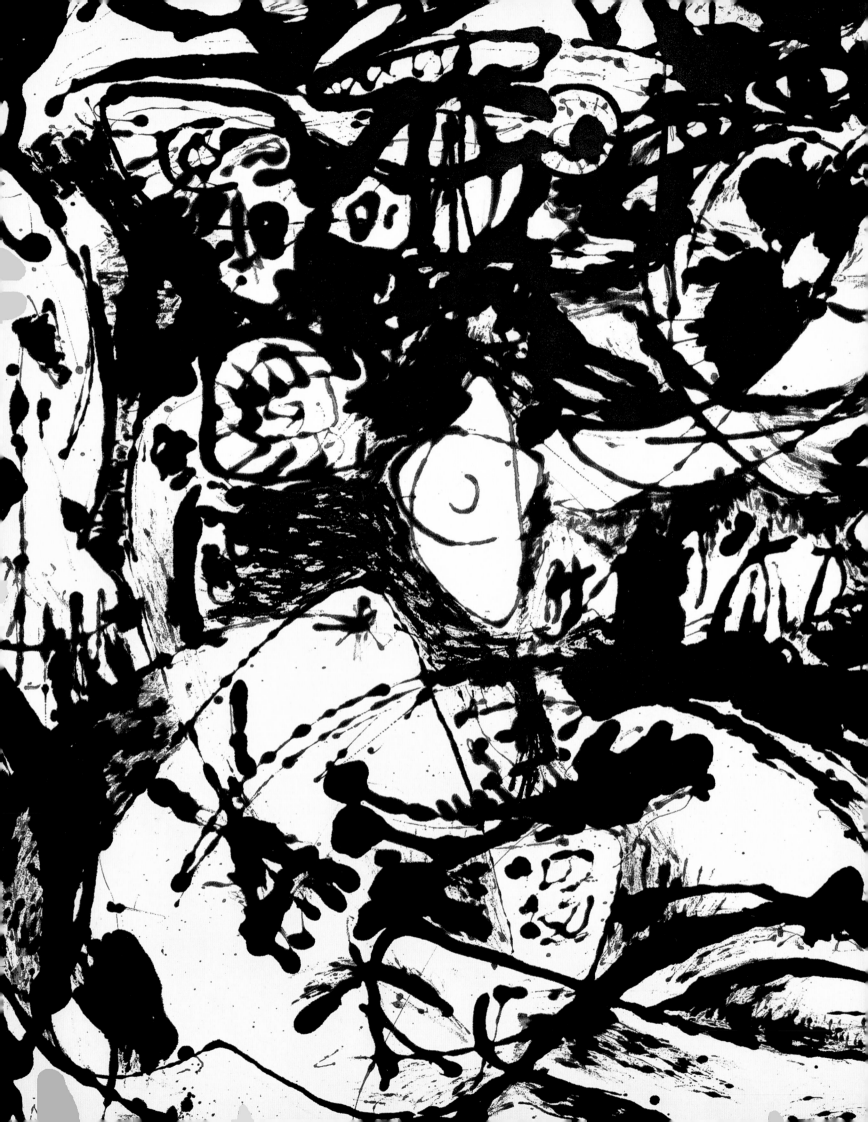

An American Legacy, A Gift to New York
Recent Acquisitions from the Board of Trustees

Marla Prather
Dana A. Miller

Whitney Museum of American Art, New York

Distributed by Prestel Verlag
Munich • Berlin • London • New York

This book was published on the occasion of the exhibition *An American Legacy, A Gift to New York*, at the Whitney Museum of American Art, New York, October 24, 2002–January 26, 2003.

An American Legacy, A Gift to New York is sponsored by HSBC ⟨X⟩

Library of Congress Cataloging-in-Publication Data

Whitney Museum of American Art.
 An American legacy, a gift to New York / Marla Prather and
Dana Ashley Miller.
 p. cm.
 ISBN 2002013600 (cloth)
 1. Art, American—20th century—Catalogs. 2. Art—New York
(State)—New York—Catalogs. 3. Whitney Museum of American
Art—Catalogs. I. Prather, Marla. II. Miller, Dana Ashley. III.
Title.
N6512 .W532 2002
709'.73'0747471—dc21

 2002013600

Prestel books are available worldwide. Visit our website at www.prestel.com or contact one of the
following Prestel offices for further information.

Prestel Verlag
Koeniginstrasse 9, 80539 Munich
Tel. +49 (89) 38 17 09-0, Fax +49 (89) 38 17 09-35
email: sales@prestel.de

4 Bloomsbury Place, London WC1A 2QA
Tel. +44 (20) 7323-5004, Fax +44 (20) 7636-8004
email: sales@prestel-uk.co.uk

175 Fifth Avenue, New York 10010
Tel. +1 (212) 995-2720, Fax +1 (212) 995-2733
email: sales@prestel-usa.com

WHITNEY

Printed and bound in England

CONTENTS

FOREWORD

Building on a venerable tradition of philanthropy at the Whitney, fifteen trustees have donated eighty-seven extraordinary works of art to the Museum. With discerning eyes and unflinching commitment to the Whitney's mission, these trustees have invaluably enriched the permanent collection with paintings, drawings, sculptures, and prints by twenty-three prominent artists of the last fifty years. In a single, collaborative gesture, this gift transforms the Museum's holdings overall and significantly deepens our already strong representation of the individual artists it embraces. In addition to these holdings the Whitney has represented all of these artists in dozens of group shows between 1955 and 2002, and has organized major monographic exhibitions of Jim Dine, Helen Frankenthaler, Jasper Johns, Donald Judd, Ellsworth Kelly, Franz Kline, Claes Oldenburg and Coosje van Bruggen, Robert Rauschenberg, Edward Ruscha, Lucas Samaras, Cy Twombly, and Andy Warhol.

With a focus on American artists who came of age in the 1950s and 1960s, this initiative, spearheaded by Whitney Chairman Leonard A. Lauder, reaffirms with works of the highest quality the Whitney's reputation as the premier museum of American art. Spanning the years 1949 to 2002, the selection includes early formative works by key postwar artists such as Roy Lichtenstein, Barnett Newman, Jackson Pollock, and Warhol. These works will enable the Museum to present to the public major concentrations in the crucial areas of Abstract Expressionism, early Pop art, and the varieties of abstraction in the 1960s. In addition, the show highlights later achievements by several of the era's greatest innovators, such as Johns, Kelly, Oldenburg, and Twombly, reinforcing the Museum's commitment to the continuing careers of American artists and the future of American art.

The Whitney is a prime example of how private philanthropy has shaped the nation's museums. Beginning with a gift from our founder, Gertrude Vanderbilt Whitney, in 1930, we have received thousands of works of art from private collectors. Mrs. Whitney launched the collection with a donation of some five hundred works. In the decades since, other major gifts and bequests have included those of Howard and Jean Lipman (1966), the Josephine Niven Hopper Bequest (1968) by Edward Hopper's widow, the Lawrence H. Bloedel Bequest (1977), and the Felicia Meyer Marsh Bequest (1978) by Reginald Marsh's widow.

This exhibition extends the tradition of giving by one person or one family at a time. In this instance, Mr. Lauder and fourteen other trustees have generously donated private treasures for the benefit of a global audience. *An American Legacy, A Gift to New York* sets an extraordinary example for museums around the country, demonstrating how individual patronage has sustained America's leading art museums since the 1870s. With this gift of remarkable magnitude, Whitney benefactors have expanded the collection in profound and unparalleled ways. At a pivotal moment in the history of the institution, they have bestowed a legacy that will benefit both New York City and our international audience.

Maxwell L. Anderson
Alice Pratt Brown Director

CATALOGUE
OF THE EXHIBITION

Chuck Close

Since the 1960s Chuck Close has painted large-scale portraits of his family, friends, fellow artists, and himself. Close photographs his subjects mugshot-style and charts a regular grid directly onto the image. He then enlarges the grid, transposes it to a canvas, and carefully reproduces each square of the photograph until the face emerges as a precisely detailed likeness. As with his photographs, Close made his early paintings in black and white, and used an airbrush to achieve a smooth, even paint surface. The intricately executed portraits reveal aspects of their subjects that might go unnoticed in the source photograph, or even in the flesh. "In viewing my work, you can, by stepping back and looking at my paintings, get pretty much the standard, normal understanding of a head as a whole image," Close has said. "However, by including all the little surface details and enlarging them to the point that they cannot be overlooked, the viewer cannot help but scan the surface of the head a piece at a time. Hopefully, he gets a deeper knowledge of the forest by knowing what the individual trees look like."

In the 1970s Close began integrating color into his work. To compose *Lyle*, his recent portrait of photographer and writer Lyle Ashton Harris, he used a dizzying array of colors. Although the grids remain only faintly visible beneath the paint surface in Close's early works, they figure prominently in later ones. Up close, *Lyle* appears to be a mosaiclike abstract composition of squares, each containing hand-painted layers of irregular circles, ovals, lines, X's, and dots. Close has treated the entire canvas uniformly, rendering the background in as much detail as central areas of the face. Only when seen from a distance do all the elements coalesce into a legible portrait. *Lyle* is the second of Close's paintings to be acquired by the Whitney; the first, *Phil* (1969), is a grisaille portrait of composer Philip Glass.

Close often makes print versions of his portraits after completing a painting. The artist has generously donated to the Whitney a set of sixteen prints titled *Lyle, Scribble Etching* (pp. 12–13). The etchings demonstrate the manner in which Close superimposes individual colors, each with a different linear pattern, to create a progressively coherent, eight-color portrait.

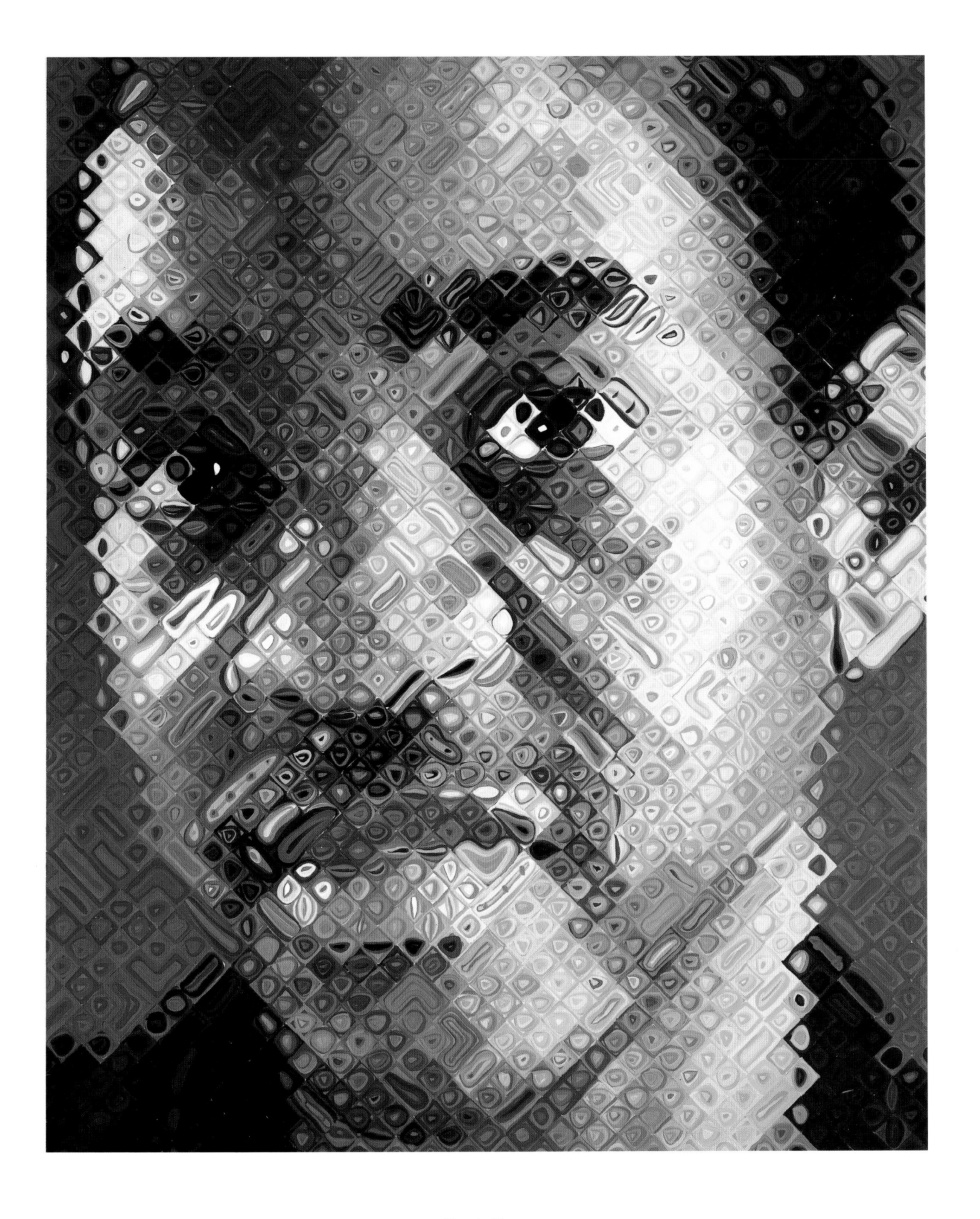

Chuck Close
Lyle, 1999
Oil on canvas
102 x 84 in. (259.1 x 213.4 cm)
Gift of The American Contemporary Art Foundation, Inc., Leonard A. Lauder, President 2002.220

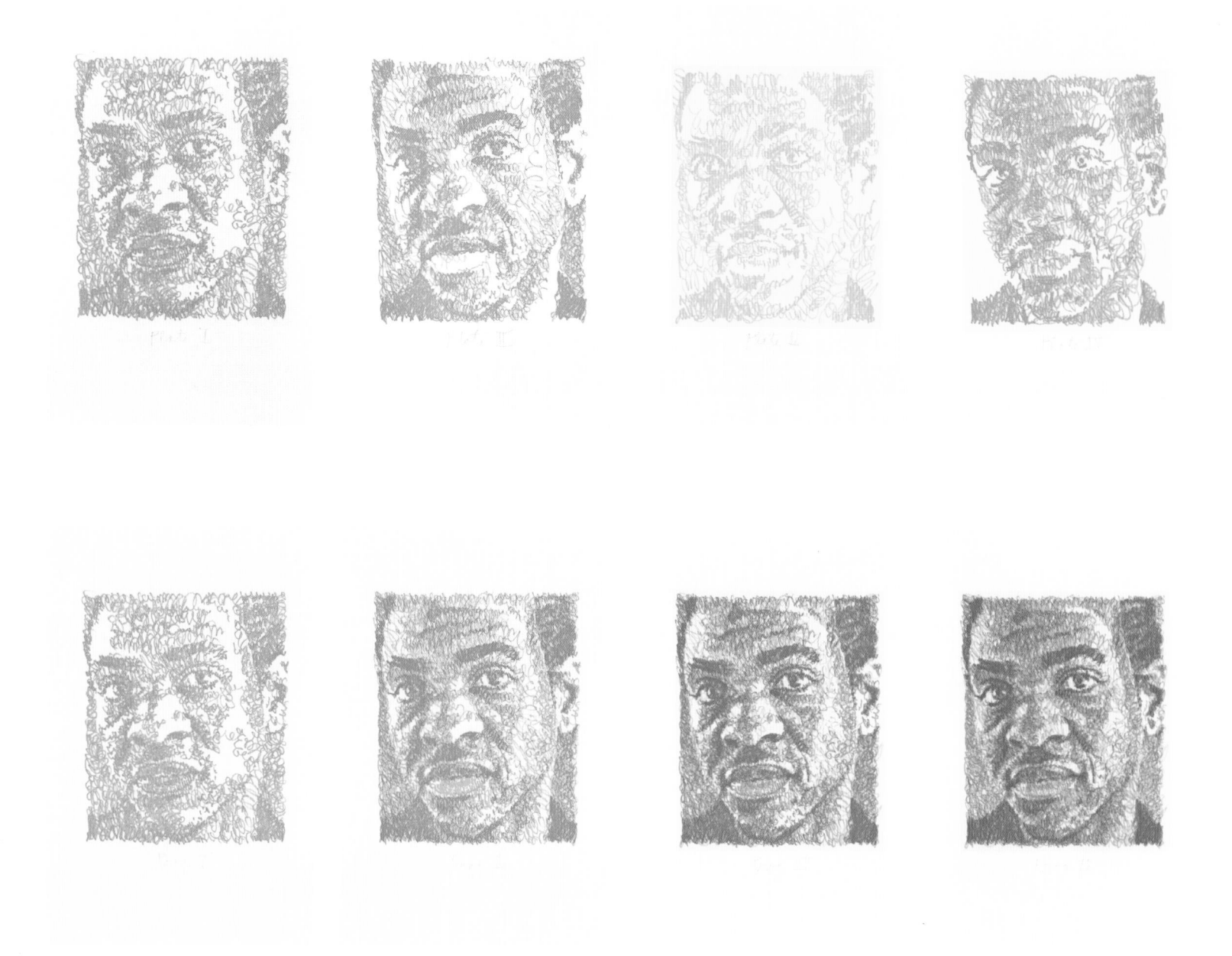

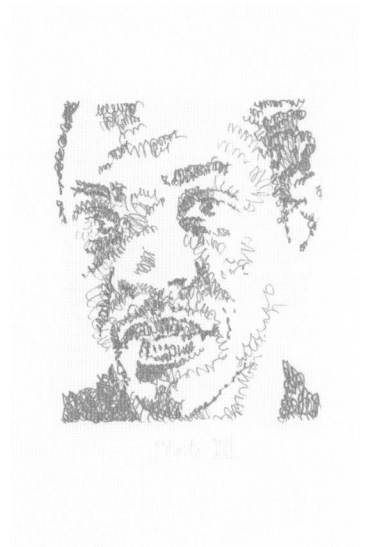

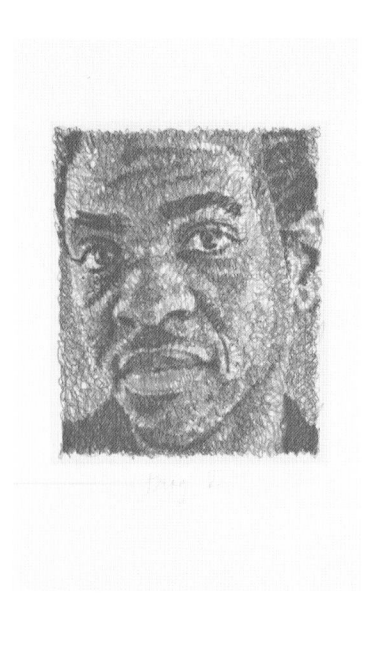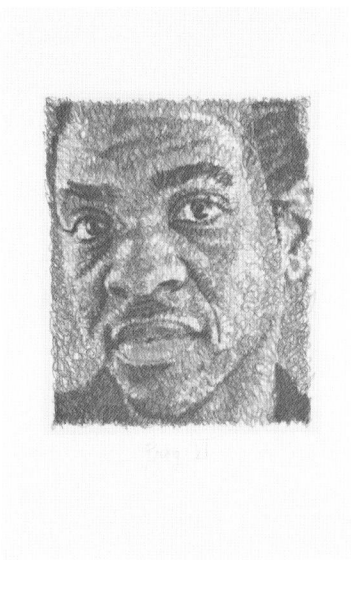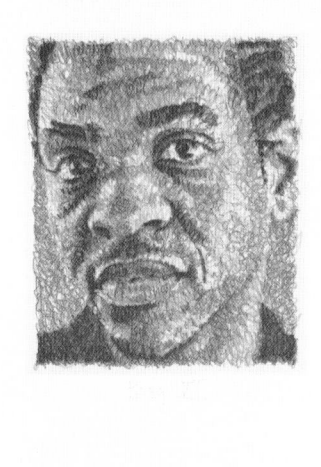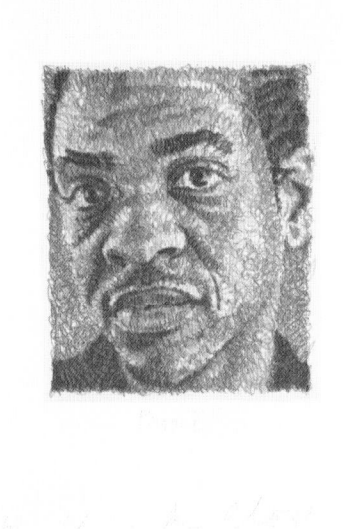

Chuck Close
Lyle, Scribble Etching, 2000
Color soft-ground, portfolio of eight plate proofs and eight progressive proofs
Sheet, 18 1/4 x 15 1/4 in. (46.4 x 38.7 cm) each; plate, 9 15/16 x 8 3/8 in. (25.2 x 21.3 cm) each
Gift of the artist 2001.307a–q

Jay DeFeo

Beginning in the 1950s, Jay DeFeo associated with a loosely defined community of artists in San Francisco. She is best known for her monumental work in the Whitney's collection, *The Rose* (1958–66), which took over seven years to complete and weighs more than a ton. DeFeo stopped painting for four years after finishing the work—a culmination that coincided with the end of her first marriage—and she even referred to her life as "pre-rose" and "post-rose."

Crescent Bridge I is the first major painting DeFeo completed after this hiatus, and although not readily apparent, the work is a large-scale depiction of the artist's teeth. DeFeo suffered from health problems, possibly from overexposure to toxins in her painting materials, and she eventually lost her teeth to gum disease. Presented with little background or context, the "bridge" in this work can also suggest a vast landscape. Much of DeFeo's work from the early 1970s, which includes paintings, drawings, photographs, and photo-collages, features the abstracted forms of objects in her studio seen at close range.

DeFeo began experimenting with acrylic paints in the 1970s, and in *Crescent Bridge I* she used these materials to capture what she described as the "pearliness and translucency" of her teeth. She created an array of surfaces in her paintings, ranging from a light-absorbing matte to a highly reflective gloss. To balance these sensuous textures and what she described as Expressionistic imagery, DeFeo worked with a limited palette of blacks, grays, and whites—colors that the artist said lent her work "a tougher edge." When painted, *Crescent Bridge I* was paired with *Crescent Bridge II*, which has a black ground and a masonite support instead of wood. The works took two years to complete and form an arc when juxtaposed, representing literally the bridge of the artist's teeth and figuratively a transition in her career and personal life.

This is the second painting by DeFeo to enter the Whitney's collection. In addition to *The Rose*, the Museum owns nine drawings by DeFeo and nine photographs made in collaboration with Wallace Berman.

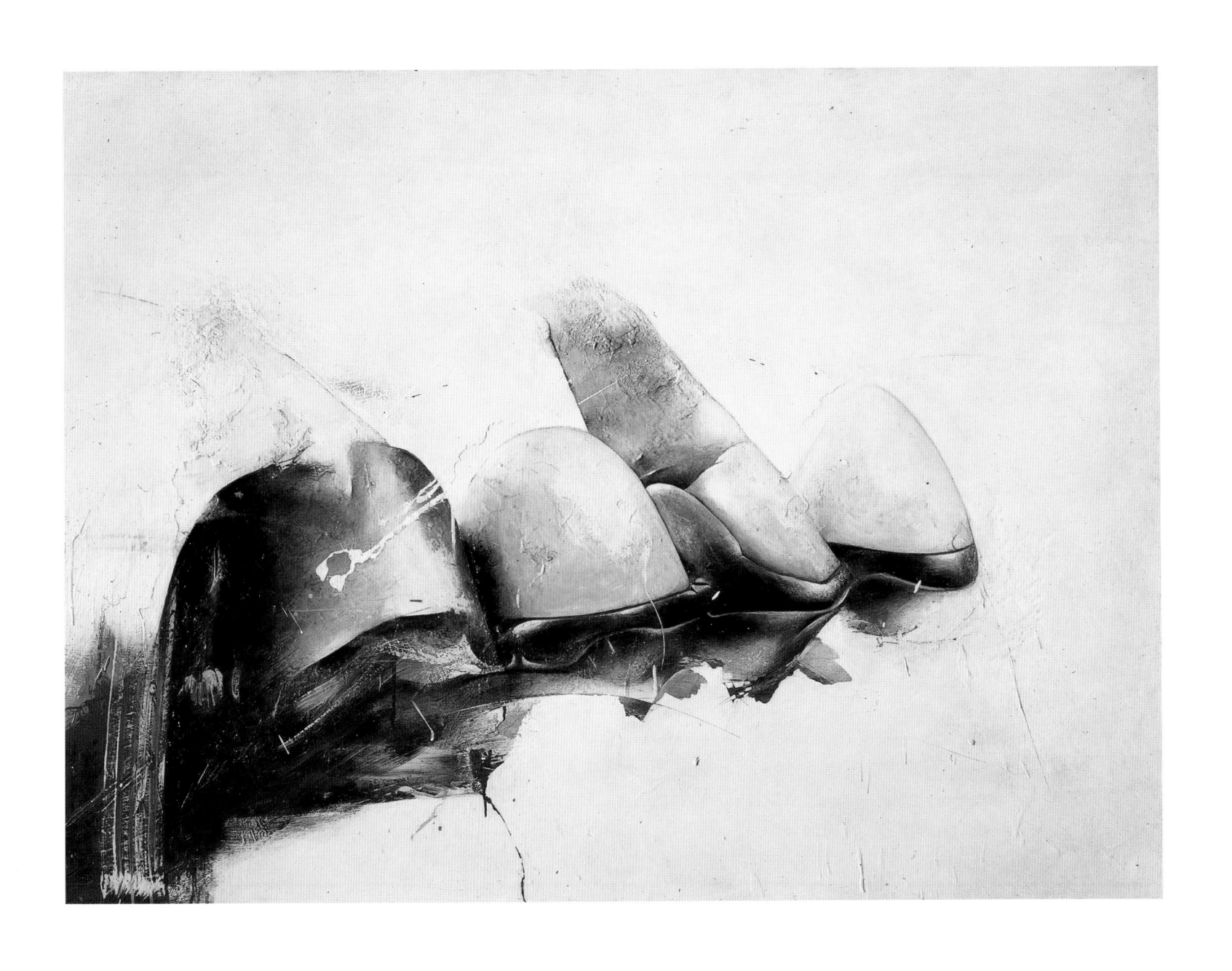

Jay DeFeo
Crescent Bridge I, 1970–72
Synthetic polymer and mixed media on plywood
48 x 66 1/2 in. (121.9 x 168.9 cm)
Purchase, with funds from Daniel C. Benton 2002.279

Jim Dine

The empty bathrobe featured in Jim Dine's *Afternoon Robe* is one of the handful of subjects, along with garden tools, hearts, trees, and gates, that have been mainstays of Dine's semiautobiographical iconography over the course of four decades. In 1963 Dine was attempting to paint a self-portrait when he came across an advertisement for bathrobes in the *New York Times Magazine*. As he explained, "The ad shows a robe with the man airbrushed out of it. Well, it somehow looked like me, and I thought I'd make that a symbol for me."

Dine experimented with various robe compositions in 1963 and 1964 in works such as *Double Isometric Self-Portrait (Serape)* (1964), already in the Whitney's collection, but by 1965 he had largely abandoned the subject in his paintings. He resumed painting the bathrobe in 1975, and his works from this period are more modulated and richer in color than the earlier canvases. "The robes have become much more mysterious than they used to be, and that's because I understand them more," Dine explained in 1977. "Obviously, there's some hidden significance there. But what's funny is that I don't own a bathrobe. I don't wear one. I don't walk around in one. I never see bathrobes around me, nor do I see people wearing them. I don't have a bathrobe to paint from."

Afternoon Robe realizes Dine's desire to make a painting about corrections. Numerous pentimenti—vestiges of earlier compositional placements—are visible in the heavily worked surface of the painting. The loose contours of the robe resemble those of a sketch more than a finished painting. This imprecise effect, perhaps indicative of Dine's newly adopted practice of drawing every day, is compounded by his nonlocal use of color; the red, for example, does not conform to the shape of the robe and grows more luminous toward the bottom of the canvas. The "corrective" markings recall works by two artists Dine reveres, Henri Matisse and Alberto Giacometti, who often left incidental marks and earlier compositional decisions visible in their finished works.

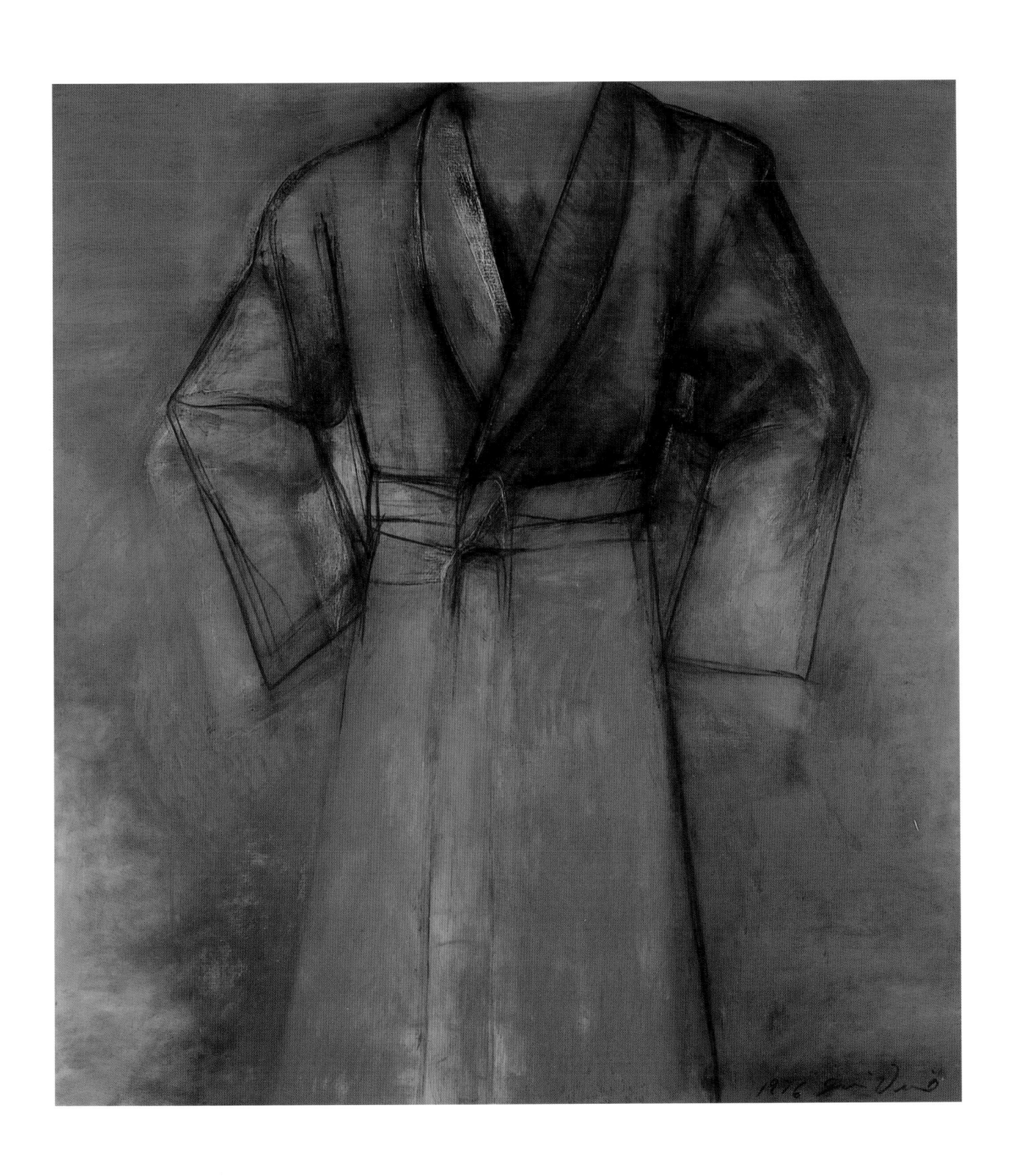

Jim Dine
Afternoon Robe, 1976
Oil on canvas
72 x 66 1/4 in. (182.9 x 168.3 cm)
Gift of Anne and Joel Ehrenkranz 99.146

Helen Frankenthaler

Helen Frankenthaler is best known for the stain painting method that she began to develop in 1952. Like Jackson Pollock, she poured paint onto unstretched canvases laid on the floor. But Frankenthaler thinned her oil paint and used unprimed canvas so that her fluid color forms soaked into the canvas with varying degrees of translucency and saturation.

Frankenthaler's stain method did not allow for mistakes: "I'd rather risk an ugly surprise," she said, "than rely on things I know I can do. The whole business of spotting; the small area of color in a big canvas; how edges meet; how accidents are controlled; all this fascinates me...." The artist also brushed or blotted medium onto her canvases, and almost always left areas unpainted, allowing the bare canvas to serve as a prominent element in the final composition. "When a picture needs blank canvas to breathe a certain way I leave it," she explained. Frankenthaler's stain method had a significant influence on the work of Morris Louis and Kenneth Noland, both of whom adopted the stain technique after visiting her studio in 1953.

Like Frankenthaler's other large-scale paintings of the late 1950s and early 1960s, such as *Arden* (1961), among the five paintings by Frankenthaler already in the Whitney's collection, the composition of *Blue Form in a Scene* is more centralized than her earlier work, with wider stretches of canvas at the periphery. Though it originated in the same year as *Arden*, *Blue Form in a Scene* involves a different orientation and palette. Halos of oil have seeped out of the colors, most visibly around the brown shape toward the bottom left. Frankenthaler embraced such incidental marks and described them as "something that often comes unwittingly yet can serve as a bridge between the shape and the negative canvas."

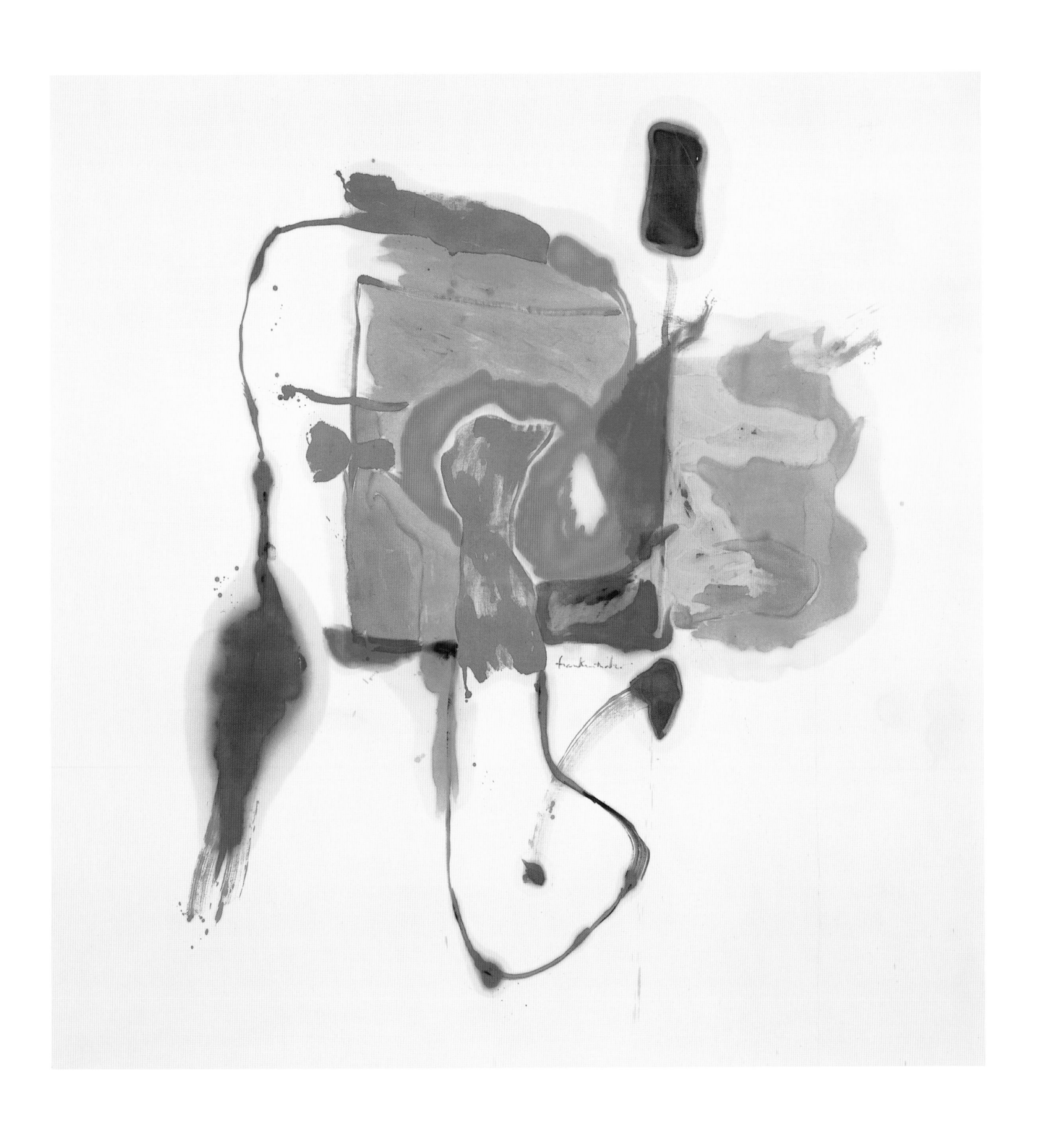

Helen Frankenthaler
Blue Form in a Scene, 1961
Oil on canvas
95 x 92 1/2 in. (241.3 x 235 cm)
Gift of The American Contemporary Art Foundation, Inc., Leonard A. Lauder, President 2002.221

Jasper Johns

Of the thirty-two works by Jasper Johns in this gift, *0 through 9* is the earliest. Johns began painting familiar images such as numbers, flags, maps, and targets in the mid-1950s, which allowed him, as he put it, "room to work on other levels." He turned his attention instead to the materials and the process of painting, as well as to the mechanisms of perception.

Johns first painted numbers in 1955 using commercial stencils, the standardization and impersonality of which appealed to him. He initially painted only single figures, but his compositions grew in complexity to include sequences of the numerals 0 to 9. In 1959 Johns began a drawing in which he superimposed the stenciled integers on top of one another. In 1960 and 1961 Johns made eleven paintings of superimposed numbers, including *0 through 9*, and four other identically scaled variations with the same title. The double-entendre of these titles describes not only the numerical subject of the painting, but the manner in which the viewer literally sees each number *through* the other numbers. Because of Johns's active painterly manner, reading the individual integers in full is impossible. Rather, one perceives portions of the numbers simultaneously and conceptually completes their forms. As Johns once stated, "I prefer work that appears to come out of a changing focus—not just one relationship or even a number of them but constantly changing and shifting relationships to things in terms of focus. Often, however, one is very single-minded and pursues one particular point; often one is blind to the fact that there is another way to see what is there."

The first of Johns's number paintings to be acquired by the Whitney, *0 through 9* richly augments the six major paintings by Johns already in the collection.

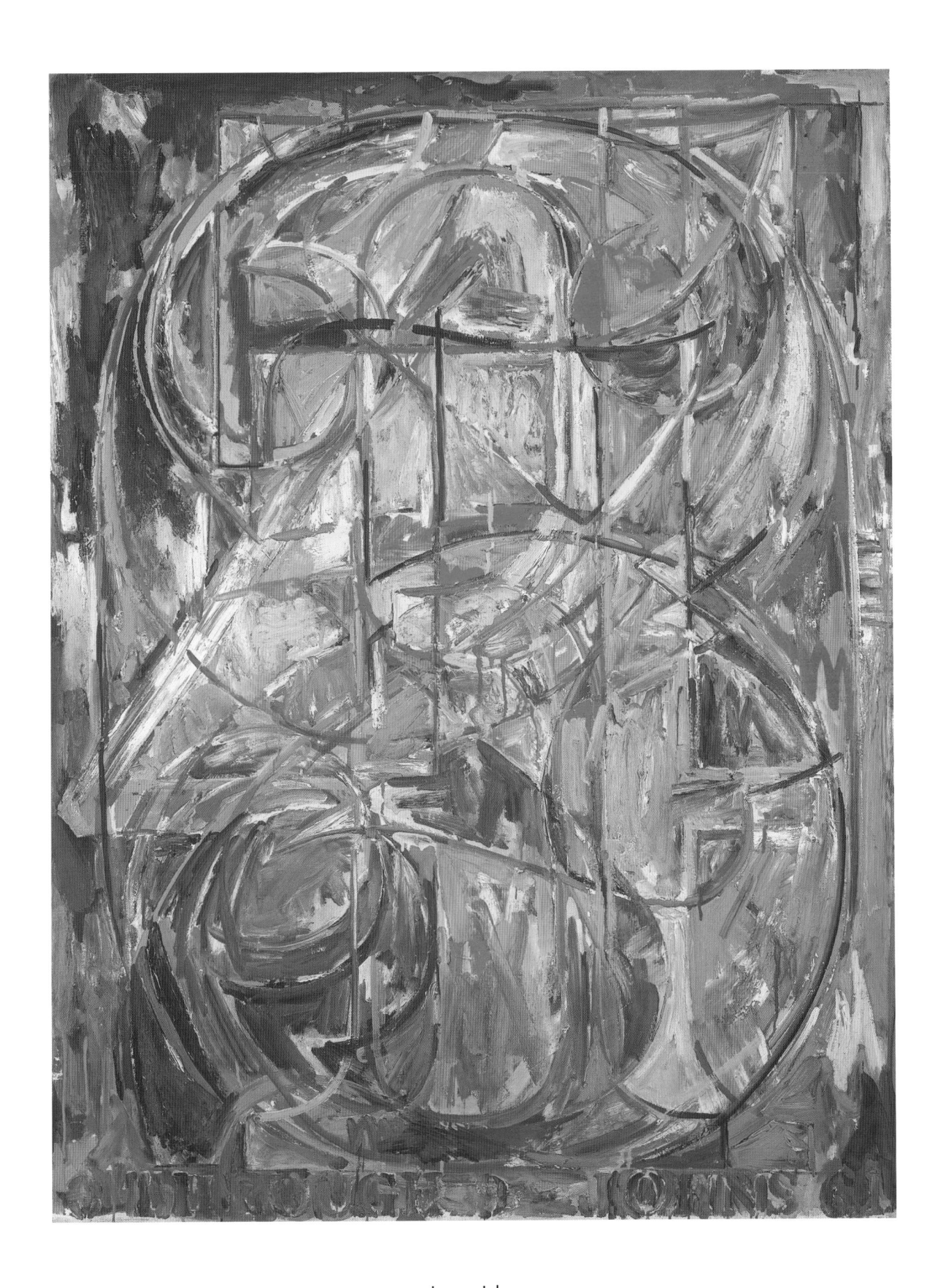

Jasper Johns
0 through 9, 1961
Oil on canvas
54 x 45 in. (137.2 x 114.3 cm)
Gift of The American Contemporary Art Foundation, Inc., Leonard A. Lauder, President 2002.222

In 1960 Johns painted his first map on top of a small diagram of the United States, given to him by Robert Rauschenberg. In subsequent years Johns experimented with variations on the map motif, including this monumental two-paneled version, *Double White Map*, from 1965. The stacked canvases each show the contiguous United States and neighboring portions of Canada and Mexico. Johns used encaustic, a mixture of pigment suspended in warm wax, to produce a range of softly translucent whites, off-whites, and beiges. Bits of collaged fabric and paper are visible through the painted surface, including items such as yellowed newspaper advertisements and pages from a Perry Mason detective story, *The Case of the Calendar Girl*. The red, white, and blue trim of airmail envelopes can also be discerned, but only in certain areas outside of the United States—in Canada and the Pacific Ocean, for example. Johns labeled the states and oceans with stenciled letters, varying their orientation and sometimes repeating the names in the upper map. Each state is labeled only once in the bottom map, and the size and abbreviations often differ from those in the map above. At the bottom left corner of the lower map the beginning of the word "VOICE" emerges through the paint layer, which relates to a number of Johns's other works, in particular the painting *Voice* (1964–67). The words "PACIFIC OCEAN" traverse the canvases vertically along the left side—the only way in which Johns has united the two compositions.

While conserving *Double White Map* in the late 1980s, Johns wondered what it would look like if he remade the work in its entirety. In 1989 he made a version with no collage elements, along with a number of related drawings and prints, including *Two Maps* (1989; p. 24).

Johns has also revisited the double flag motif he first used in a painting in 1959 in a variety of media. This group of gifts includes the lithograph *Two Flags* (1980; p. 25), *Two Flags (Study for Whitney Museum 50th Anniversary Poster)* (1980; p. 26), and the ink on plastic *Two Flags* (1985; p. 27). In 1980 Johns gave the study for the Whitney poster to Flora Miller Biddle, then president of the Museum's Board of Trustees, and granddaughter of Gertrude Vanderbilt Whitney, who founded the Whitney Museum of American Art in 1930. The Whitney's *Three Flags* (1958), perhaps Johns's best-known flag painting, was acquired in 1980 by the Museum in part as a fiftieth anniversary gift. *Three Flags* along with the five other Johns paintings and more than one hundred prints and drawings already in the Whitney collection span nearly five decades of the artist's career.

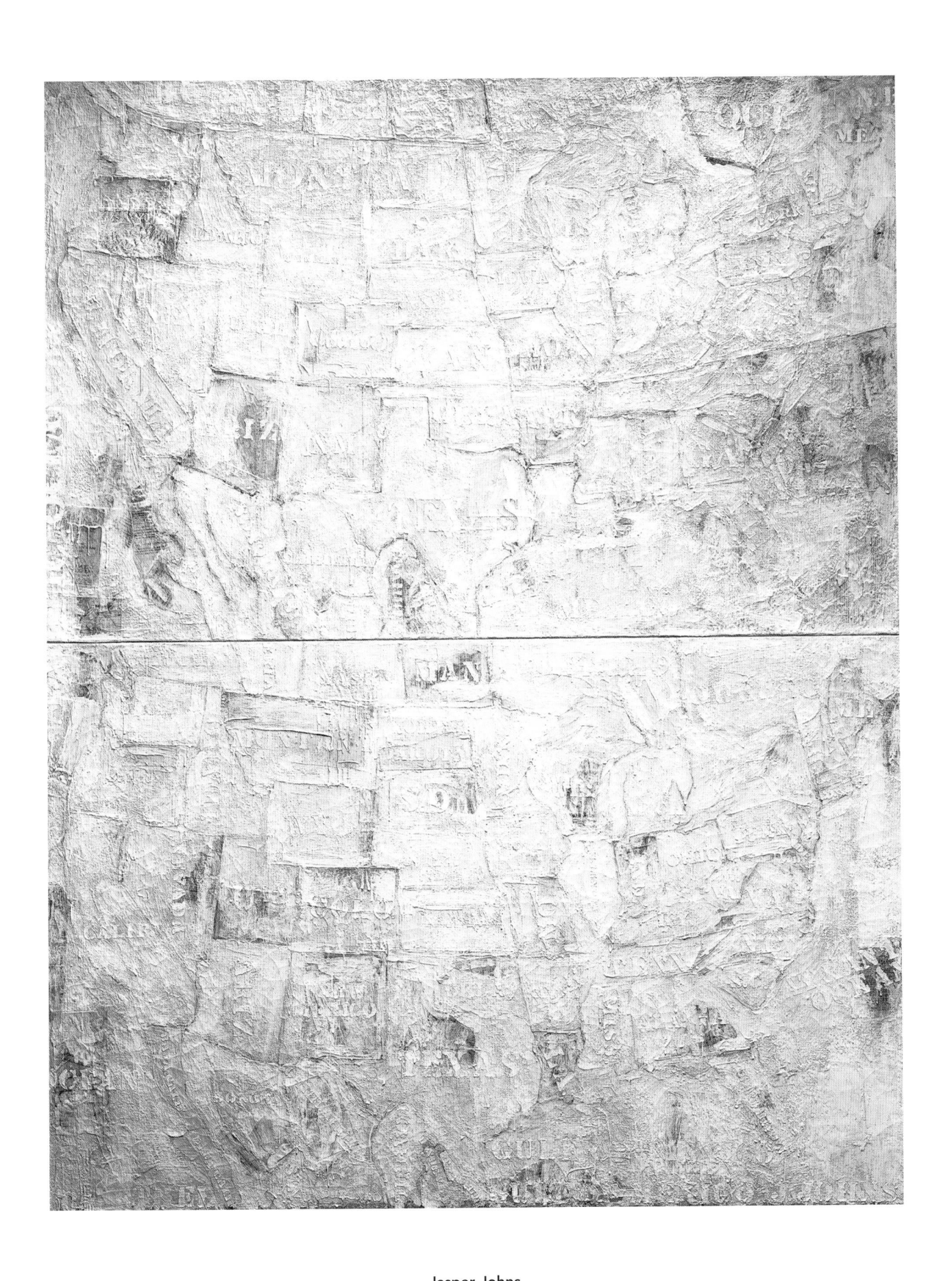

Jasper Johns
Double White Map, 1965
Encaustic and collage on canvas
Two panels, 90 x 70 in. (228.6 x 177.8 cm) overall
Gift of The American Contemporary Art Foundation, Inc., Leonard A. Lauder, President 2002.275

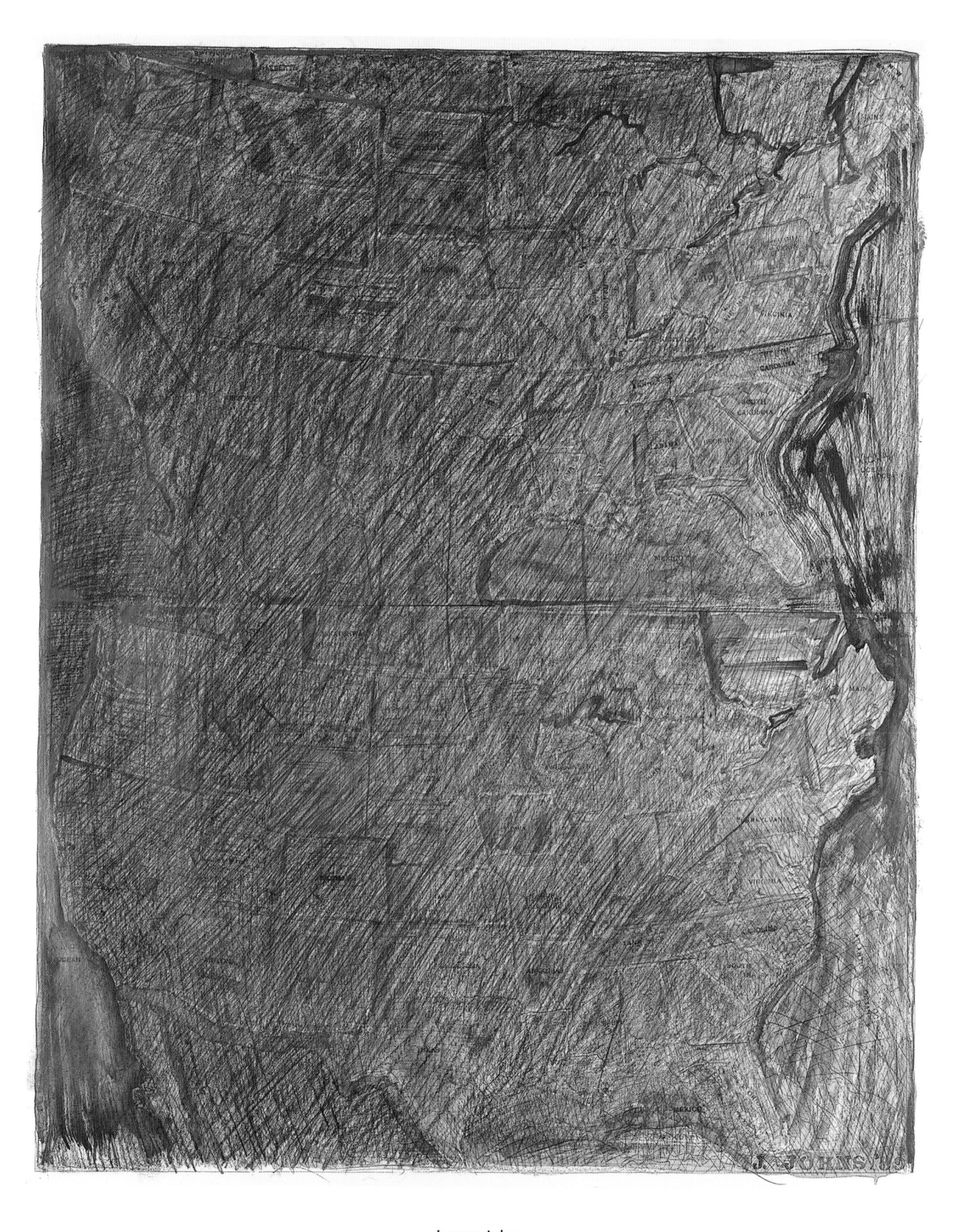

Jasper Johns
Two Maps, 1989
Graphite, Carborundum, and graphite and Carborundum washes on paper
52 x 41 3/4 in. (132.1 x 106 cm)
Promised gift of Anne and Joel Ehrenkranz P.2002.64

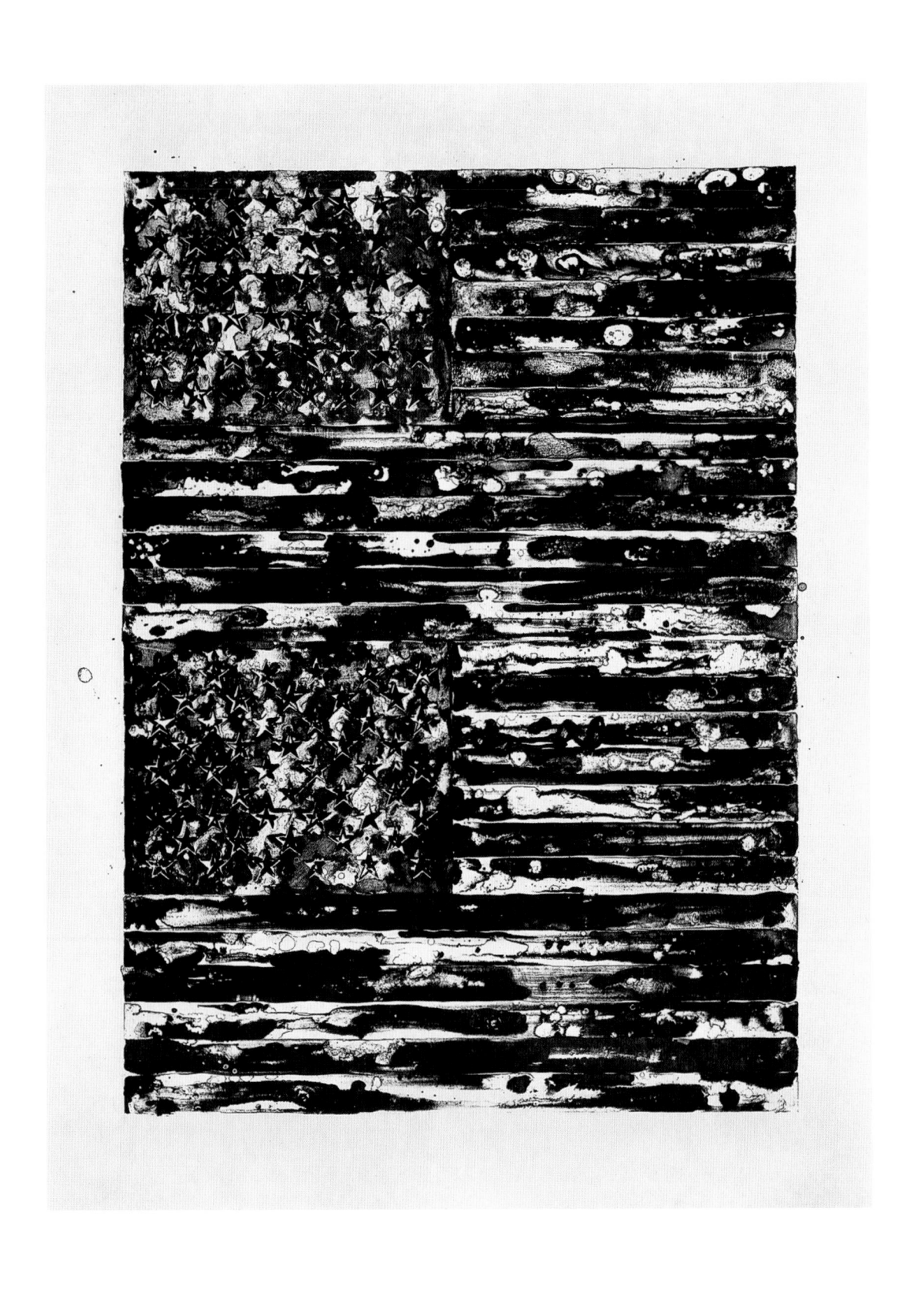

Jasper Johns
Two Flags, 1980
Lithograph
47 1/2 x 36 in. (120.6 x 91.4 cm)
Promised gift of Andrea and James Gordon P.2002.65

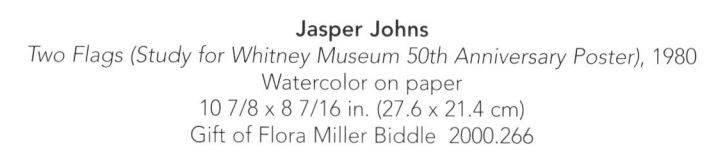

Jasper Johns
Two Flags (Study for Whitney Museum 50th Anniversary Poster), 1980
Watercolor on paper
10 7/8 x 8 7/16 in. (27.6 x 21.4 cm)
Gift of Flora Miller Biddle 2000.266

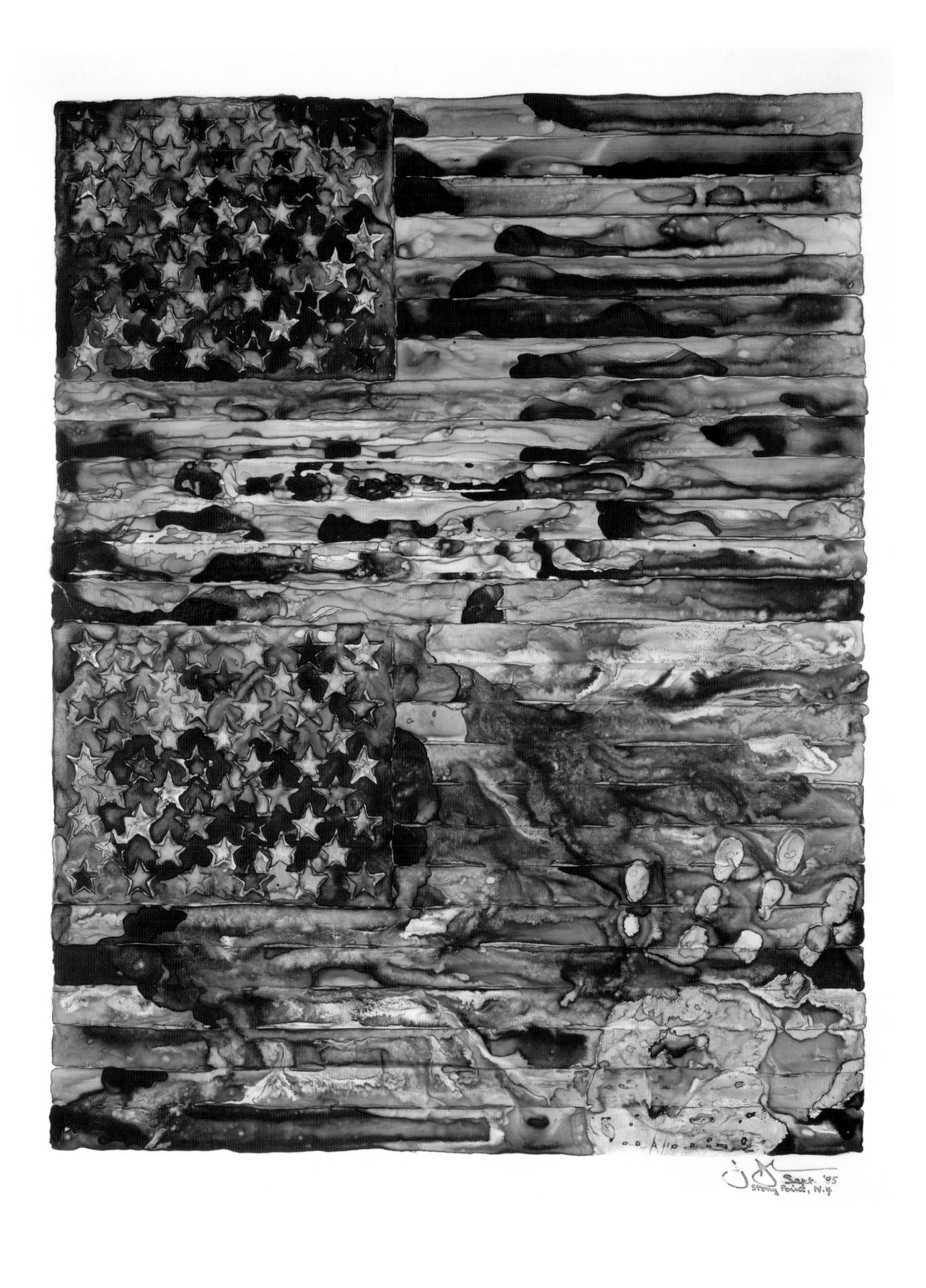

Jasper Johns
Two Flags, 1985
Ink on plastic
26 5/8 x 21 7/8 in. (67.6 x 55.6 cm)
Gift of The American Contemporary Art Foundation, Inc., Leonard A. Lauder, President 2002.240

Like many artists in the 1960s, Johns drew subject matter for his art from his immediate surroundings. In 1960 he made a life-size bronze sculpture based on a Savarin coffee can that he used to hold paintbrushes in his studio. Titled *Painted Bronze*, the sculpture alludes to the work of Marcel Duchamp, the Dada inventor of "readymades"—found objects re-presented as works of art— and an artist much admired by Johns. Johns inverted Duchamp's notion of a readymade by fabricating a work of art that resembles a found object.

In 1977 Johns made a large-scale lithograph of the Savarin can for a poster announcing a retrospective of his work at the Whitney. He then used extra plates from this print run to create a new variation on the image in 1981. At the bottom right of this later version Johns placed the initials E.M., which stand for Edward Munch, the Norwegian Symbolist artist renowned for his printmaking skills. Among Munch's most famous prints is a self-portrait in which his gaunt face floats above a skeletal arm at the bottom edge of the work. Johns also imprinted an arm, presumably his own, at the bottom of his composition and substituted the brush-filled Savarin can as a surrogate for his portrait.

Johns withheld a group of proofs from the 1981 Savarin edition because of a discrepancy in the paper color. The following year he used these extra prints as the basis for a group of monotypes, including the seventeen *Savarin* monotypes recently given to the Whitney. This same group was shown at the Museum in a 1982–83 exhibition. To make these unique works, Johns painted on surfaces such as paper or plastic, placed that image face down onto one of the Savarin lithographs, and ran the sheet through a press. In the group presented here, six of the works were printed with no lithographic under layer (pp. 31, 34, 36, 39, 43, and 45); in one of these (p. 34), Johns's handprints in the background echo the pattern and color distribution of the hatch marks in his original lithographs.

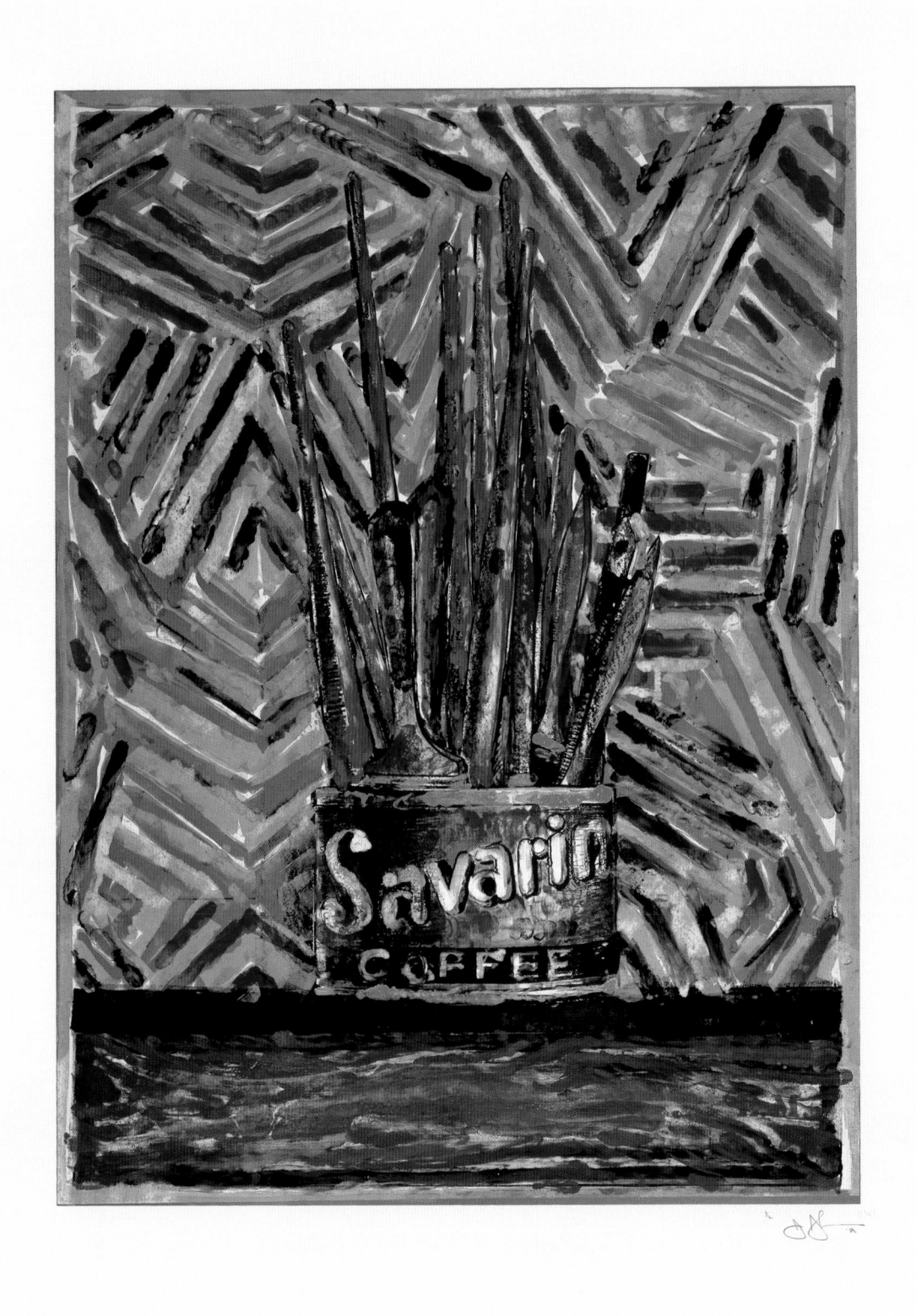

Jasper Johns
Savarin, 1982
Monotype over lithograph
50 x 38 in. (127 x 96.5 cm)
Gift of The American Contemporary Art Foundation, Inc., Leonard A. Lauder, President 2002.223

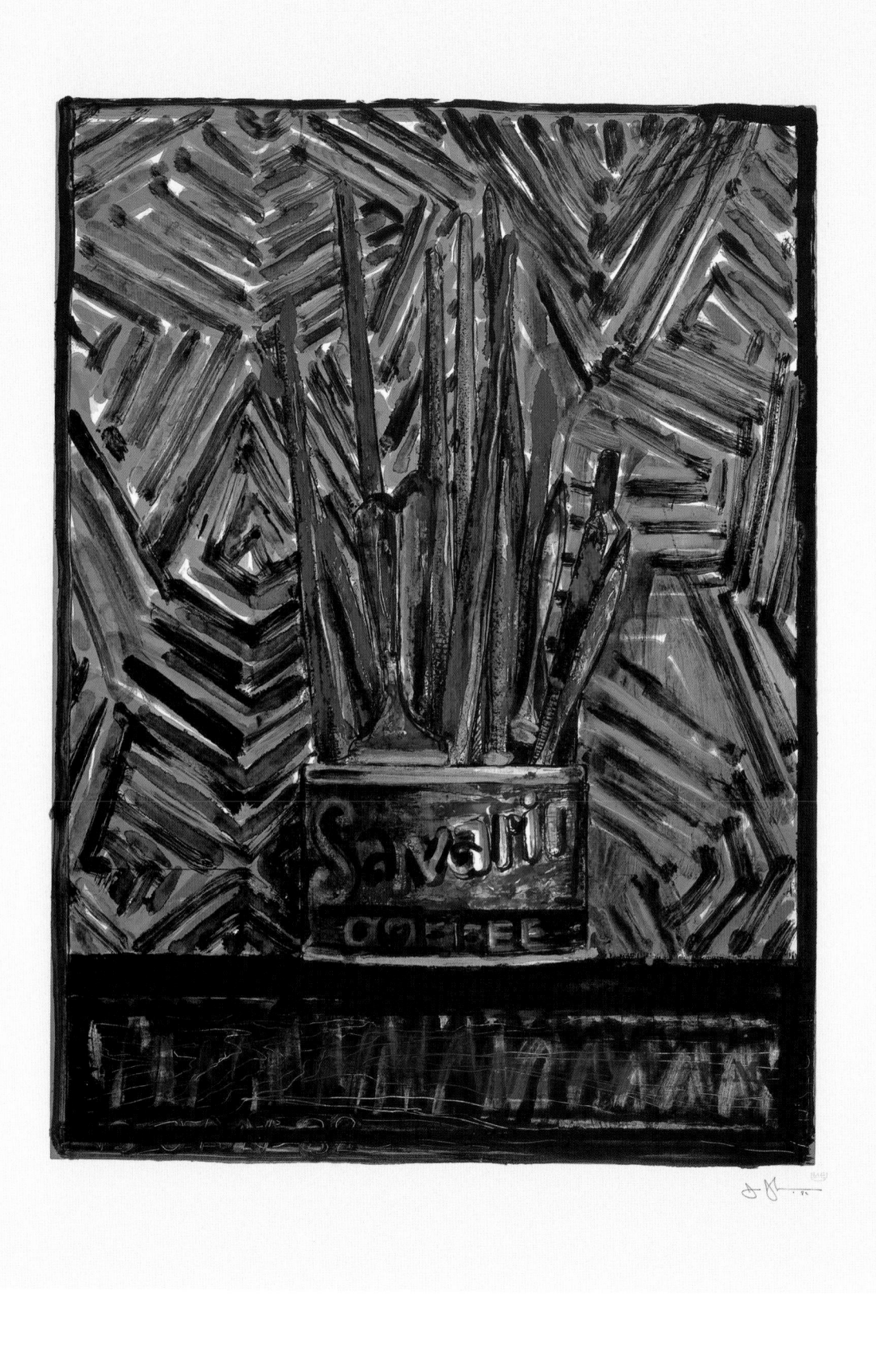

Jasper Johns
Savarin, 1982
Monotype over lithograph
50 x 38 in. (127 x 96.5 cm)
Gift of The American Contemporary Art Foundation, Inc., Leonard A. Lauder, President 2002.224

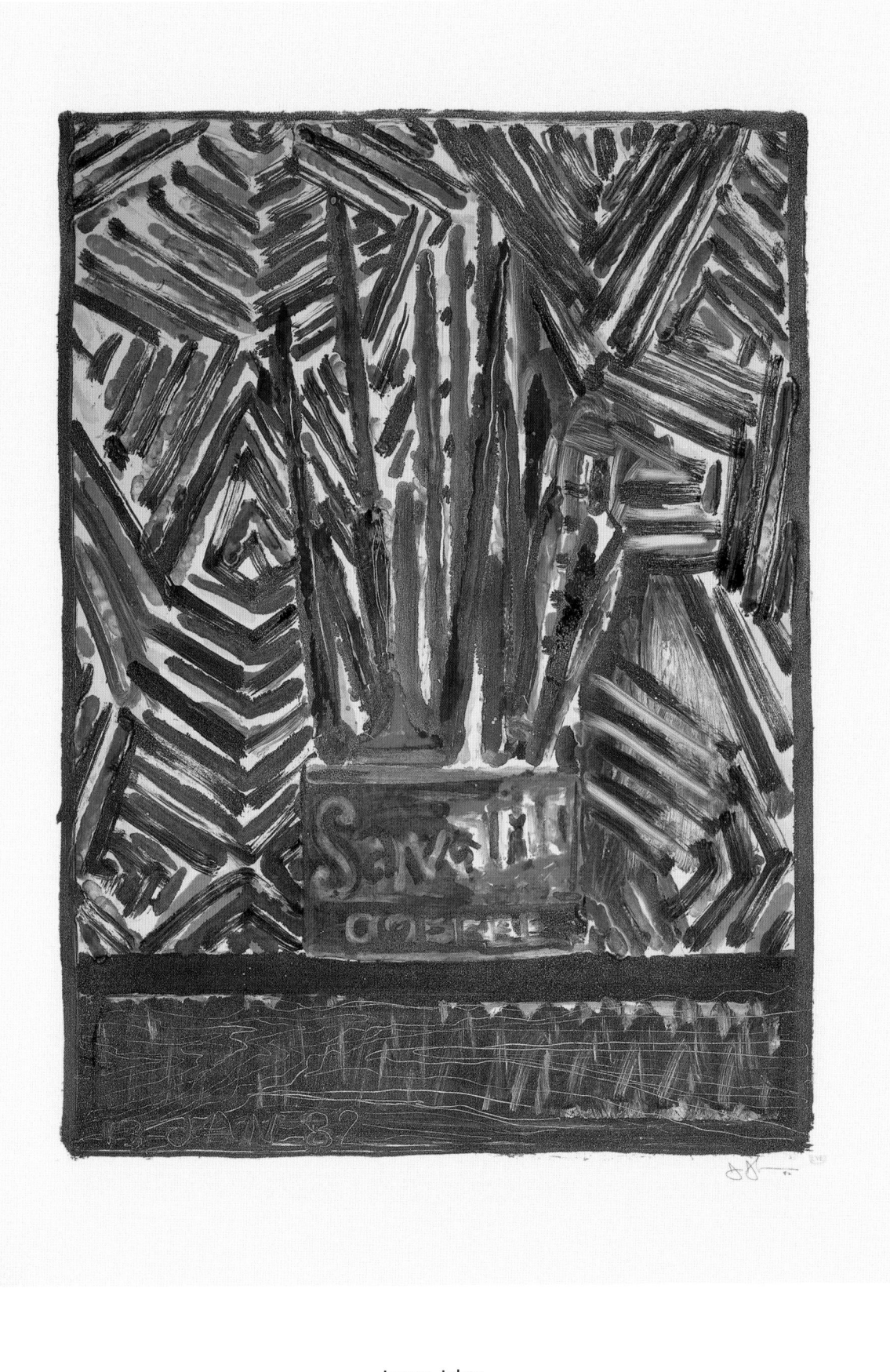

Jasper Johns
Savarin, 1982
Monotype
50 x 38 in. (127 x 96.5 cm)
Gift of The American Contemporary Art Foundation, Inc., Leonard A. Lauder, President 2002.225

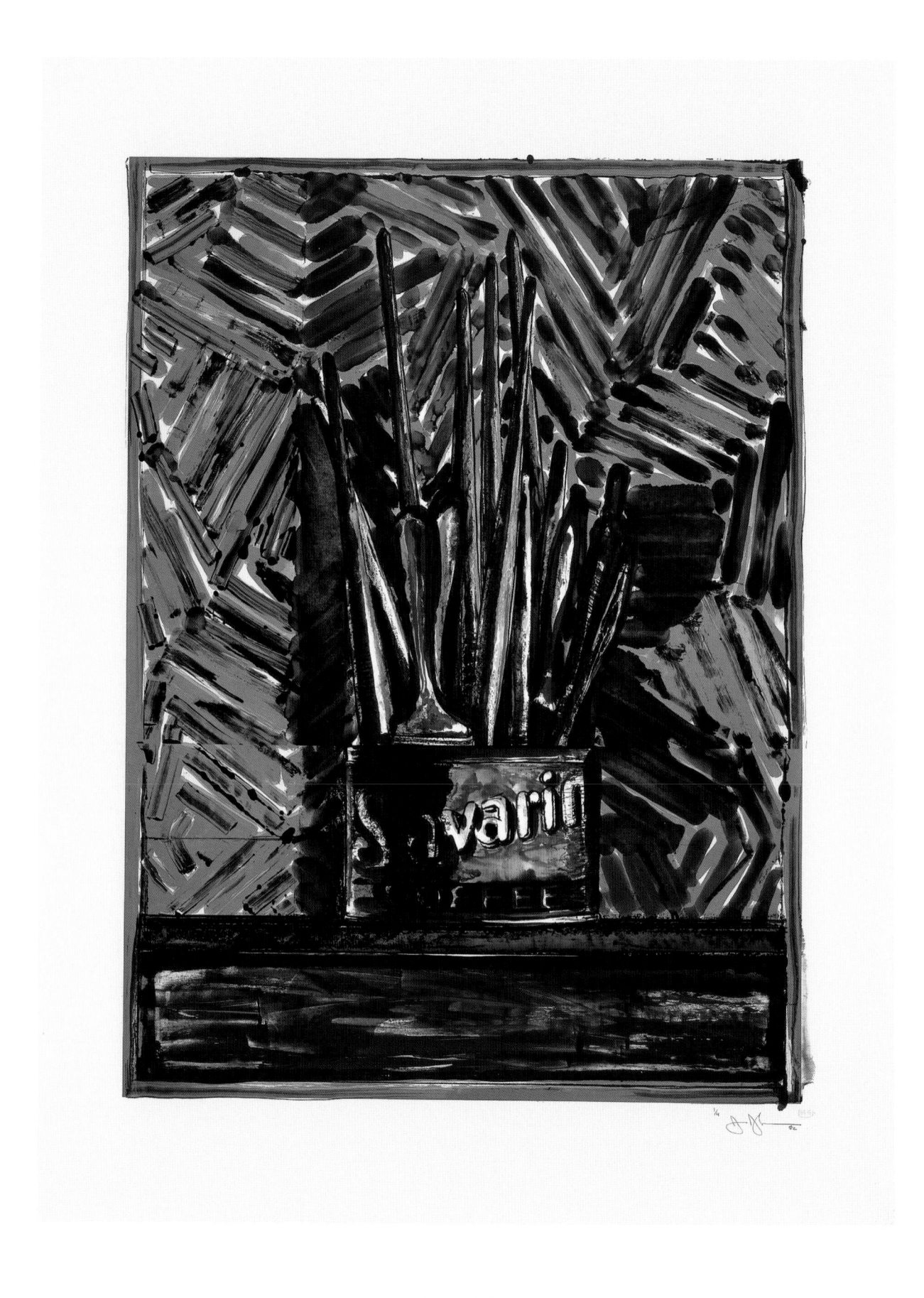

Jasper Johns
Savarin, 1982
Monotype over lithograph
50 x 38 in. (127 x 96.5 cm)
Gift of The American Contemporary Art Foundation, Inc., Leonard A. Lauder, President 2002.226

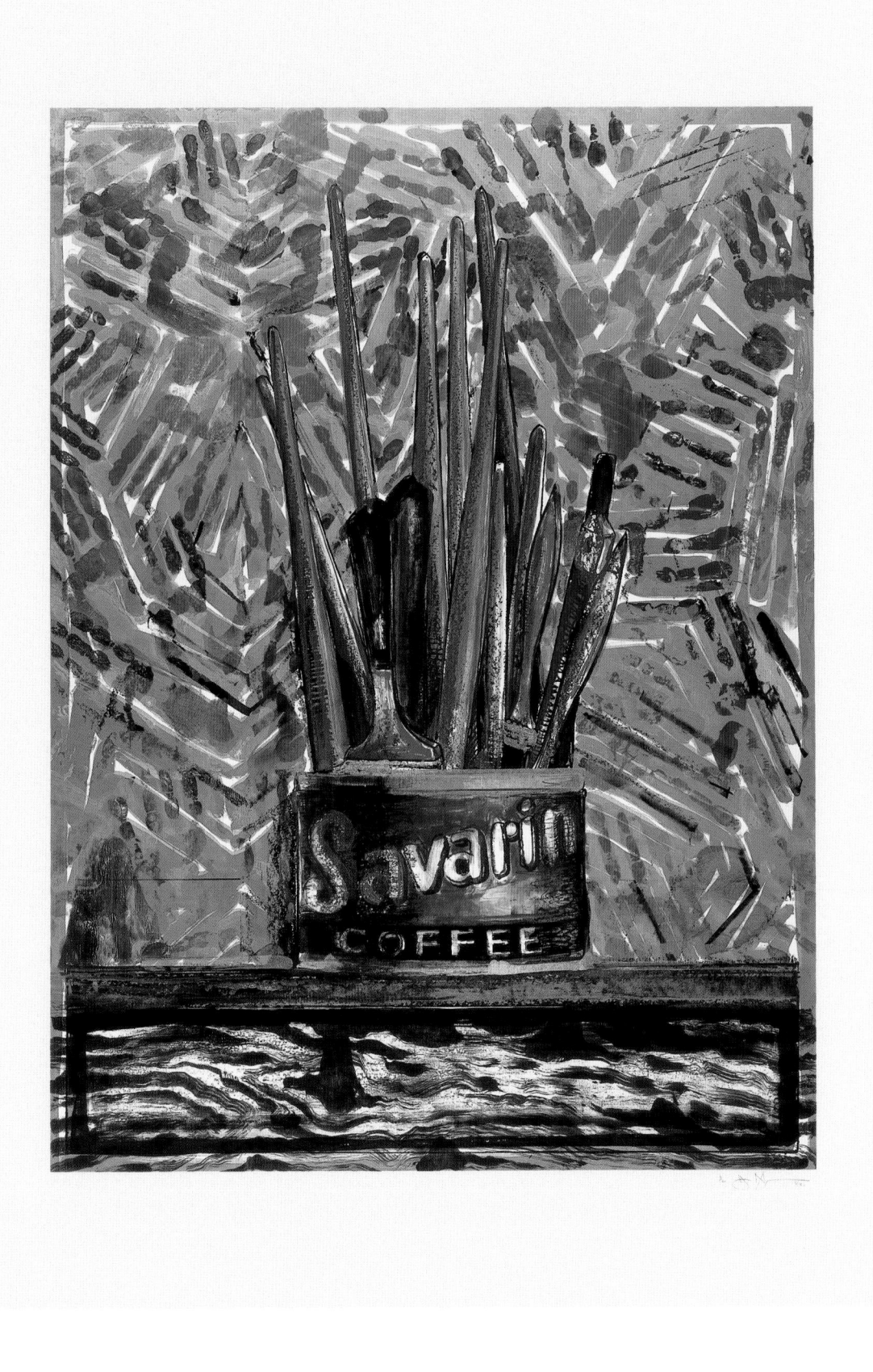

Jasper Johns
Savarin, 1982
Monotype over lithograph
50 x 38 in. (127 x 96.5 cm)
Gift of The American Contemporary Art Foundation, Inc., Leonard A. Lauder, President 2002.227

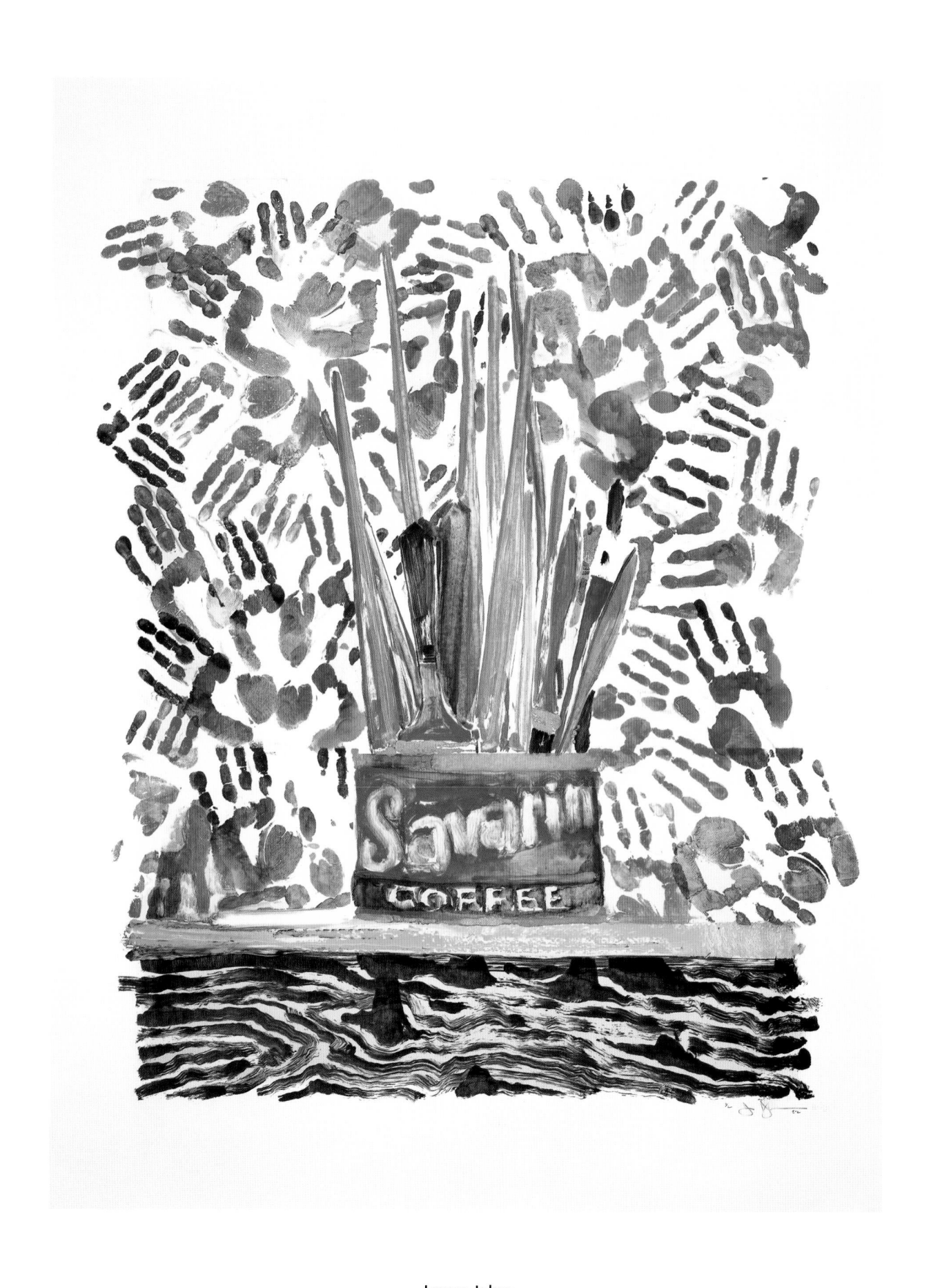

Jasper Johns
Savarin, 1982
Monotype
50 x 38 in. (127 x 96.5 cm)
Gift of The American Contemporary Art Foundation, Inc., Leonard A. Lauder, President 2002.228

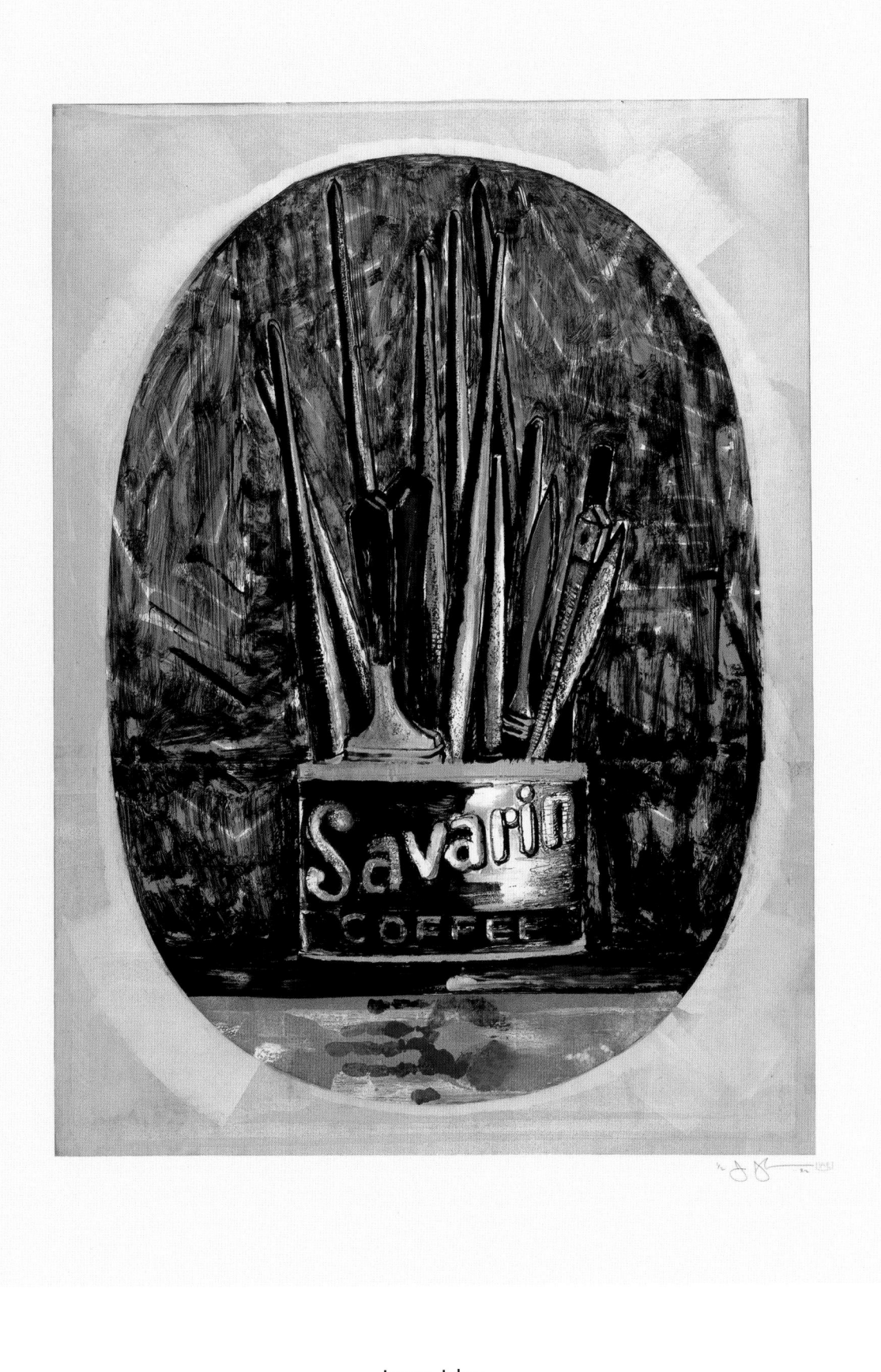

Jasper Johns
Savarin, 1982
Monotype with hand additions over lithograph
50 x 38 in. (127 x 96.5 cm)
Gift of The American Contemporary Art Foundation, Inc., Leonard A. Lauder, President 2002.229

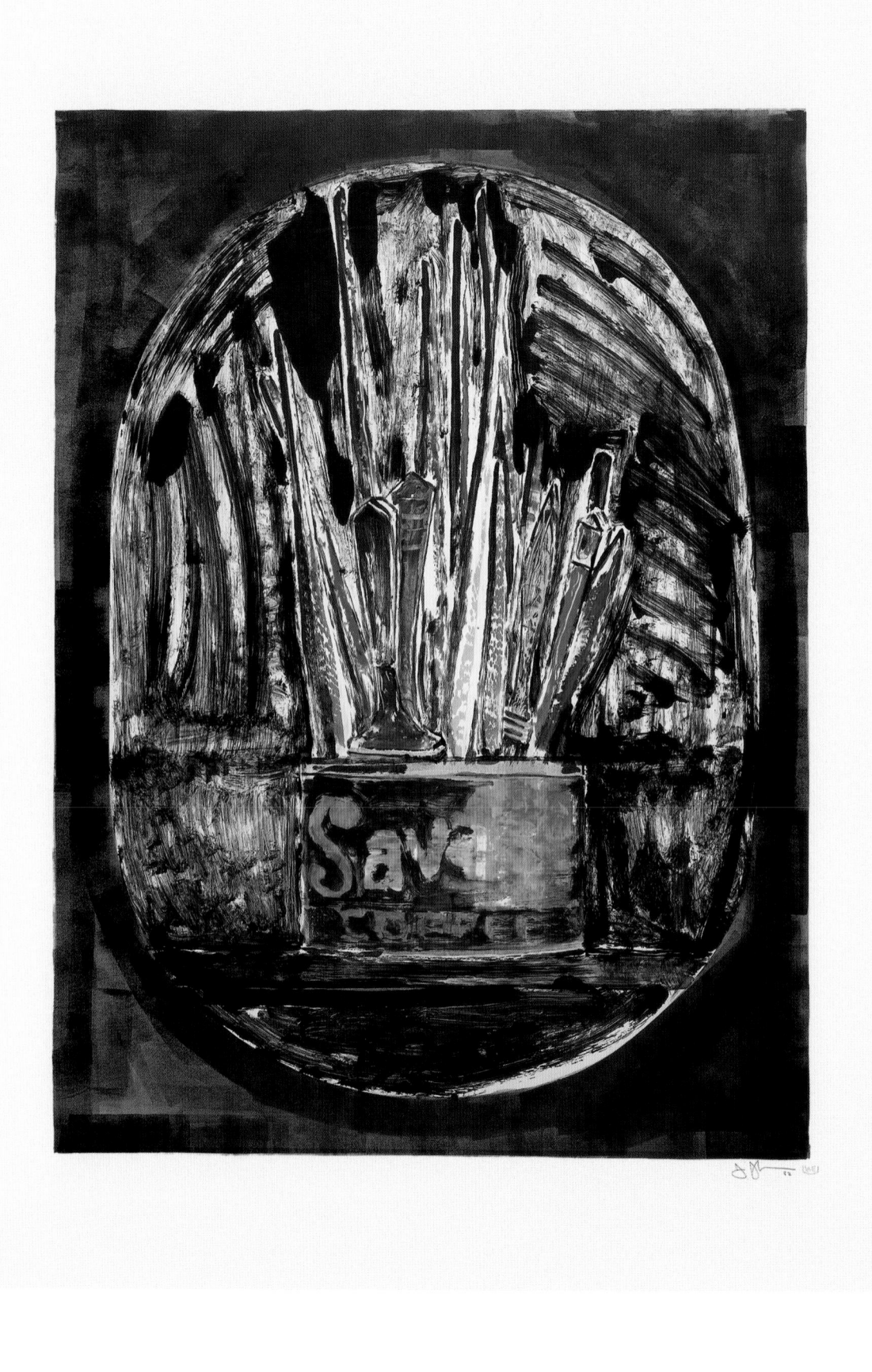

Jasper Johns
Savarin, 1982
Monotype with hand additions
50 x 38 in. (127 x 96.5 cm)
Gift of The American Contemporary Art Foundation, Inc., Leonard A. Lauder, President 2002.230

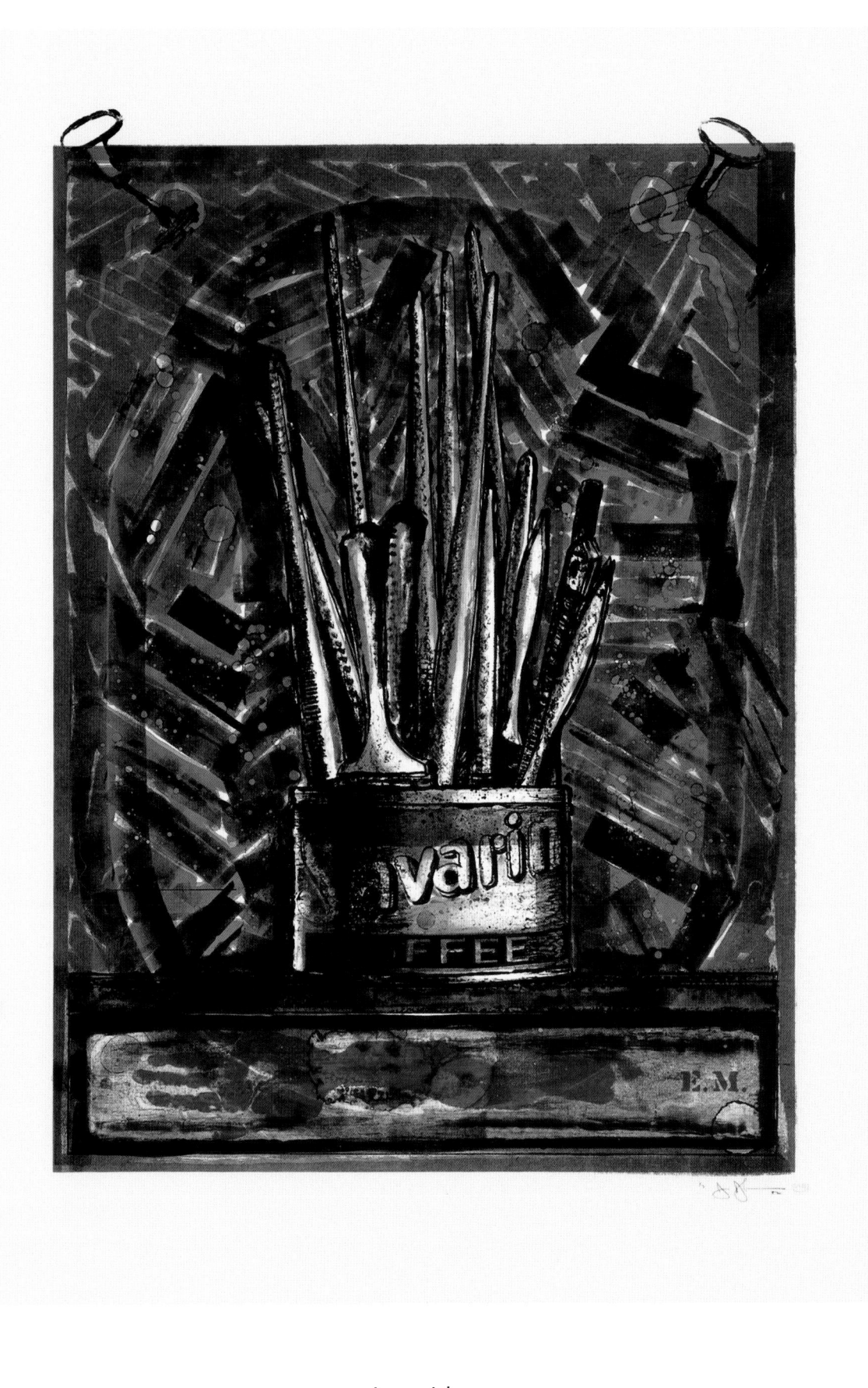

Jasper Johns
Savarin, 1982
Monotype over lithograph
50 x 38 in. (127 x 96.5 cm)
Gift of The American Contemporary Art Foundation, Inc., Leonard A. Lauder, President 2002.231

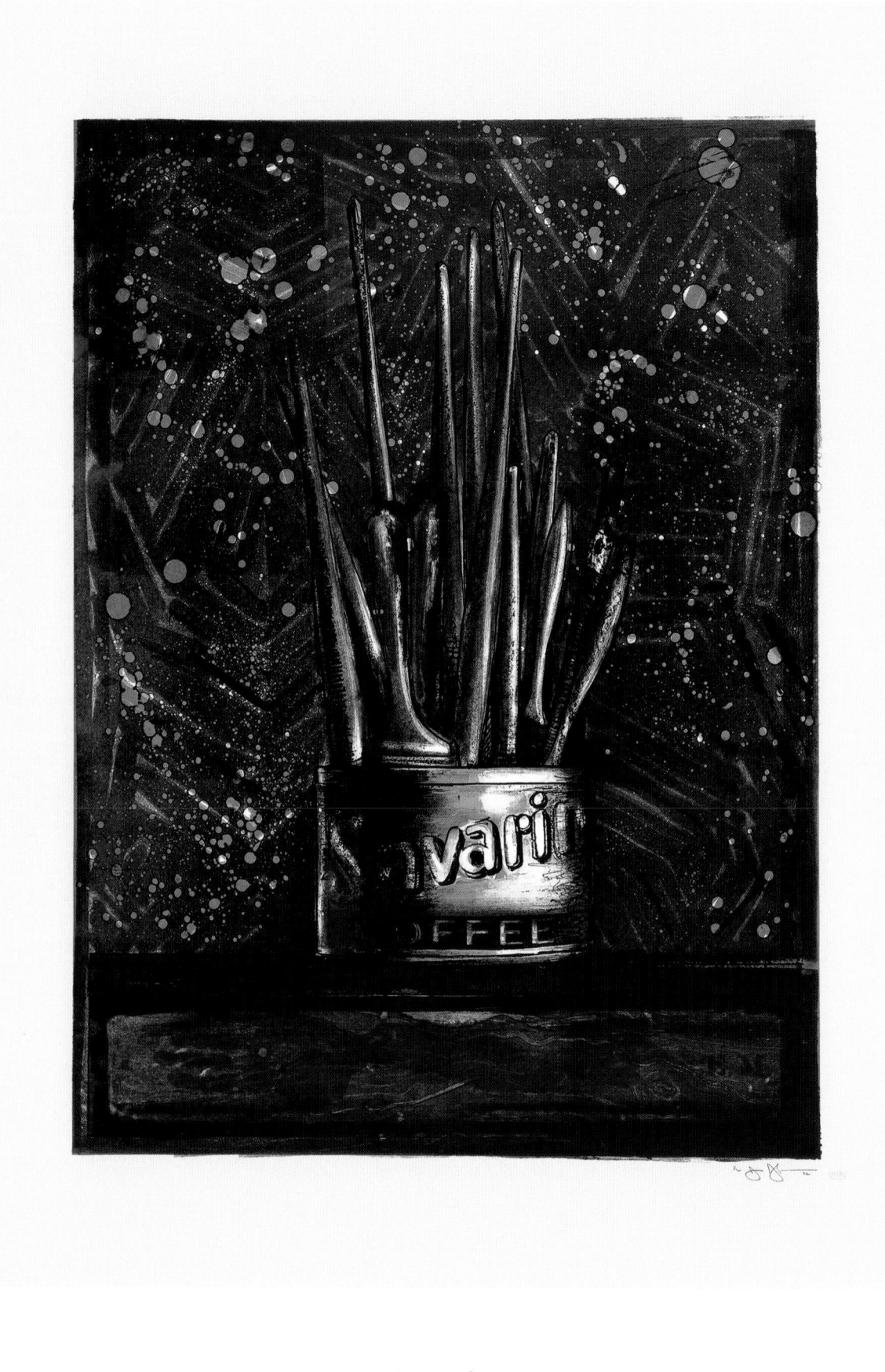

Jasper Johns
Savarin, 1982
Monotype over lithograph
50 x 38 in. (127 x 96.5 cm)
Gift of The American Contemporary Art Foundation, Inc., Leonard A. Lauder, President 2002.232

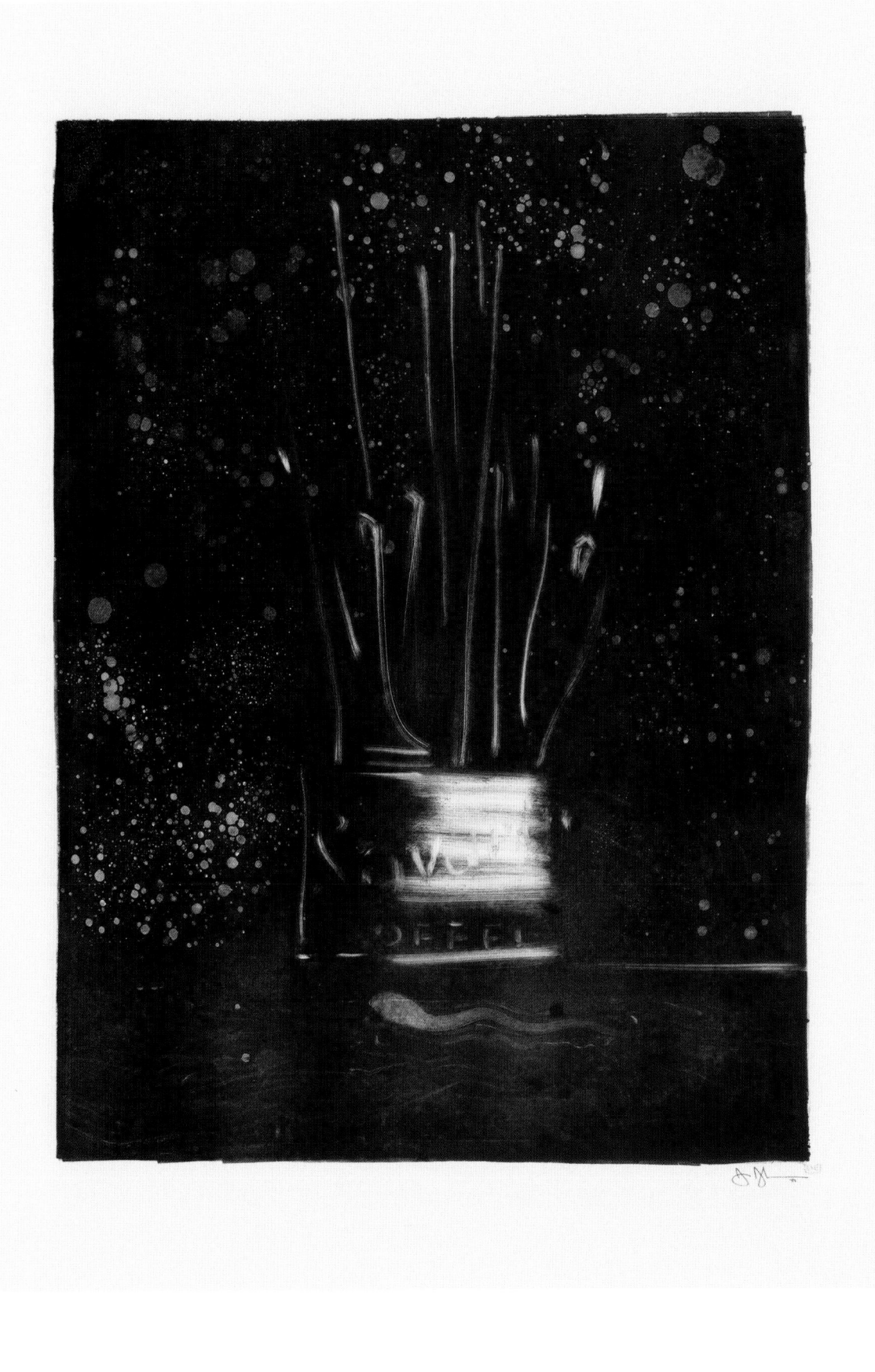

Jasper Johns
Savarin, 1982
Monotype
50 x 38 in. (127 x 96.5 cm)
Gift of The American Contemporary Art Foundation, Inc., Leonard A. Lauder, President 2002.233

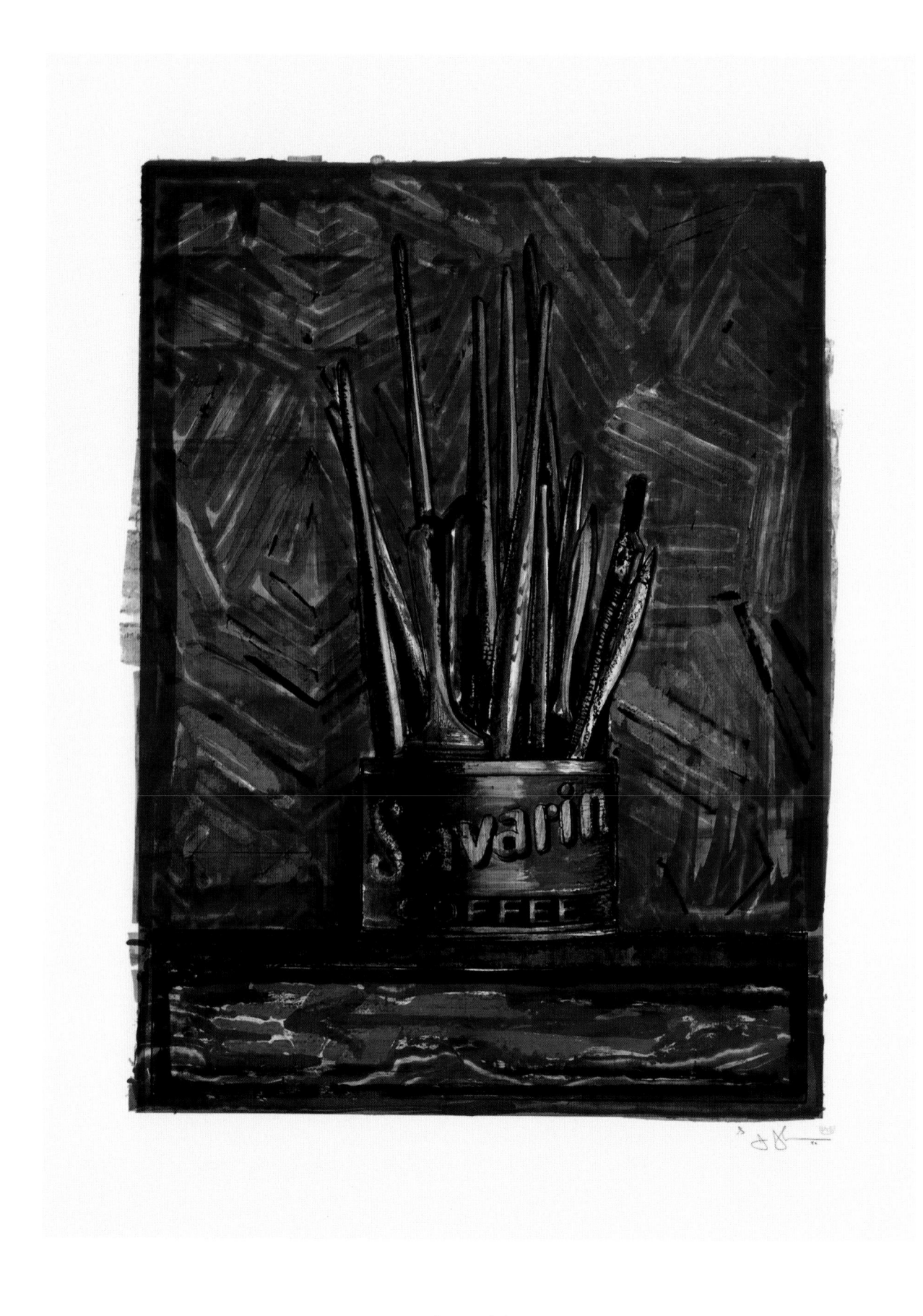

Jasper Johns
Savarin, 1982
Monotype over lithograph
50 x 38 in. (127 x 96.5 cm)
Gift of The American Contemporary Art Foundation, Inc., Leonard A. Lauder, President 2002.234

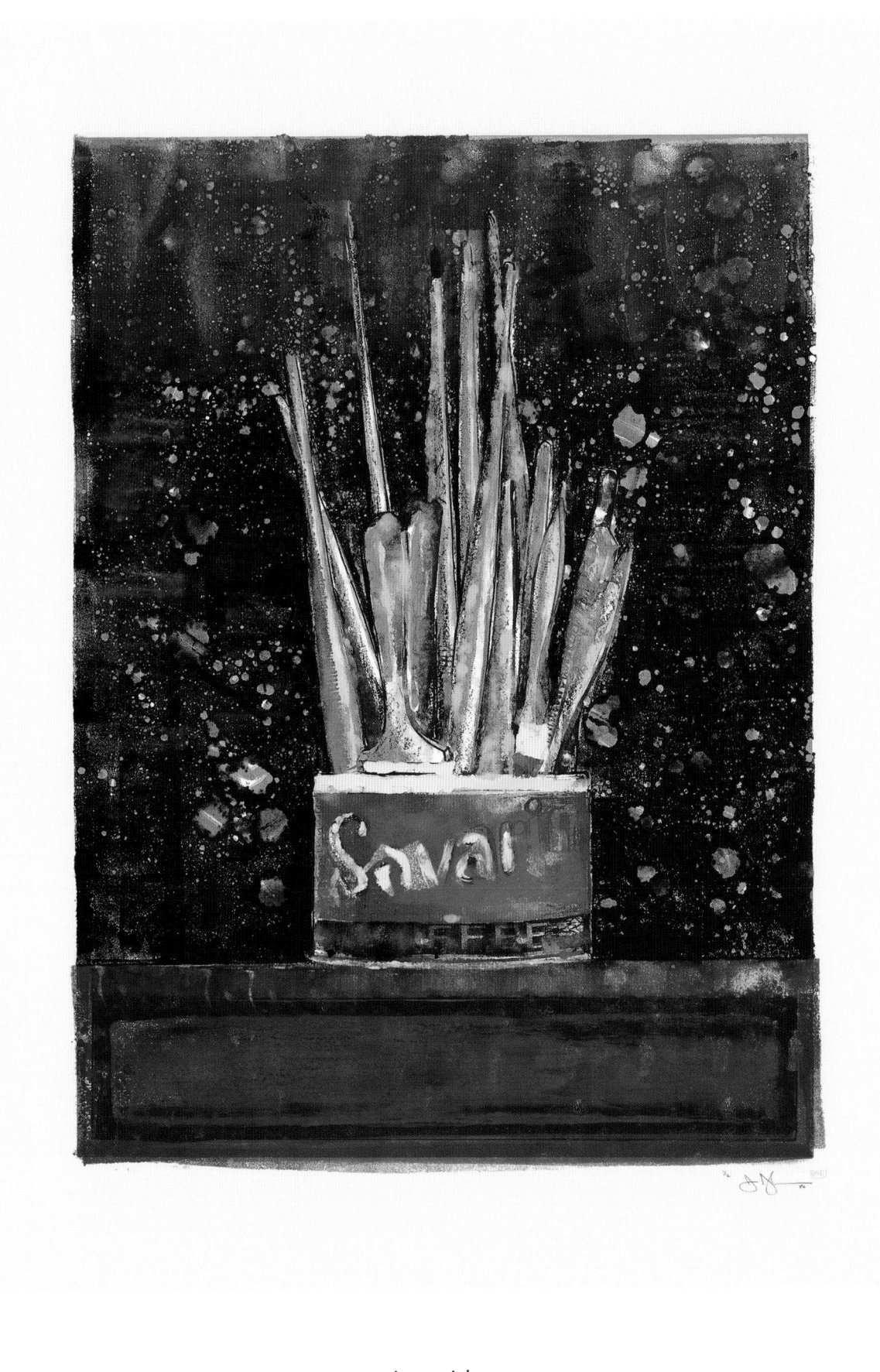

Jasper Johns
Savarin, 1982
Monotype over lithograph
50 x 38 in. (127 x 96.5 cm)
Gift of The American Contemporary Art Foundation, Inc., Leonard A. Lauder, President 2002.235

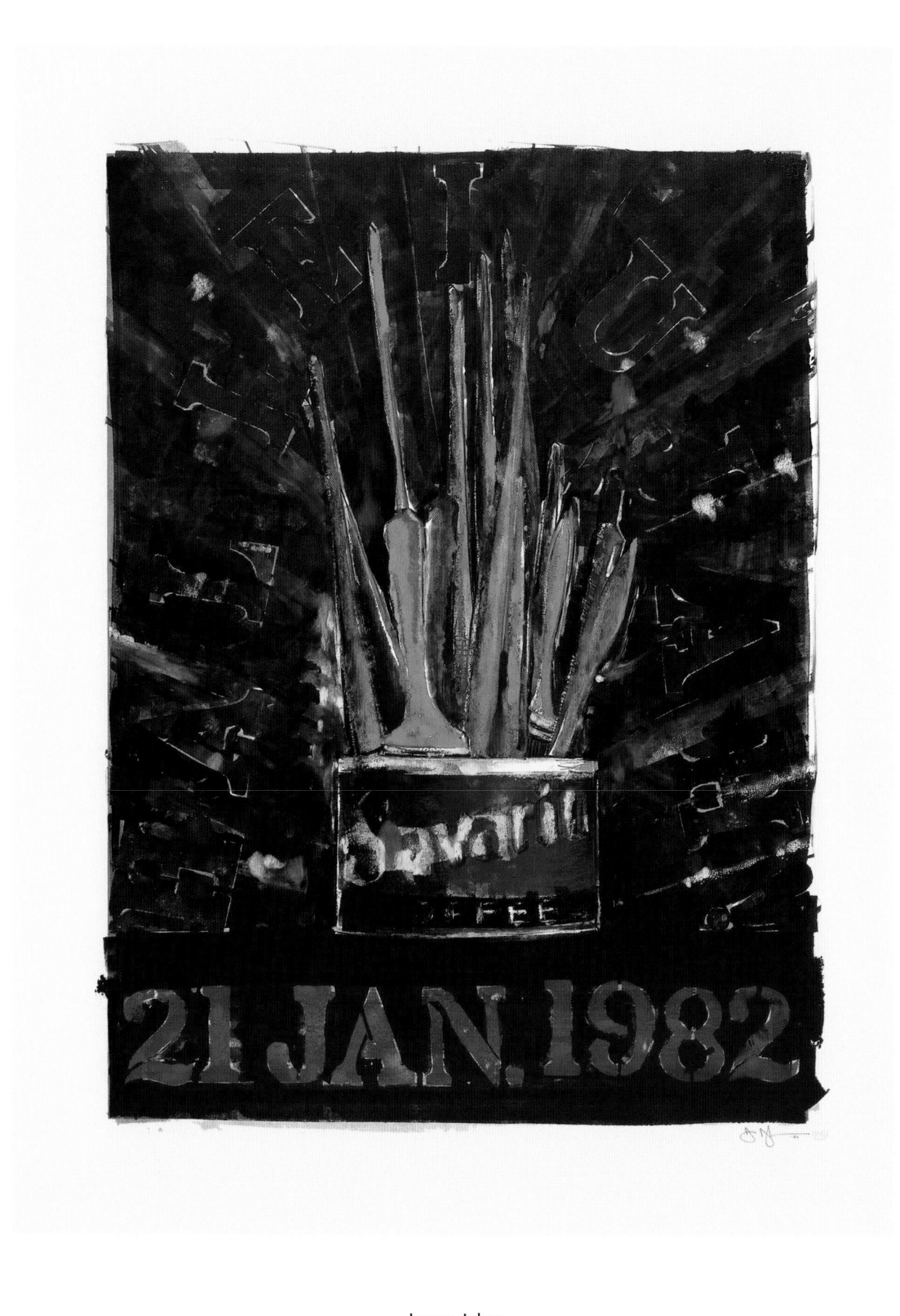

Jasper Johns
Savarin, 1982
Monotype over lithograph
50 x 38 in. (127 x 96.5 cm)
Gift of The American Contemporary Art Foundation, Inc., Leonard A. Lauder, President 2002.236

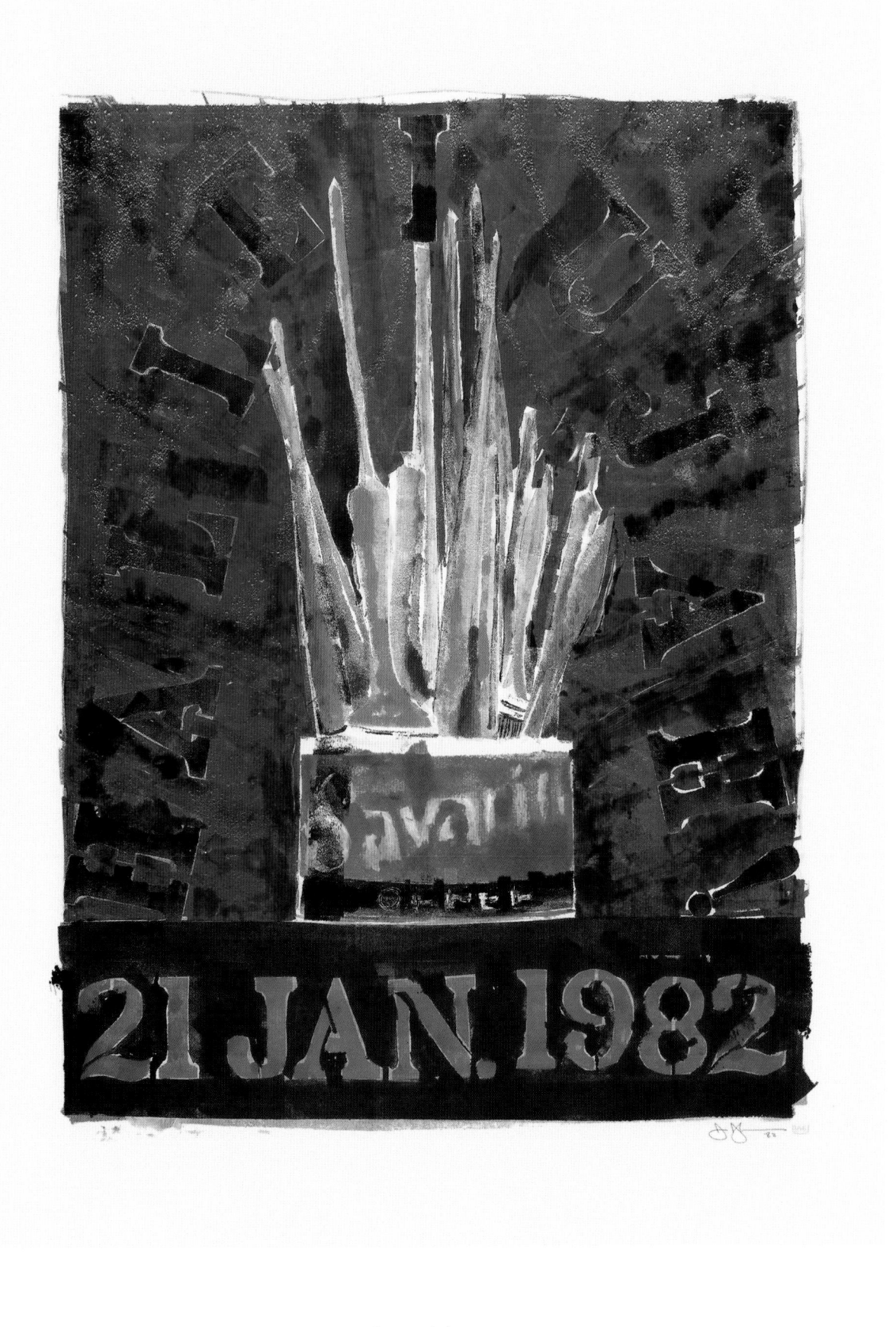

Jasper Johns
Savarin, 1982
Monotype
50 x 38 in. (127 x 96.5 cm)
Gift of The American Contemporary Art Foundation, Inc., Leonard A. Lauder, President 2002.237

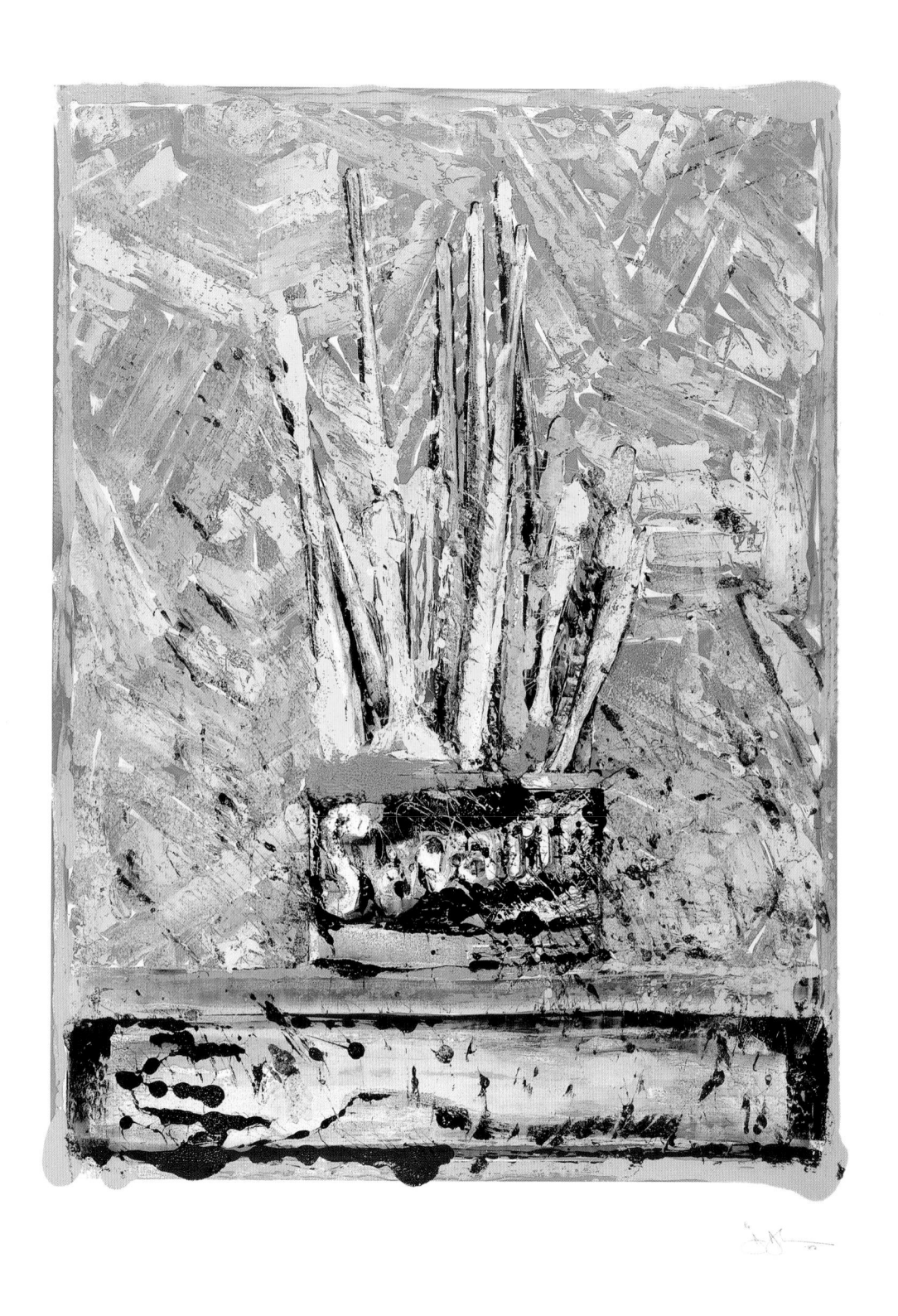

Jasper Johns
Savarin, 1982
Monotype over lithograph
50 x 38 in. (127 x 96.5 cm)
Gift of The American Contemporary Art Foundation, Inc., Leonard A. Lauder, President 2002.238

Jasper Johns
Savarin, 1982
Monotype
50 x 38 in. (127 x 96.5 cm)
Gift of The American Contemporary Art Foundation, Inc., Leonard A. Lauder, President 2002.239

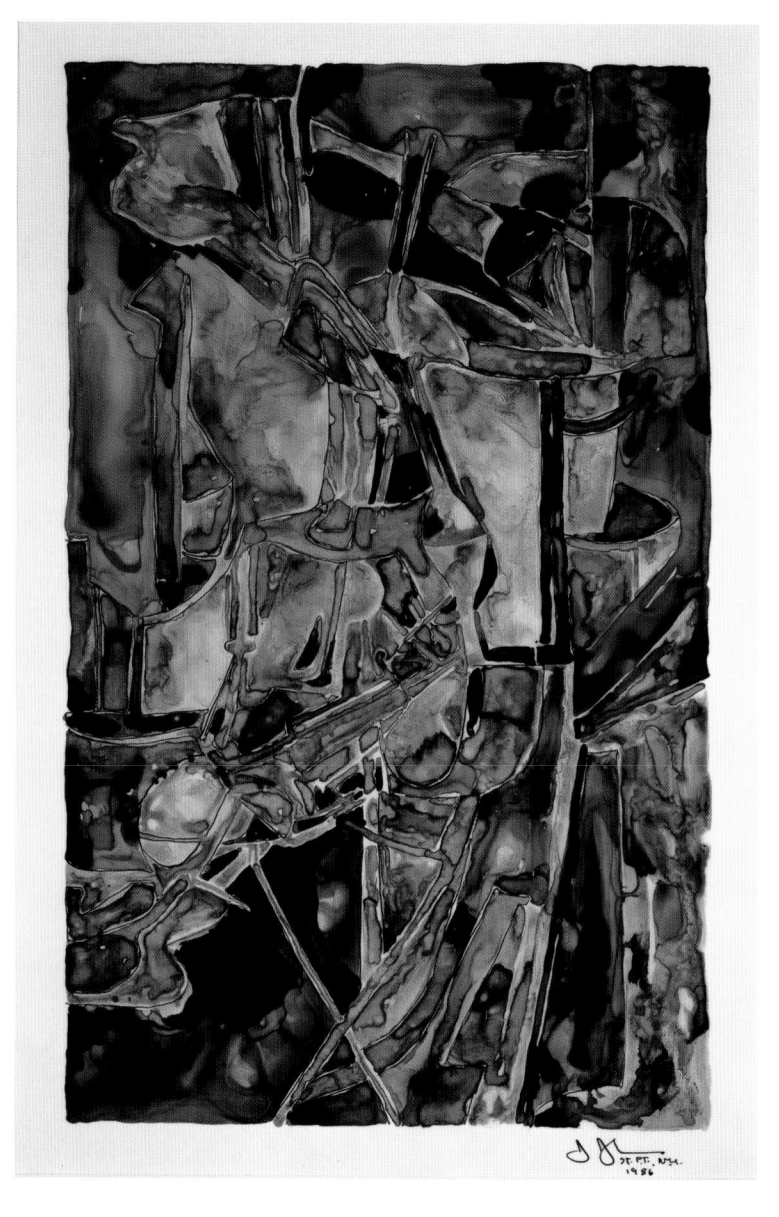 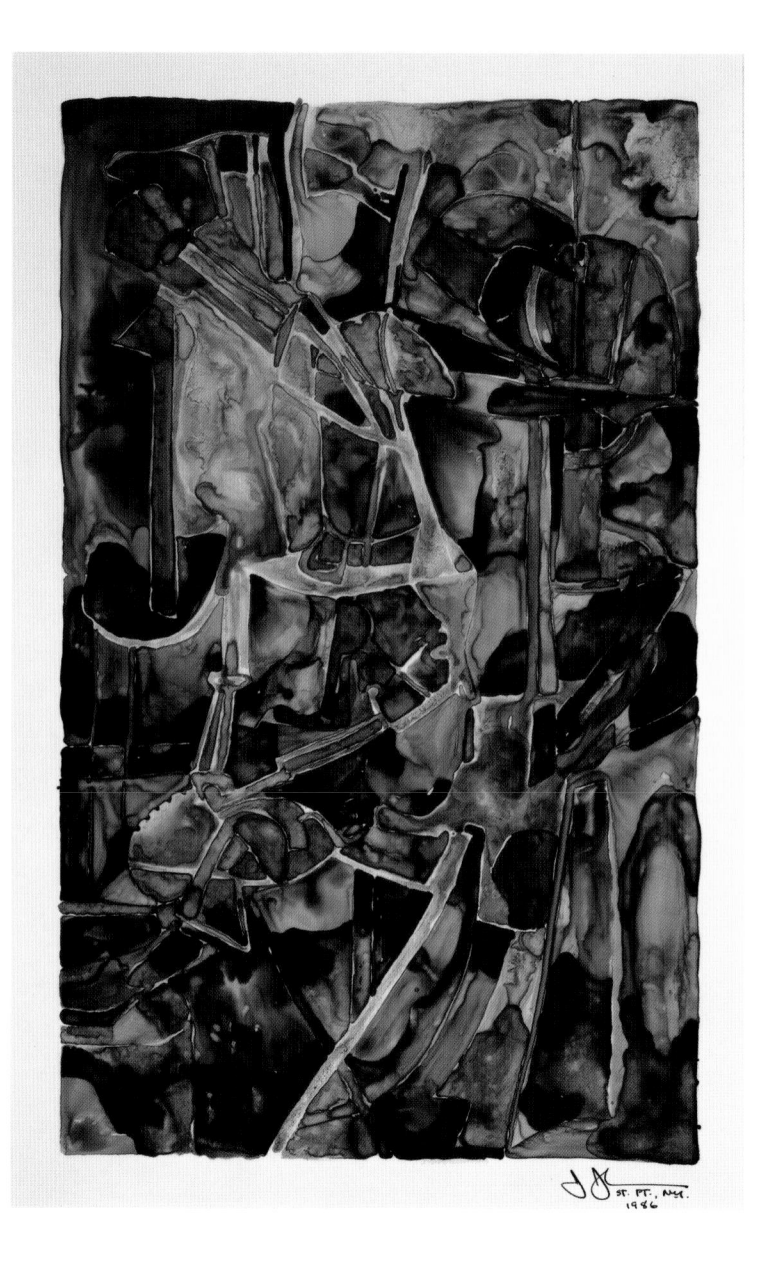

Jasper Johns
Untitled, 1986
Ink on plastic
26 x 18 1/8 in. (66 x 46 cm)
Gift of The American Contemporary Art Foundation, Inc., Leonard A. Lauder, President 2002.241

Untitled, 1986
Ink on plastic
25 5/16 x 18 in. (64.3 x 45.7 cm)
Gift of The American Contemporary Art Foundation, Inc., Leonard A. Lauder, President 2002.242

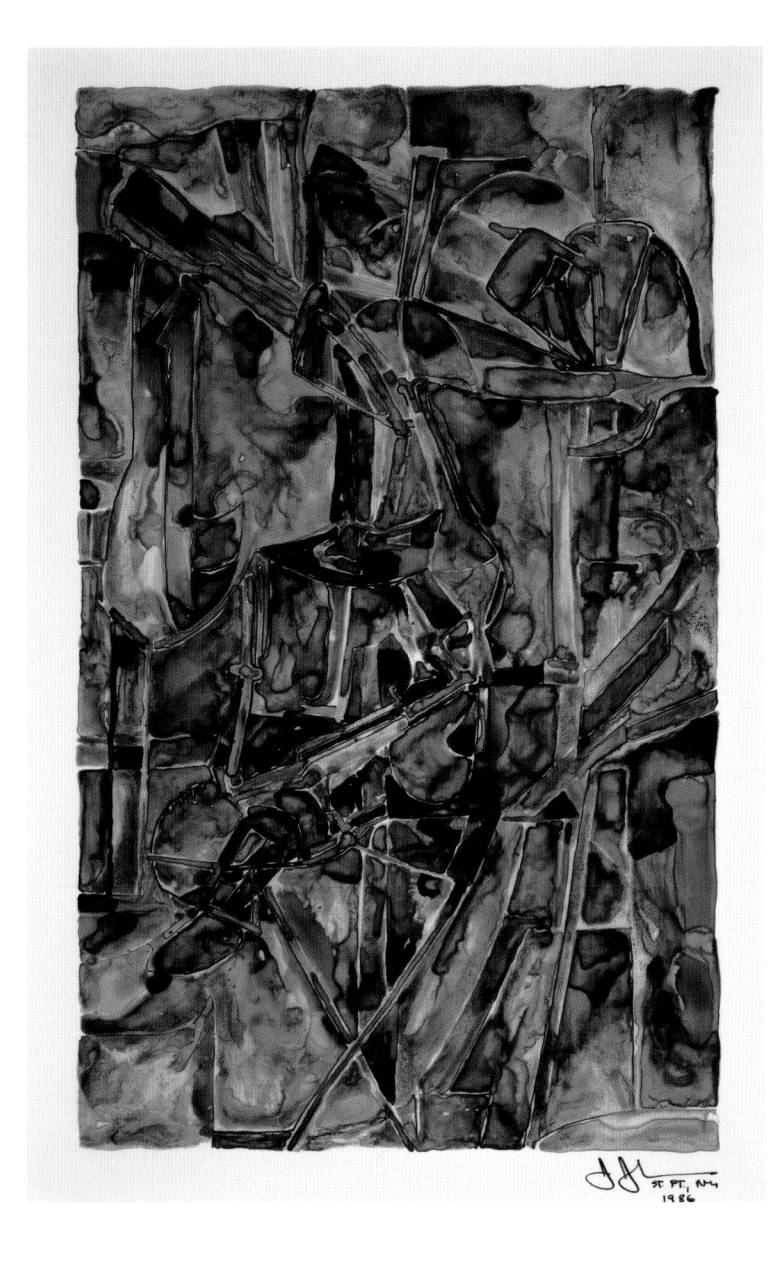 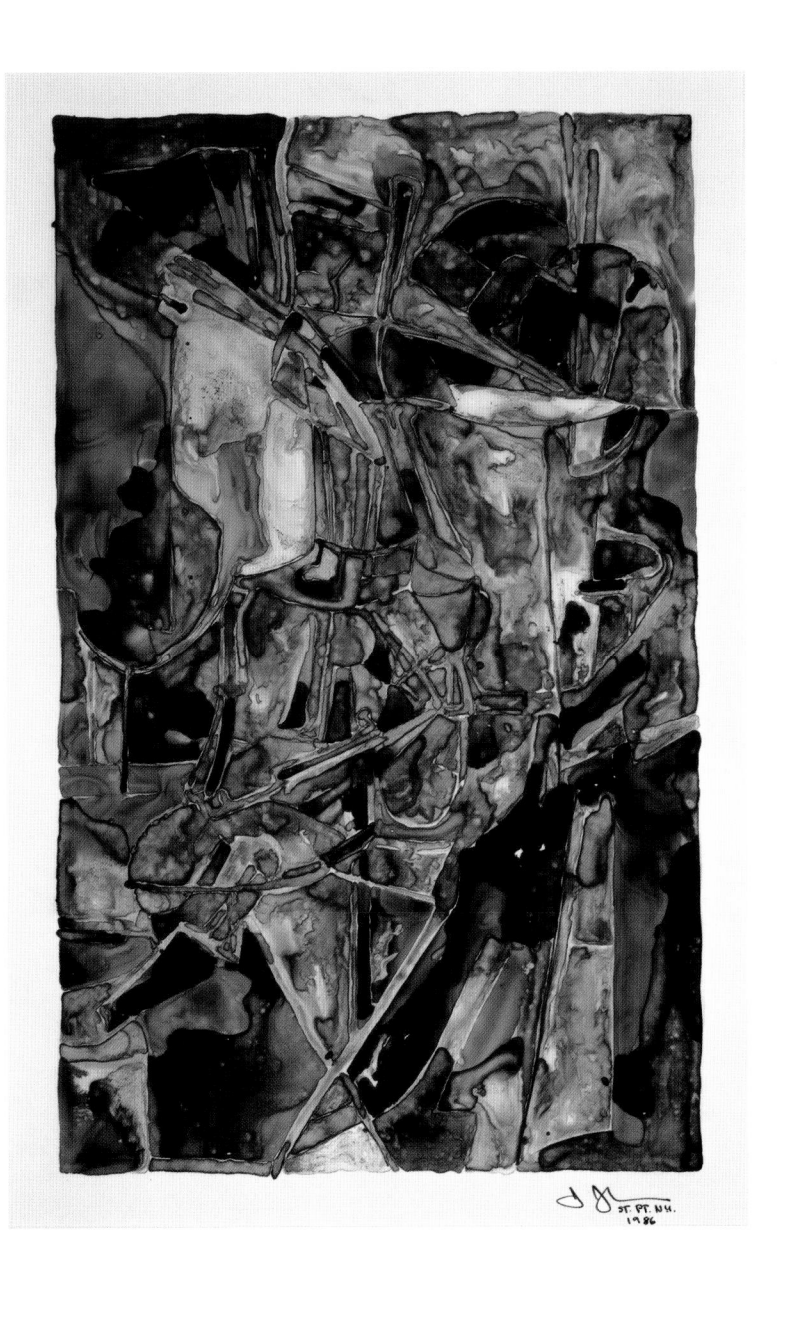

Jasper Johns
Untitled, 1986
Ink on plastic
26 x 18 1/8 in. (66 x 46 cm)
Gift of The American Contemporary Art Foundation, Inc., Leonard A. Lauder, President 2002.243

Untitled, 1986
Ink on plastic
25 15/16 x 18 1/4 in. (64.3 x 46.4)
Gift of The American Contemporary Art Foundation, Inc., Leonard A. Lauder, President 2002.244

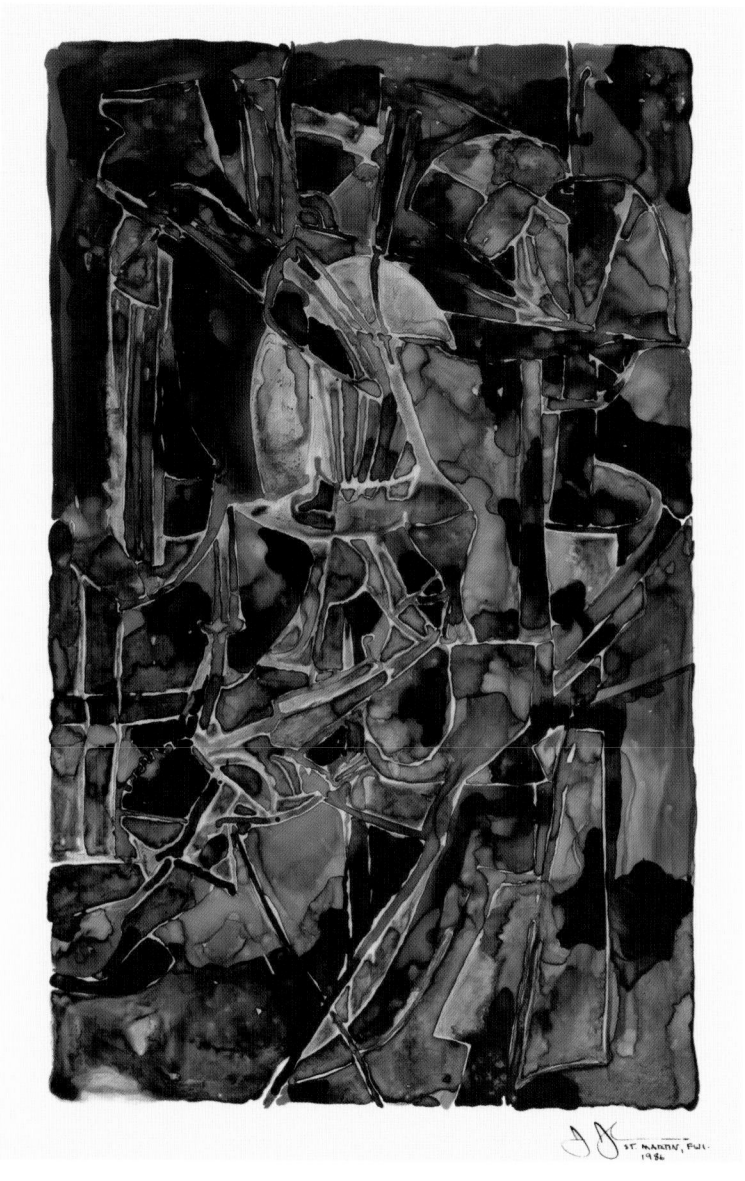
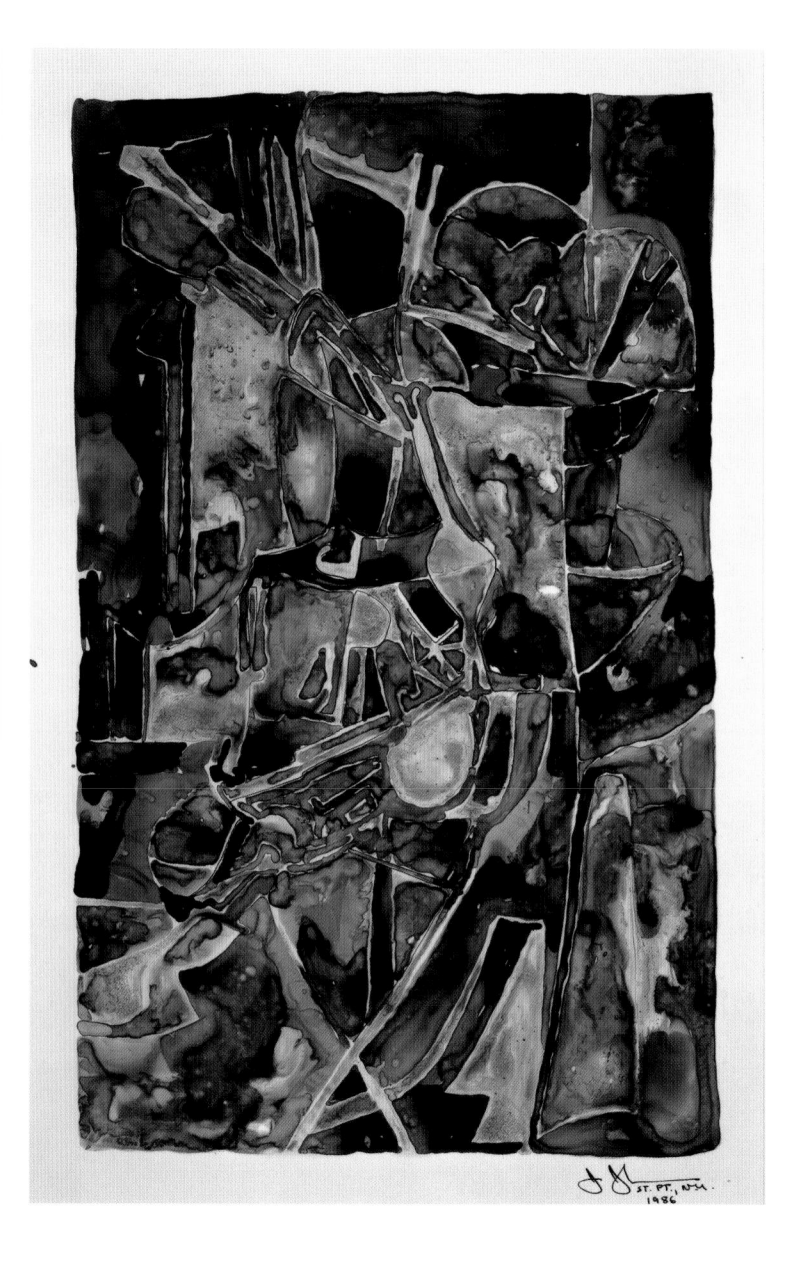

Jasper Johns
Untitled, 1986
Ink on plastic
25 7/8 x 18 in. (65.7 x 45.7 cm)
Gift of The American Contemporary Art Foundation, Inc., Leonard A. Lauder, President 2002.245

Untitled, 1986
Ink on plastic
26 x 18 1/8 in. (66 x 46 cm)
Gift of The American Contemporary Art Foundation, Inc., Leonard A. Lauder, President 2002.246

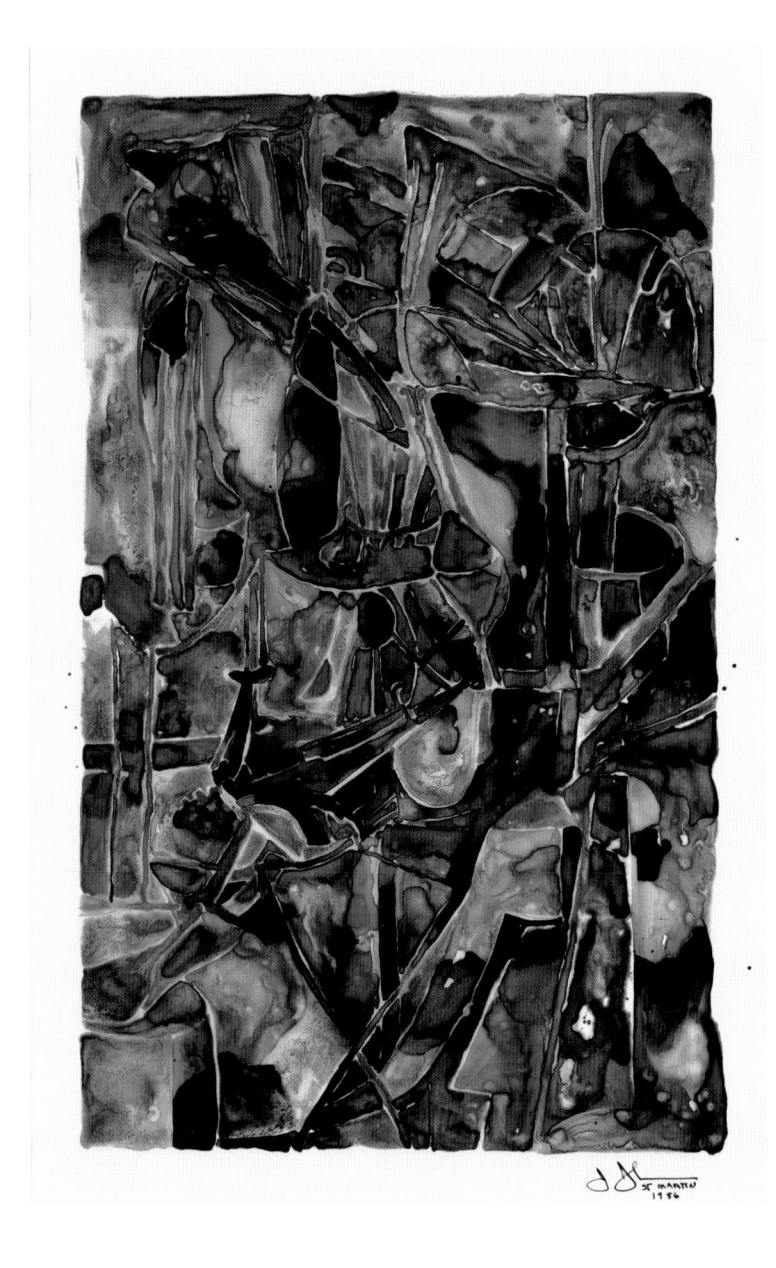
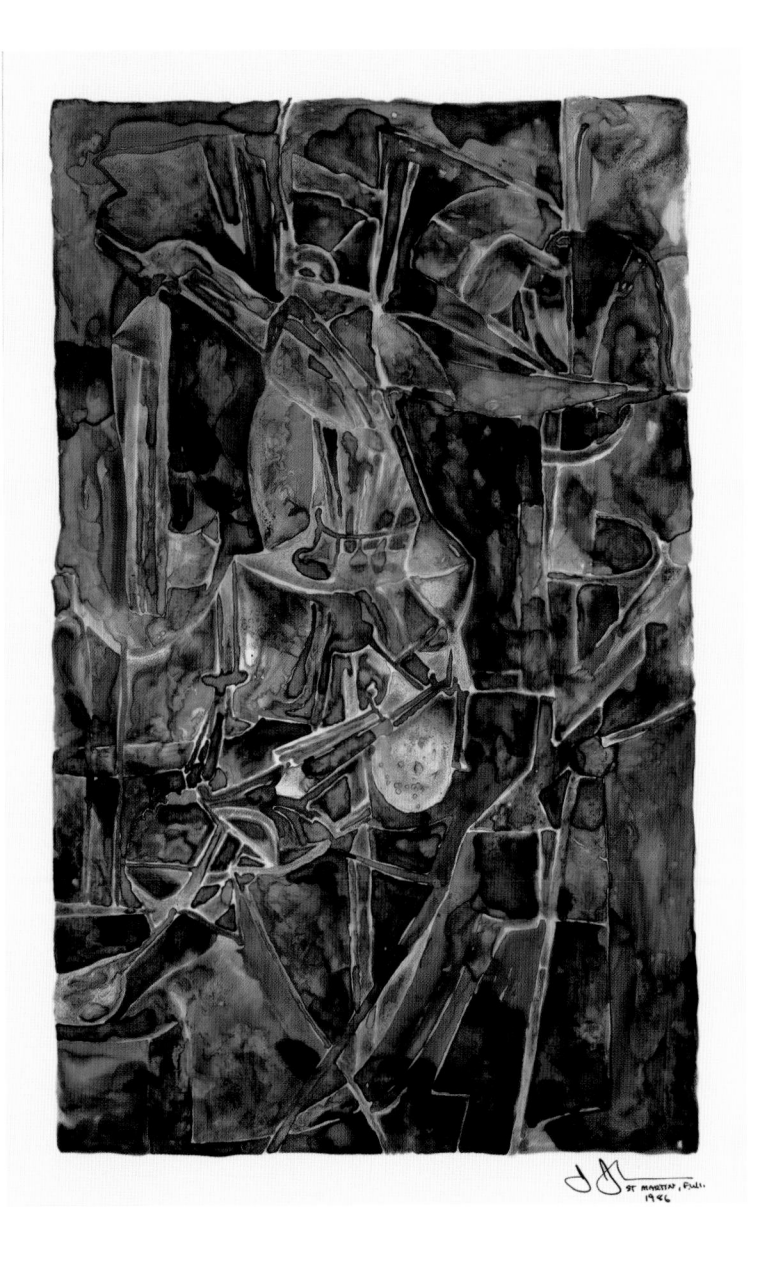

Jasper Johns
Untitled, 1986
Ink on plastic
26 x 18 1/8 in. (66 x 46 cm)
Gift of The American Contemporary Art Foundation, Inc., Leonard A. Lauder, President 2002.247

Untitled, 1986
Ink on plastic
25 15/16 x 18 3/4 in. (65.9 x 47.6 cm)
Gift of The American Contemporary Art Foundation, Inc., Leonard A. Lauder, President 2002.248

As part of an exhibition in 2000 entitled *Encounters: New Art from Old*, the National Gallery in London invited Johns, along with twenty-five other artists, to create a work inspired by an object in their permanent collection. Johns chose the painting *The Execution of Maximilian* (1867–68) by French artist Édouard Manet as the starting point for his work.

Manet's painting depicts what was, at the time of its creation, a controversial event: the execution by firing squad of the Emperor of Mexico in 1867. Ferdinand Maximilian, an Austrian archduke, was installed on the throne of Mexico by Napoleon III of France in 1864, but when French troops withdrew, Maximilian was left to defend himself against Republican insurgents, who eventually had him executed. Manet's painting was an open criticism of the policies of Napoleon III and, perhaps for that reason, was refused by the Salon of 1869.

The Execution of Maximilian was cut into sections that were dispersed, it is believed, after Manet's death. The painter Edgar Degas painstakingly recouped four of the sections and in 1896 partially reconstructed Manet's work by attaching the recovered sections to a larger canvas in positions corresponding to their original placement. The National Gallery bought the work from the sale of Degas's personal collection in 1918.

Johns titled his 1999 painting for the National Gallery exhibition *Catenary (Manet-Degas)*. He also made a drawing, pictured here, of the same title. Both the painting and the drawing reference the peculiar history of Manet's work. The faint, rectangular outlines in the gray section of Johns's drawing represent the contours of the four recovered sections, as recomposed on the larger canvas. In this way *Catenary (Manet-Degas)* follows Johns's pattern of using preexisting images, including other works of art, as subject matter. "Works of art…can be treated like any other object, since they are just given," Johns explained. "And sometimes the image is so striking you simply want to use [it] again in some other context."

Johns has drawn a string spanning the surface of the drawing (an actual string hangs suspended in front of the painted version). The string forms a shape called a catenary, a curve assumed by a cord hanging freely from two fixed points and a device used frequently in suspension bridges. In this work the catenary bridges the fragments of the composition and traces an art historical thread from Manet to Degas to Johns. This chain is reinforced by the letters Johns stenciled at the bottom of the gray section that read "CATENARYMANETDEGASJ.JOHNS1999."

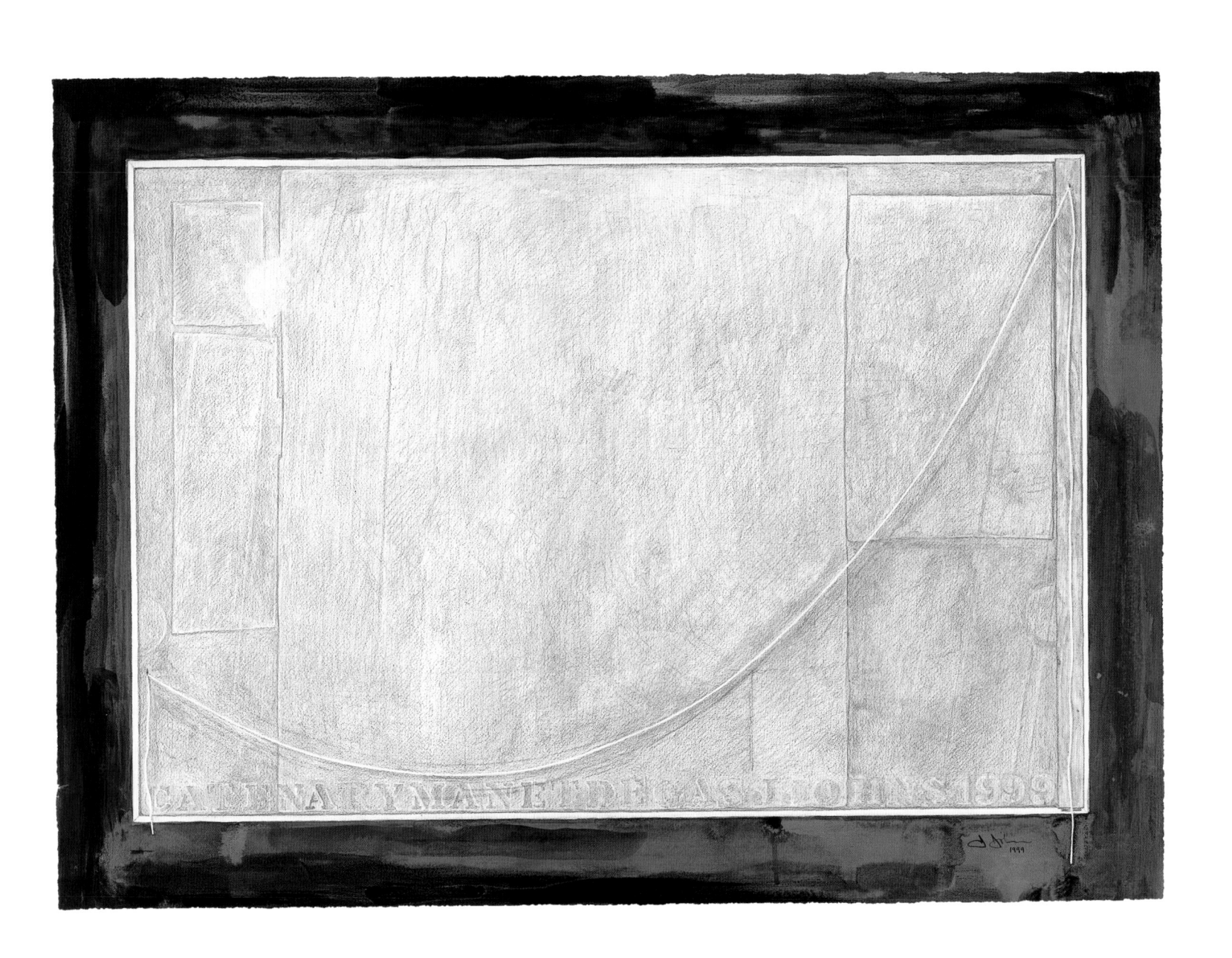

Jasper Johns
Catenary (Manet-Degas), 1999
Graphite, watercolor, synthetic polymer, and ink on paper
24 3/8 x 33 5/8 in. (61.9 x 85.4 cm)
Gift of The American Contemporary Art Foundation, Inc., Leonard A. Lauder, President 2002.281

Donald Judd

Often called a Minimalist, Donald Judd preferred to be recognized as an artist who worked with "specific objects." In the early 1960s, Judd turned from the inherent illusion of spatial recession in traditional painting and began a search to create works of art that were completely independent forms expressive only of their own objectivity. Canvas was quickly replaced by wood panels with deeply routed lines or inset with industrial forms like pipe segments, screening, or bread pans. In Judd's pivotal exhibition at Manhattan's Green Gallery in 1963, some of these reliefs were hung on the gallery walls; but most significantly, Judd emphasized the independent existence of these new forms as objects by placing several of them on the floor.

Although he did not return to painting, Judd continued to explore two-dimensional form through printmaking. In 1968 he returned to a small group of woodblock reliefs that he had included in the Green Gallery exhibition. He expanded these three rhomboids scored with routed vertical lines into a series of twenty-six blocks, investigating a complete sequence of thirteen possible delineations with a linear system. His father, Roy C. Judd, assisted him in cutting these blocks and in their subsequent printing. The artist arbitrarily chose eleven blocks to be printed in his signature cadmium red on sheets of fine Japanese paper in an edition of six sets. The oil in the cadmium red leached into the sheets, forming translucent halos around the rhomboidal shapes. Visually, these forms hover within the larger sheets and appear to be independent of the paper support, as if the color is a physical entity unto itself.

These ten sheets from an original set of eleven are an important addition to the Whitney's holdings of Judd's prints, probably the largest such grouping in an American museum collection. In the past twenty years, the Whitney has methodically collected Judd's prints: impressions pulled in the 1970s from other early woodblocks, three significant suites of ten blocks from 1988 in cadmium red, ultramarine blue, and ivory black, and examples of his later work. With this new acquisition, the Museum can fully trace the evolution of Judd's pursuit of the independent "specific object" through printmaking.

 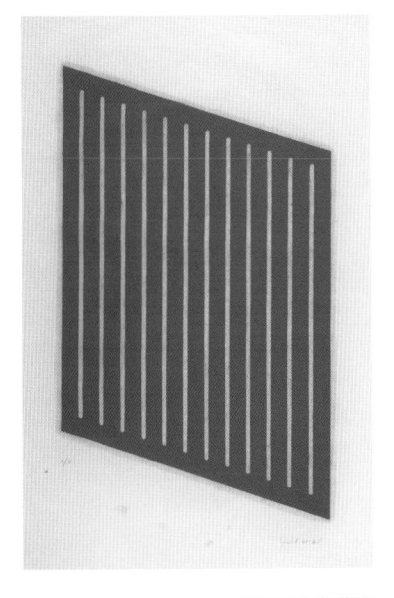 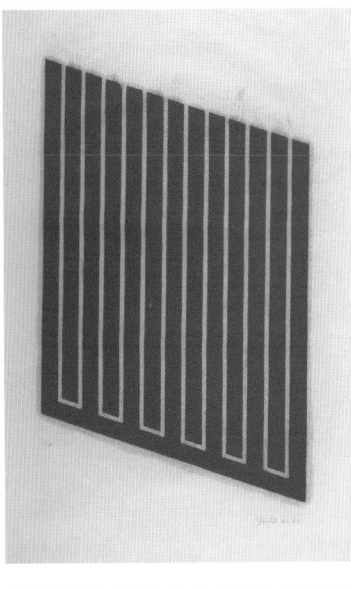 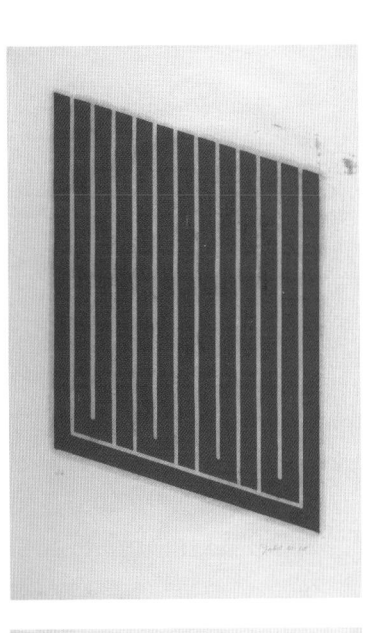

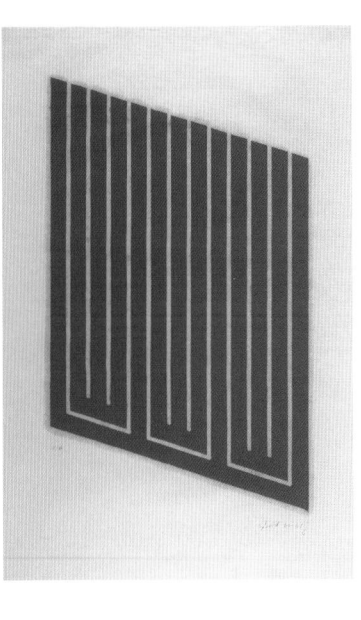 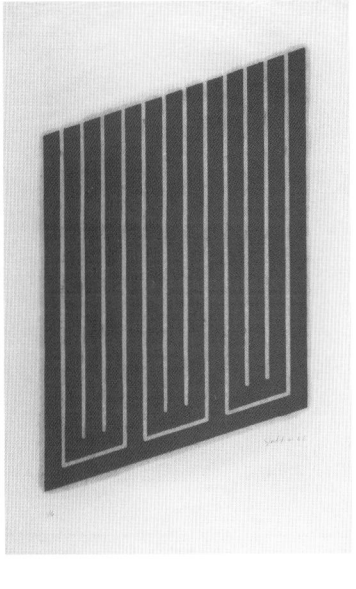 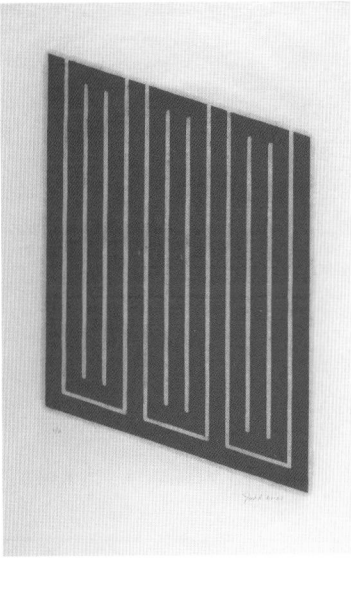 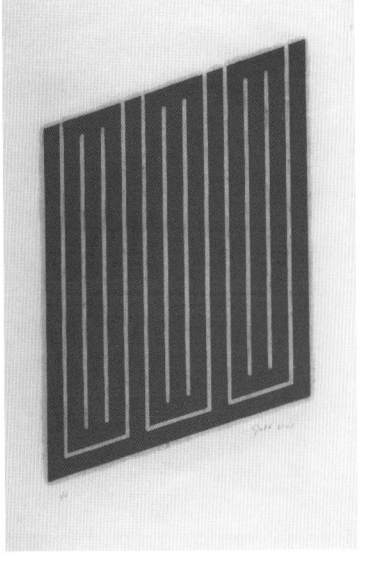

Donald Judd
Untitled, 1961–63/1968
Suite of ten woodcuts printed in cadmium red
Sheet, 33 7/8 x 21 7/8 in. (86 x 55.6 cm) each
Purchase, with funds from Brooke Garber Neidich and Daniel Miller Neidich 2002.278

Ellsworth Kelly

In 1948, after serving in the U.S. Army during World War II in a unit designing camouflage, Ellsworth Kelly enrolled in the École des Beaux-Arts in Paris on the G.I. Bill of Rights. Kelly remained in Paris until 1954 and traveled extensively throughout Europe, where he saw many masterpieces of European art. During this period Kelly carefully studied the forms in his surroundings, recalling them as he developed his spare, abstract paintings. This method allowed Kelly to "get away from the business of choice," as he put it. "Instead I wanted to *recognize* things. For example, I look into a room or at a landscape and I see fragments, I see thousands of fragments around—any of which I can use."

While staying with friends at the Villa La Combe in Meschers, France, in the summer of 1950, Kelly closely observed a flight of stairs and the complex shadows cast upon it by the balustrade. He photographed the stairs and made numerous sketches, recording the shadows throughout the day as the position of the sun changed. His series of works titled *La Combe* refers to the architecture of the stairs, with the nine-part structure of each composition recalling the nine steps. Kelly has turned the flight of stairs on its side and made each white "stair" section in *La Combe I* of equal width to eliminate any sense of mass and volume. The disjunctive arrangement of red lines both infers the shadows on the steps and stands as an autonomous abstract form. Without the artist's explanation of its origins, many years after the completion of the work, the source for the work would likely have been unidentifiable. *La Combe I* is now the earliest work by Kelly in the Whitney's collection, and the only example from his Paris period.

Kelly returned to the United States in 1954 and continued to experiment with observed forms, focusing in particular on the relationship of figure to ground in works such as *Red Blue* and *Yellow White* (pp. 56 and 57). The composition of the former was preceded by three drawings in 1963. In the final work the red parabola just barely extends beyond the blue ground at the right, creating visual tension at the perimeter. *Yellow on Blue* (p. 58), now the most recent Kelly in the Whitney's collection, the three other works in this exhibition, and the five paintings already in the collection together span five decades of the artist's work.

Ellsworth Kelly
La Combe I, 1950
Oil on canvas
38 x 63 1/2 in. (96.5 x 161.3 cm)
Gift of The American Contemporary Art Foundation, Inc., Leonard A. Lauder, President 2002.249

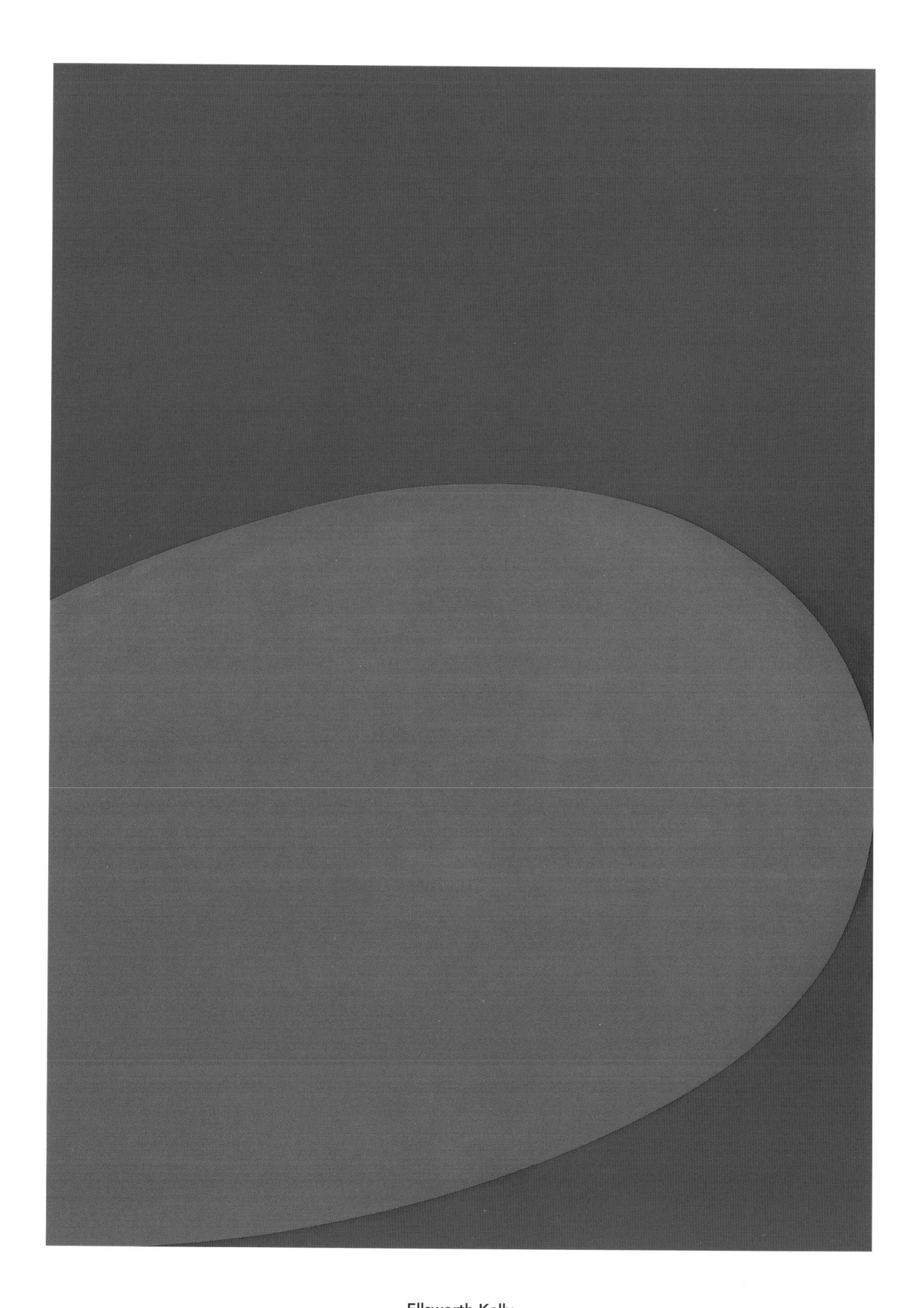

Ellsworth Kelly
Red Blue, 1964
Oil on canvas
90 x 66 in. (228.6 x 167.6 cm)
Promised gift of Thomas H. Lee and Ann Tenenbaum P.2002.66

Ellsworth Kelly
Yellow White, 1966
Synthetic polymer on canvas
78 x 74 3/4 in. (198.1 x 189.9 cm)
Gift of The American Contemporary Art Foundation, Inc., Leonard A. Lauder, President 2002.250

Ellsworth Kelly
Yellow on Blue, 2001
Oil on canvas
Two joined panels, 77 x 80 x 2 5/8 in. (195.6 x 203.2 x 6.7 cm) overall
Gift of The American Contemporary Art Foundation, Inc., Leonard A. Lauder, President 2002.251

Franz Kline

Although Franz Kline is best known for the black-and-white paintings he created between the late 1940s and early 1960s, he worked with color throughout his career. Regarded as one of the preeminent Abstract Expressionists, Kline traversed his monumental canvases with sweeping strokes of black paint that he typically painted over and around with white paint, disrupting any clear boundary between figure and ground. Kline began using increasing amounts of color in the late 1950s, keeping his signature black brushstrokes, but painting under, around, and over them with deep jewel tones. Partial to the saturated hue seen in *Red Painting*, Kline said he bought all the red paint he could find for the work. The color also forms the background of *Dahlia* (1959), a painting already in the Whitney's collection.

Although many of Kline's paintings appear to be the result of spontaneous gestures, he often used smaller preparatory sketches to carefully compose his works before he began painting. "Some of the pictures I work on a long time and they look as if I'd knocked them out, you know, and there are other pictures that come off right away. The immediacy can be accomplished in a picture that's been worked on for a long time just as well as if it's been done rapidly," he explained. Kline often structured his compositions around rectangular shapes similar to the one in *Red Painting*. Although critics have compared the black girder-like marks in Kline's paintings to bridges and railroads, the artist only acknowledged their urban inspiration: "When I look out the window—I've always lived in the city—I don't see trees in bloom or mountain laurel. What I do see—or rather, not what I see but the feelings aroused in me by that looking—is what I paint." One of Kline's last works, *Red Painting* was in the artist's studio when he died of heart disease in 1962.

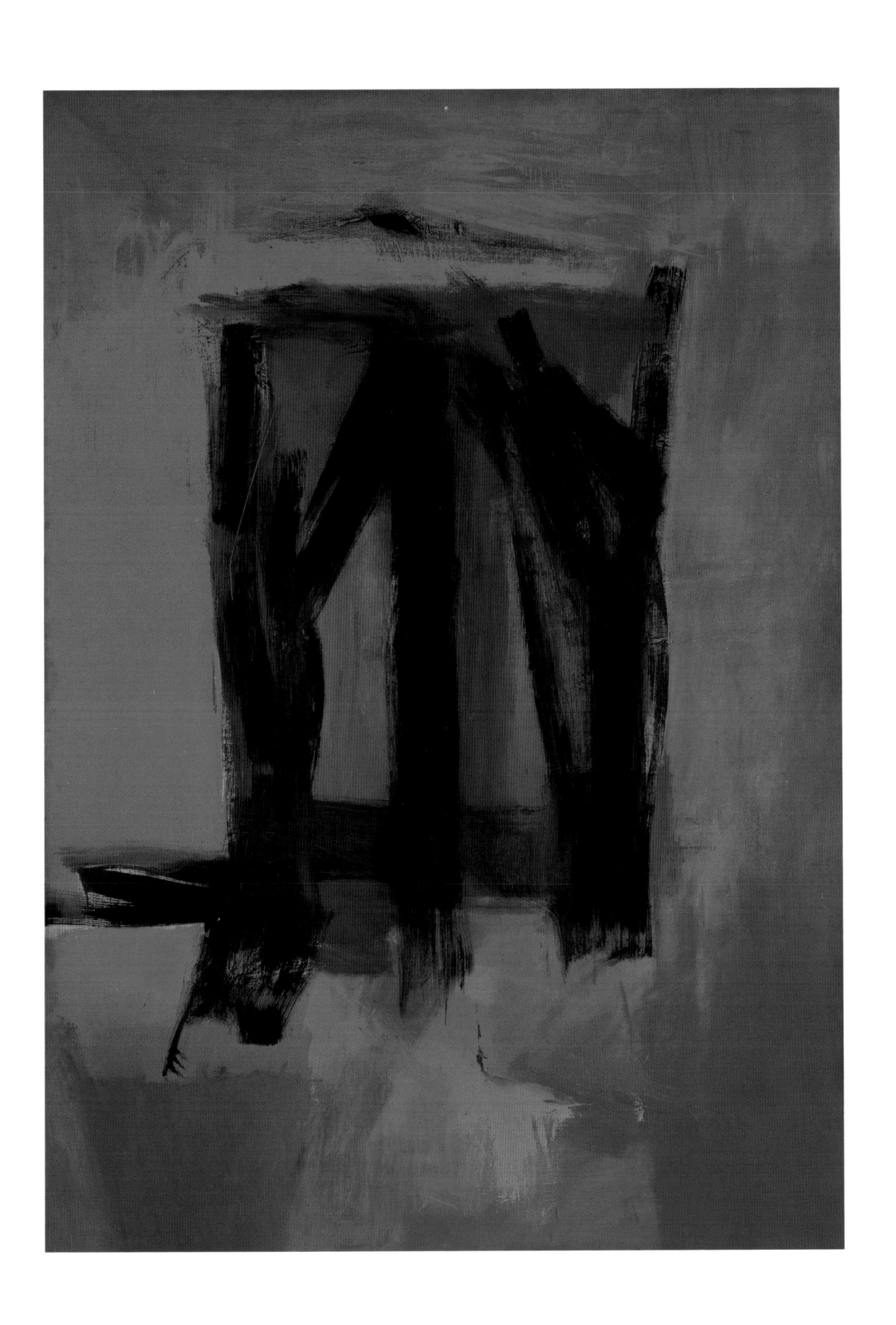

Franz Kline
Red Painting, 1961
Oil on canvas
110 x 78 1/4 in. (279.4 x 198.8 cm)
Gift of The American Contemporary Art Foundation, Inc., Leonard A. Lauder, President 2002.252

Sol LeWitt

A pioneer of Conceptual art in the 1960s, Sol LeWitt has consistently emphasized his ideas for works of art over the finished objects. He is perhaps best known for the wall drawings he began to make in 1968, when he drew directly on a gallery wall instead of on paper. By removing the traditional support and frame, he advanced the inherent two-dimensionality of drawing to its logical conclusion. LeWitt provides written instructions for his wall drawings, which since the early 1970s have been executed by others, usually his team of trained assistants. As he explained, "The underpinning, theoretically, is to separate the idea of art from the idea of craft."

LeWitt made his first wall drawing in pencil, but he began using multi-colored ink washes after encountering the Italian Renaissance frescoes around Spoleto, where he moved in 1980. For *Wall Drawing #444* LeWitt composed an asymmetrical pyramid with five facets of color. He produces a wide range of hues by layering washes of gray and primary colors in assigned combinations. Each wash of color is carefully applied to the wall in three separate layers with a cloth. The first layer is swiped on, the second layer blotted on, and the last layer is a combination of swiping and blotting. The facets of the geometric shape follow the precise color formulations set forth in LeWitt's instructions. The facet farthest to the left, for example, is executed in layers of gray, red, and blue, three separate applications for each color.

LeWitt first lays out his wall drawings on paper. *Drawing for Wall Drawing #444* is the preparatory work for *Wall Drawing #444*, which has been executed for this exhibition. As with many of LeWitt's wall drawings, the final outcome of a work is dictated by its architectural context and can exist in various incarnations. When LeWitt placed this drawing among a group of his other wall drawings during a retrospective of his work at the Whitney in 2000, he inverted the pyramid's apex from the right to the left of the composition, demonstrating a characteristic flexibility within his conceptual framework.

Of the five wall drawings now owned by the Whitney, *Wall Drawing #444* is the first to be paired with its preparatory drawing.

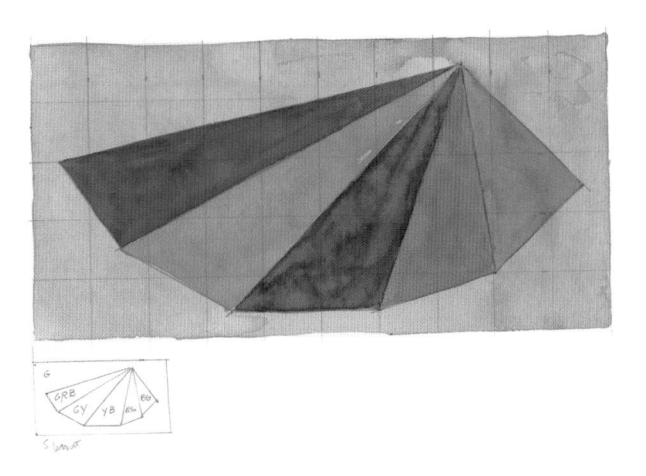

Sol LeWitt
Wall Drawing #444 (Asymmetrical pyramid, based on the size of the wall,
with color ink washes superimposed), 1985
Color ink wash on white wall
Dimensions variable
Gift of Faith Golding 99.33.1

Drawing for Wall Drawing #444 (Asymmetrical pyramid with color ink washes superimposed), 1985
Watercolor and graphite on paper
9 x 11 3/4 in. (22.9 x 29.9 cm)
Gift of Faith Golding 99.33.2

One of the pioneers of Pop art in the 1960s, Roy Lichtenstein drew his subject matter from a broad range of sources, including comic books, newspaper ads, and historical works of art. Lichtenstein did not borrow these preexisting images wholesale but translated them into his own idiom, "using those symbols to make something else," as he put it. The composition of *Bathroom* is an amalgam of several black-and-white advertisements for bathroom fixtures collected by the artist. Now the earliest work by Lichtenstein in the Whitney's collection, *Bathroom* is the artist's first interior, a genre he would explore throughout his career. His spare depiction of this utilitarian space is in part a playful riposte to the colorful, densely descriptive Old Master precedents of interiors. Lichtenstein had begun to mimic modes of mass reproduction by adopting the Benday dot—the regular, mechanically made dots used as shading in commercial printing—but *Bathroom* retains Lichtenstein's hand-applied pencil marks and irregular dots.

As in many of his works from the 1960s, Lichtenstein looked to comic books for the idealized head of the young woman in *Girl in Window (Study for World's Fair Mural)* (p. 66). He was fascinated in particular by the melodramatic displays of emotion expressed in comics through words and images. In 1963 the architect Philip Johnson offered a commission to Lichtenstein, among other young artists, for the New York State Pavilion at the 1964 World's Fair in Flushing Meadows, New York. *Girl in Window (Study for World's Fair Mural)* is the preparatory work for the 20-foot mural that hung on the outside of the Theaterama building. No doubt anticipating the amusing illusion of his mural, Lichtenstein depicted the smiling girl as if she were emerging through a window from inside the building.

In *Archaic Head VI* (p. 67) Lichtenstein returns to one of his favorite subjects, the female head, by mimicking selective elements of archaic Greek art found in vase painting or korai, columnar statues of female figures. Narrow in width and spare in contours, the work is more a succinct silhouette drawing than a volumetric sculpture. Lichtenstein painted and patinated the work in the green hue of ancient bronze, though the bare breast is a modern touch.

Roy Lichtenstein

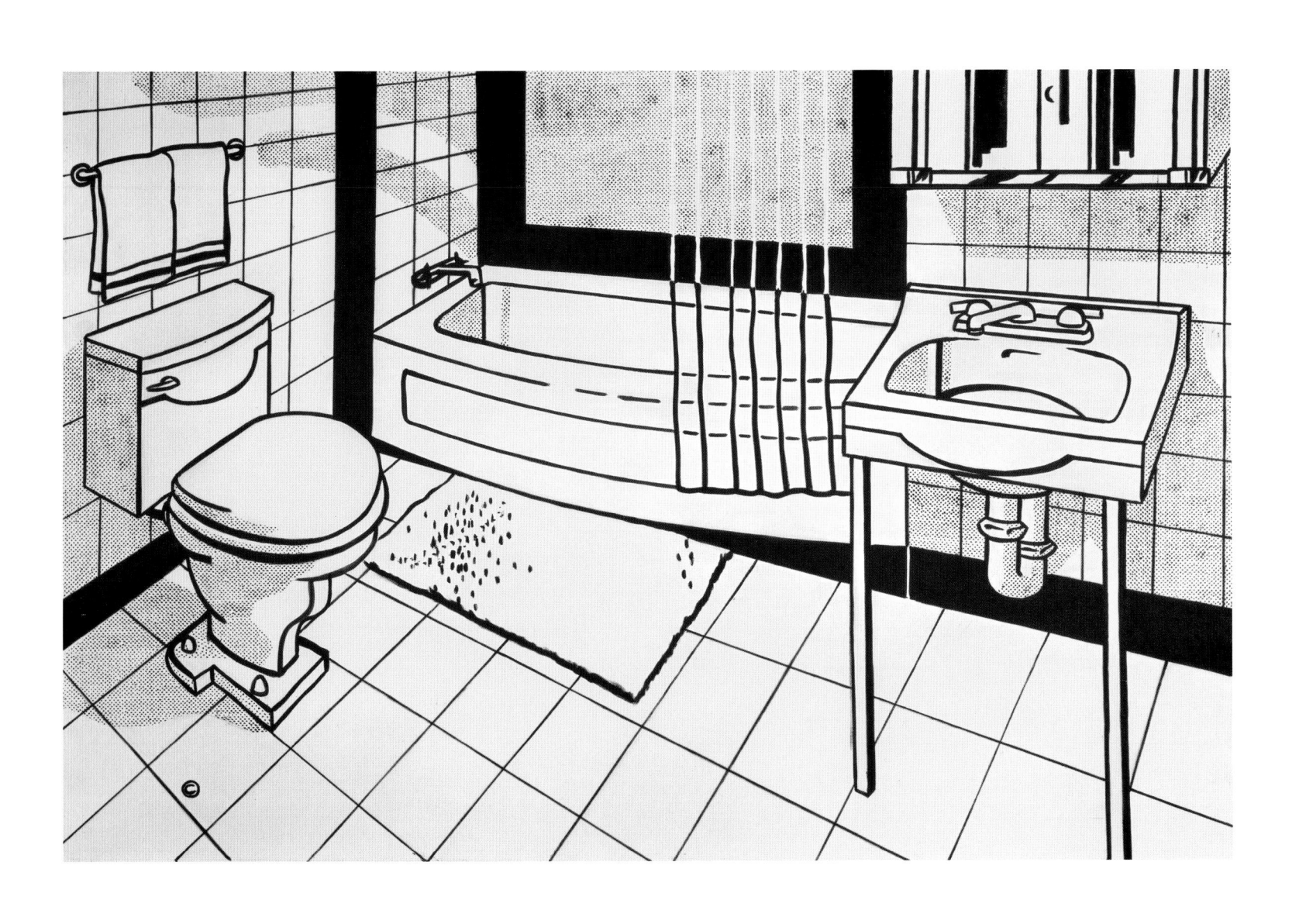

Roy Lichtenstein
Bathroom, 1961
Oil on canvas
49 x 69 1/2 in. (124.5 x 176.5 cm)
Gift of The American Contemporary Art Foundation, Inc., Leonard A. Lauder, President 2002.253

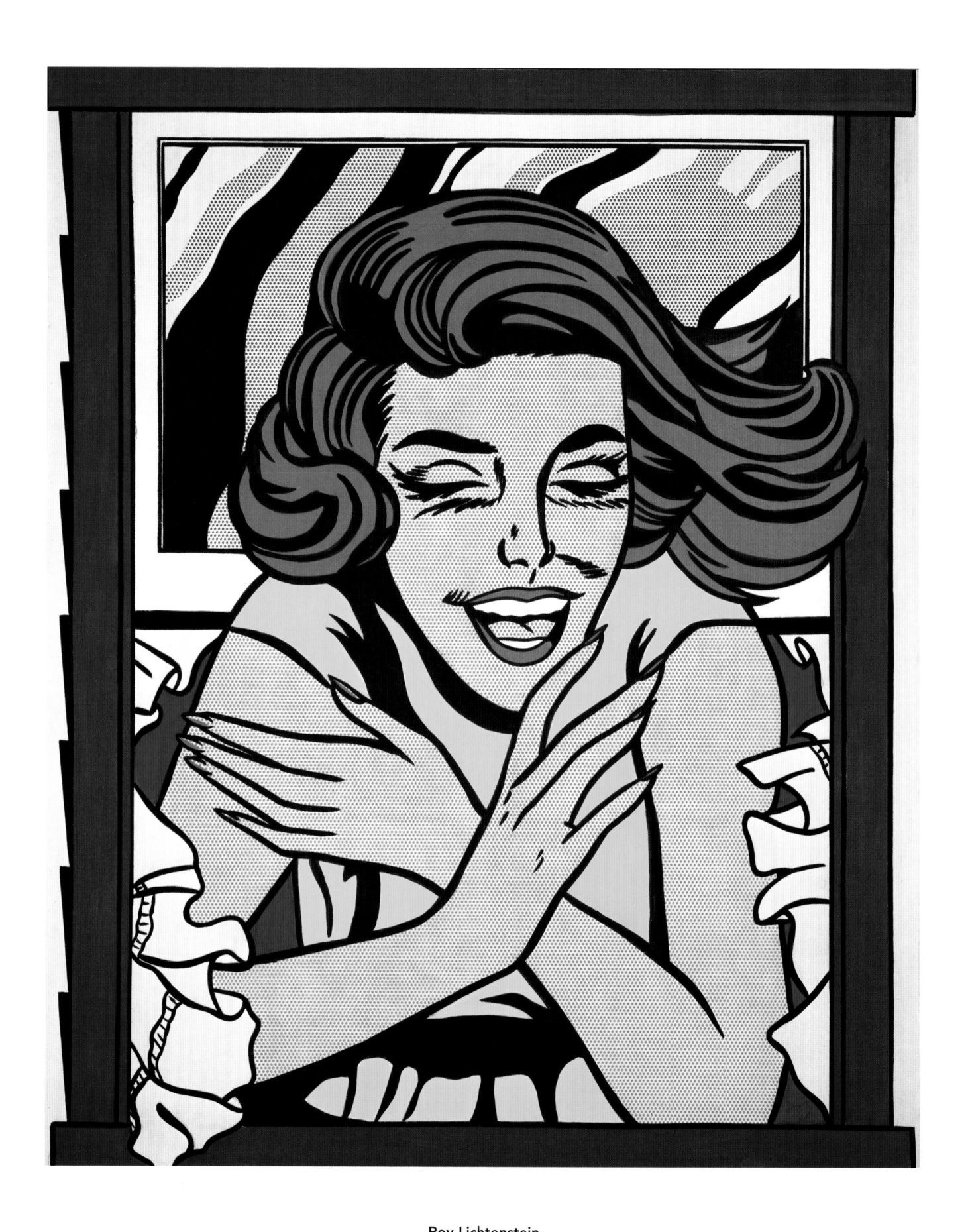

Roy Lichtenstein
Girl in Window (Study for World's Fair Mural), 1963
Oil on canvas
68 x 50 in. (172.7 x 127 cm)
Gift of The American Contemporary Art Foundation, Inc., Leonard A. Lauder, President 2002.254

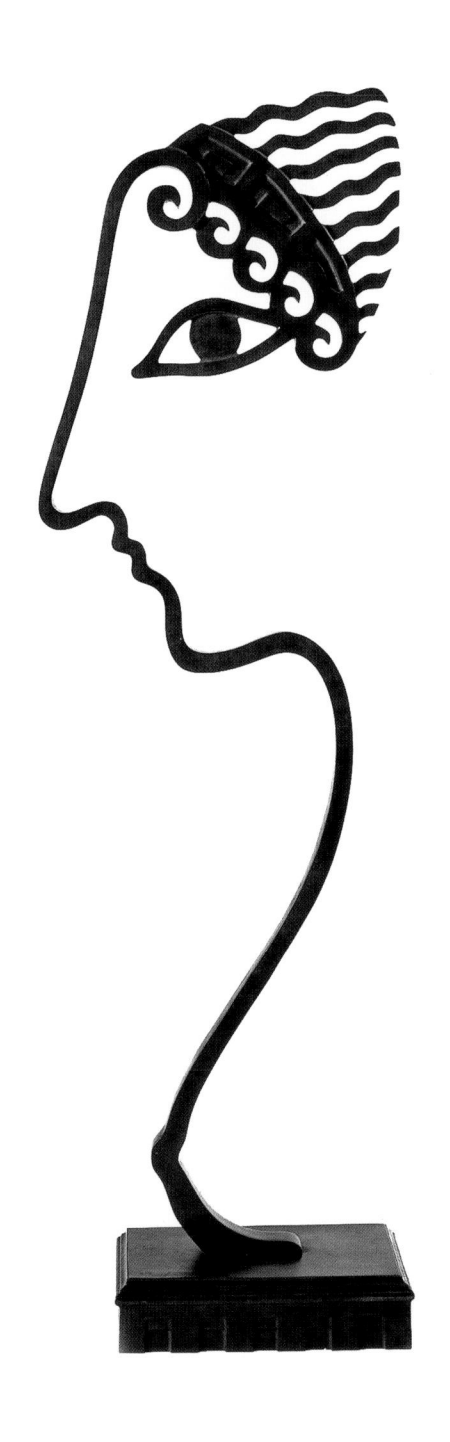

Roy Lichtenstein
Archaic Head VI, 1988
Painted and patinated bronze
58 1/2 x 16 1/2 x 10 in. (148.6 x 41.9 x 25.4 cm)
Gift of Melva Bucksbaum and Raymond J. Learsy 2002.276

In 1948 Barnett Newman began to develop his "zip" paintings, radically abstract works with subtly inflected monochromatic backgrounds partitioned by narrow bands of contrasting colors. Painted during Newman's most prolific year, *The Promise* was initially untitled. Newman added the present title sometime before 1960, when he gave the painting to art critic Clement Greenberg as a wedding present.

To make *The Promise* Newman first laid down two strips of masking tape to reserve the zips, and painted the ground black. He then removed the tape and painted the blue-gray stripe at the right with a palette knife, producing a textured and irregular effect. When the black paint was dry, he filled in the stripe at the left, taping off the edges to create a precisely defined zip, this time employing an off-white color.

The pairing of the two zips causes visual tension, activating the space between the stripes and on either side of them. The blue-gray zip seems to rest upon the black surface while the off-white zip recedes behind it. If Newman had positioned the white stripe to the right of the blue-gray one, with the same distance between them, the painting would be bisected. As the viewer's eyes move over the black ground, the afterimage of the white zip encourages this imaginary division of the work.

Newman found that these nuanced compositions best allowed him to convey the abstract concepts that interested him—particularly those of creation, beginnings, and human genesis. For example, the Whitney's other Newman holdings include the painting *Day One* (1951–52) and the sculpture *Here III* (1965–66). *The Promise* was among the paintings Newman included in his first one-artist show in 1950, held at the Betty Parsons Gallery in New York, where, along with most of the other works, it went unsold. By the mid-1960s, however, a younger generation of artists looked to Newman's pared-down canvases as models for their approaches to abstraction.

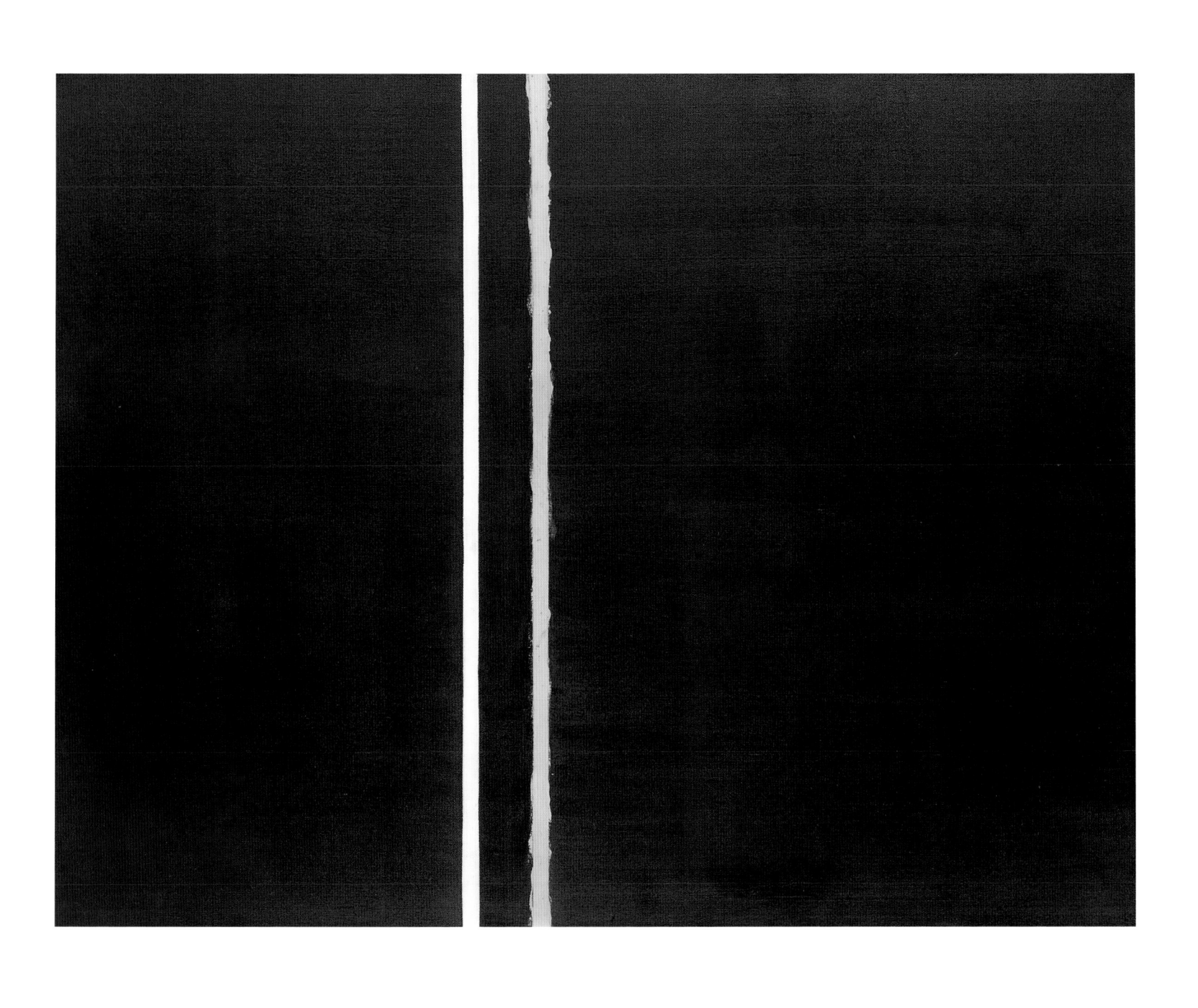

Barnett Newman
The Promise, 1949
Oil on canvas
51 1/2 x 68 1/8 in. (130.8 x 173 cm)
Gift of Adriana and Robert Mnuchin 2000.338

Kenneth Noland

Born in Asheville, North Carolina, Kenneth Noland studied under Ilya Bolotowsky and Josef Albers at Asheville's avant-garde Black Mountain College from 1946 to 1948. Albers's color theories and Bauhaus principles had a profound effect on Noland in subsequent years, as did a 1953 visit to Helen Frankenthaler's New York studio, where he first saw Frankenthaler's recent poured paintings on unprimed canvas. This innovative method fascinated Noland, particularly the way the thinned paint "reveals color," as he said, and the manner in which the nap and hue of the raw canvas become integral parts of the painting. Noland experimented with this stain technique in a variety of abstract compositions until 1958, when he settled on a format of concentric circles centered within square canvases. Noland made variations of this circular format until about 1963. By working with a predetermined composition, the artist was able to produce a wide range of colors and stains—flat and muted, matte and transparent—and to explore the optical reverberations of these combinations. The centrifugal composition of *Bolton Landing II* draws the eye first to the center of the canvas, a flat, opaque yellow circle defined by precise edges, and then to the outer rings until the feathery, painterly edges fade into a periwinkle background. Throughout the 1960s Noland expanded his compositional elements to include stripes, as seen in *Slow Rise* (pp. 72–73), and chevrons.

In early 1962 Noland moved from Washington, D.C., to New York City. He rented a summer house in Bolton Landing, a town in upstate New York on Lake George, where a number of other artists, including Noland's friend David Smith, had residences. *Bolton Landing II* was most likely painted there. In recent years Noland has returned to the concentric circles format, staining his canvas with thinned acrylic paints.

The promised gifts of *Bolton Landing II* and *Slow Rise* double the Whitney's holdings of Noland's work.

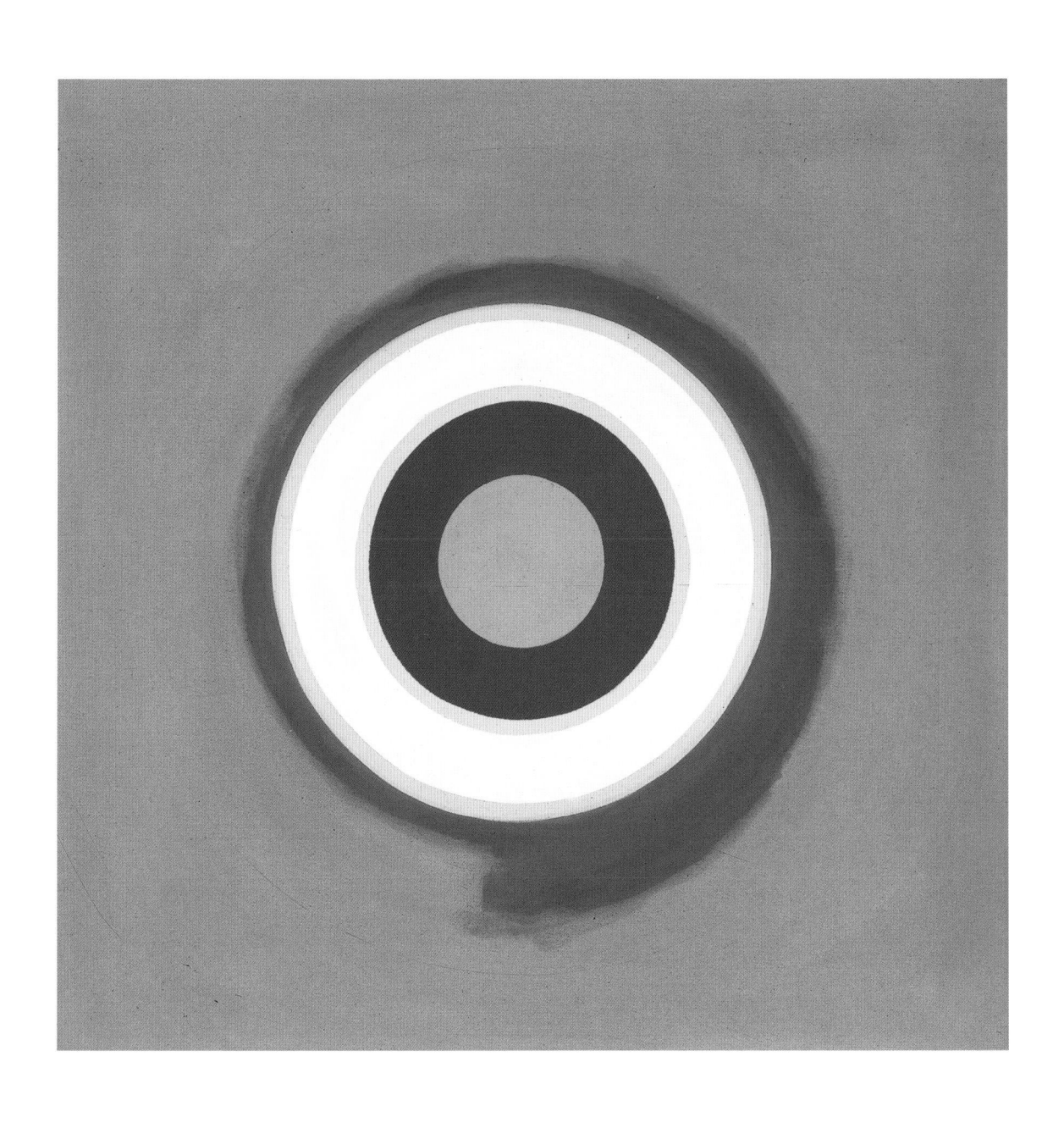

Kenneth Noland
Bolton Landing II, 1962
Oil on canvas
45 x 45 in. (114.3 x 114.3 cm)
Promised gift of Laurie Tisch Sussman P.2002.68

Kenneth Noland
Slow Rise, 1968
Oil on canvas
60 x 174 in. (152.4 x 442 cm)
Promised gift of Laurie Tisch Sussman P.2002.67

The son of a Swedish diplomat, Claes Oldenburg was born in Stockholm and as a youngster settled with his family first in New York, followed by Chicago. Since the early 1960s Oldenburg has developed a distinctive iconography through works based on common objects. He has cultivated this subject matter through families of related forms, which he executes in a broad array of media and scales. The six works in this exhibition each represent familiar themes in the artist's work, from his diverse inventions of the 1960s to the recent works he has developed in partnership with his wife, Coosje van Bruggen.

While in New York in 1962 Oldenburg discovered shiny vinyl fabrics in many colors, creating sculpture in the soft, pliable material and stuffing his forms with various fillers to achieve the optimum degree of flaccidity. Vinyl facilitated Oldenburg's desire to create malleable, mutable objects, alternatives to the hard and fixed forms of conventional sculpture. His subjects were familiar, discredited objects, ones that might be consumed, overlooked, or thrown away. Among Oldenburg's earliest vinyl sculptures, *Giant BLT (Bacon, Lettuce, and Tomato Sandwich)* joins other cafeteria edibles in his oeuvre, such as the painted plaster reliefs of his 1961 environment, *The Store*, or his soft treatments of hamburgers, ice cream cones, and French fries. Composed of several layers that are pierced with a wooden toothpick, the multipart BLT sandwich is reassembled each time it is installed. This approach allows the artist to "model" the forms—what he refers to as "pushing space around."

Since 1976 Oldenburg has collaborated with van Bruggen, an art historian and author. For their recent works, including *Soft Viola* and *Soft Viola Island* (pp. 82 and 83), Oldenburg and van Bruggen have revisited the musical motifs they explored in 1992, when they developed a body of kindred forms derived from harps, saxophones, and clarinets. Oldenburg had first turned to the subject in the mid-1960s with works such as *Giant Soft Drum Set* and had already envisioned in his drawings imaginary landscapes of enlarged objects floating dreamlike in bodies of water. In the melodious, softly hued pastel *Soft Viola Island*, a tiny sailboat harbors within the hollowed curve in the viola's side, reflecting the artists' penchant for potentially mobile forms that can be "driven by wind." Their oversized viola is an inversion of the soft sculptures. Made of canvas, it appears soft but has actually been stiffened with resin. The deconstructed instrument, deprived of its function, sags in a state of suspended animation. Like many works conceived by Oldenburg and van Bruggen, the intrinsically sculptural viola, with its voluptuous contours and illusion of flesh, is replete with erotic overtones. The subject originated in a work conceived by van Bruggen for *Encounters: New Art from Old*, an exhibition at the National Gallery in London, for which artists were asked to create a new work in response to objects in that museum's collection. She chose to explore the symbolism of the viola as it appears alongside women in the interiors of the seventeenth-century painter Johannes Vermeer.

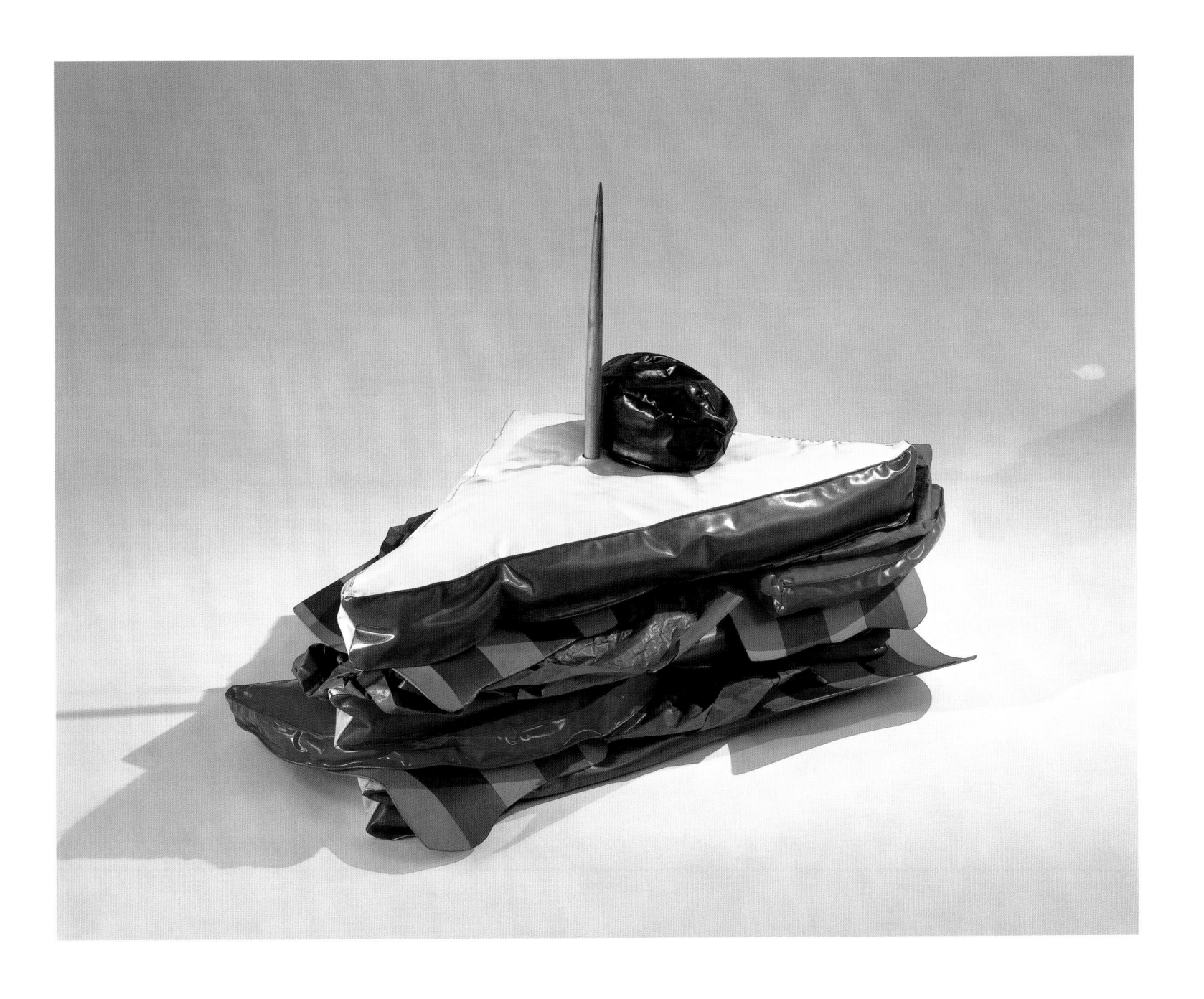

Claes Oldenburg
Giant BLT (Bacon, Lettuce, and Tomato Sandwich), 1963
Vinyl, kapok, wood, and synthetic polymer
32 x 39 x 29 in. (81.3 x 99.1 x 73.7 cm)
Gift of The American Contemporary Art Foundation, Inc., Leonard A. Lauder, President 2002.255

Having lived in New York City since 1956, Oldenburg relocated to Venice, California, for several months in the fall of 1963. There he began a long engagement with domestic objects as subject matter—bathroom fixtures, kitchen appliances, and bedroom furniture—which he collectively called *The Home*. The centerpiece of this group is *Bedroom Ensemble*, a full-scale, room-size installation of nonfunctional furniture. As a teenager Oldenburg had seen a California motel with fantasy suites thematically decorated in different animal-skin motifs, materials that inspired the synthetic, faux-fur fabrics that inhabit *Bedroom Ensemble*. Beginning in November 1963, Oldenburg had the individual pieces fabricated specifically for *Four Environments by Four New Realists*, an exhibition at New York's Sidney Janis Gallery in 1964. When installing the show he incorporated actual elements from the front room of the gallery, such as the side door and the back windows with drawn Venetian blinds. The artist has retained these site-specific details in the two replicas of *Bedroom Ensemble* that he has since made.

Oldenburg distorts the perspective of the space using foreshortening and rhomboid shapes to underscore the artificial and essentially geometric nature of *Bedroom Ensemble*. He disorients the viewer, who does not enter the room but observes it from behind a rope. This customarily intimate space, what Oldenburg has described as "the softest room in the house," is transformed into something removed and abstract, like a frozen stage set. The clean geometry of the installation resonates with the abstract work of some of Oldenburg's contemporaries in the 1960s. He said he wanted to "find a common ground between the Minimalist experiment and what I wanted to do, furniture." Among the more than ninety Oldenburg drawings owned by the Whitney, two are sketches related to *Bedroom Ensemble*, including the preparatory drawing for the announcement for the 1964 Janis show.

In 1969 Oldenburg was once again in Los Angeles, where he fabricated *Profile Airflow* (p. 78) with the print publisher Gemini G.E.L. The Chrysler Airflow was invented in 1936 by Carl Breer, the father of Oldenburg's friend, the filmmaker Robert Breer, and Oldenburg visited Carl in Detroit in 1965 to study the vintage car. Like much of the artist's source material, the Airflow has nostalgic origins—he had owned a toy version of it as a child. From 1965 to 1966 he generated a rich formal vocabulary from the Airflow, dissecting the car's anatomy into soft engines, radiators, tires, and mufflers. With its sensuously curved but rigid surface, *Profile Airflow* is soft and hard simultaneously. The polyurethane relief, placed over a lithograph, was to be, according to the artist, "transparent like a swimming pool, but of a consistency like flesh."

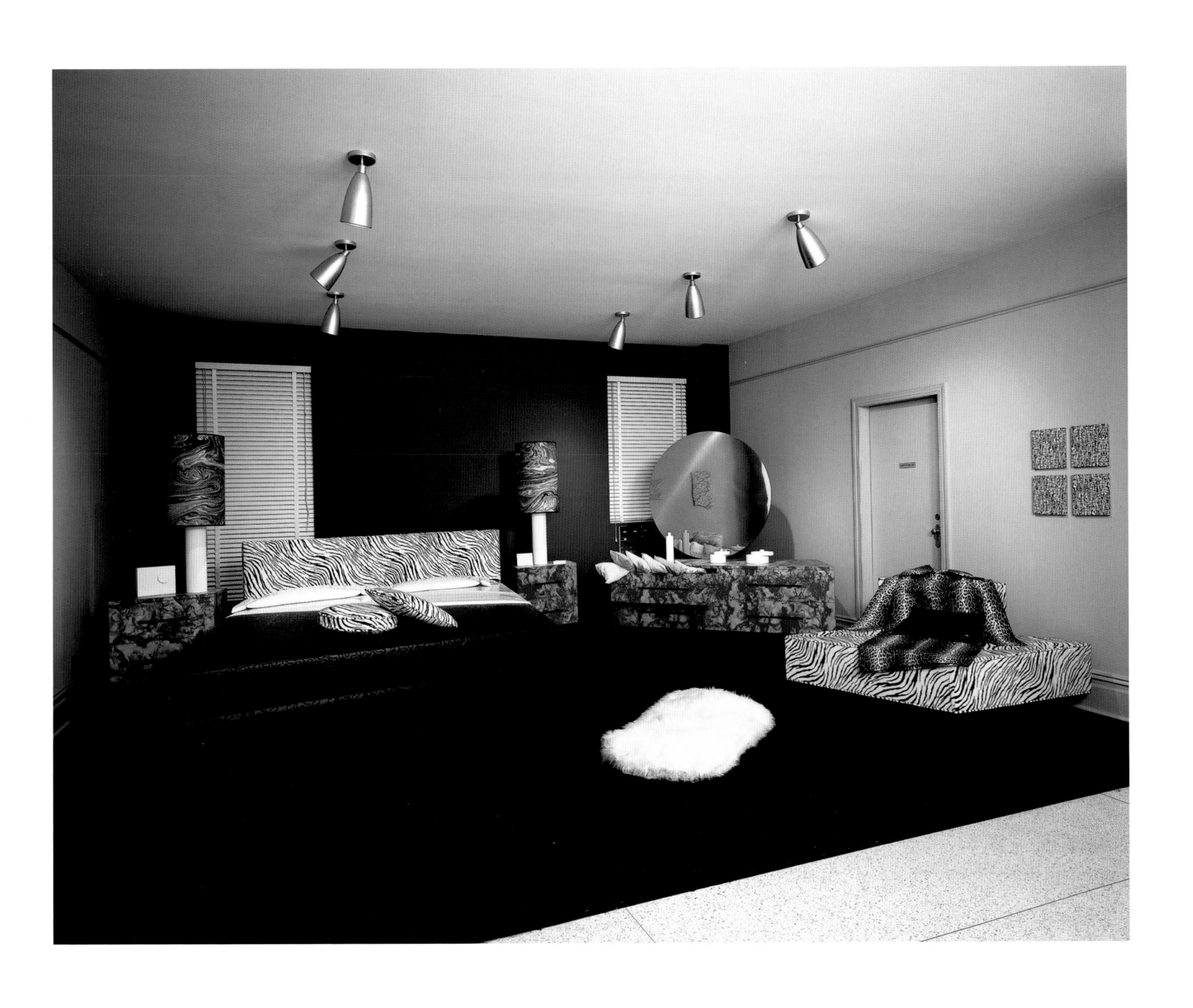

Claes Oldenburg
Bedroom Ensemble 3/3, 1963/1995
Wood, vinyl, metal, fake fur, muslin, Dacron, polyurethane foam, and lacquer
Approximately 204 x 252 in. (518.2 x 640.1 cm) overall
Gift of The American Contemporary Art Foundation, Inc., Leonard A. Lauder, President 2002.256

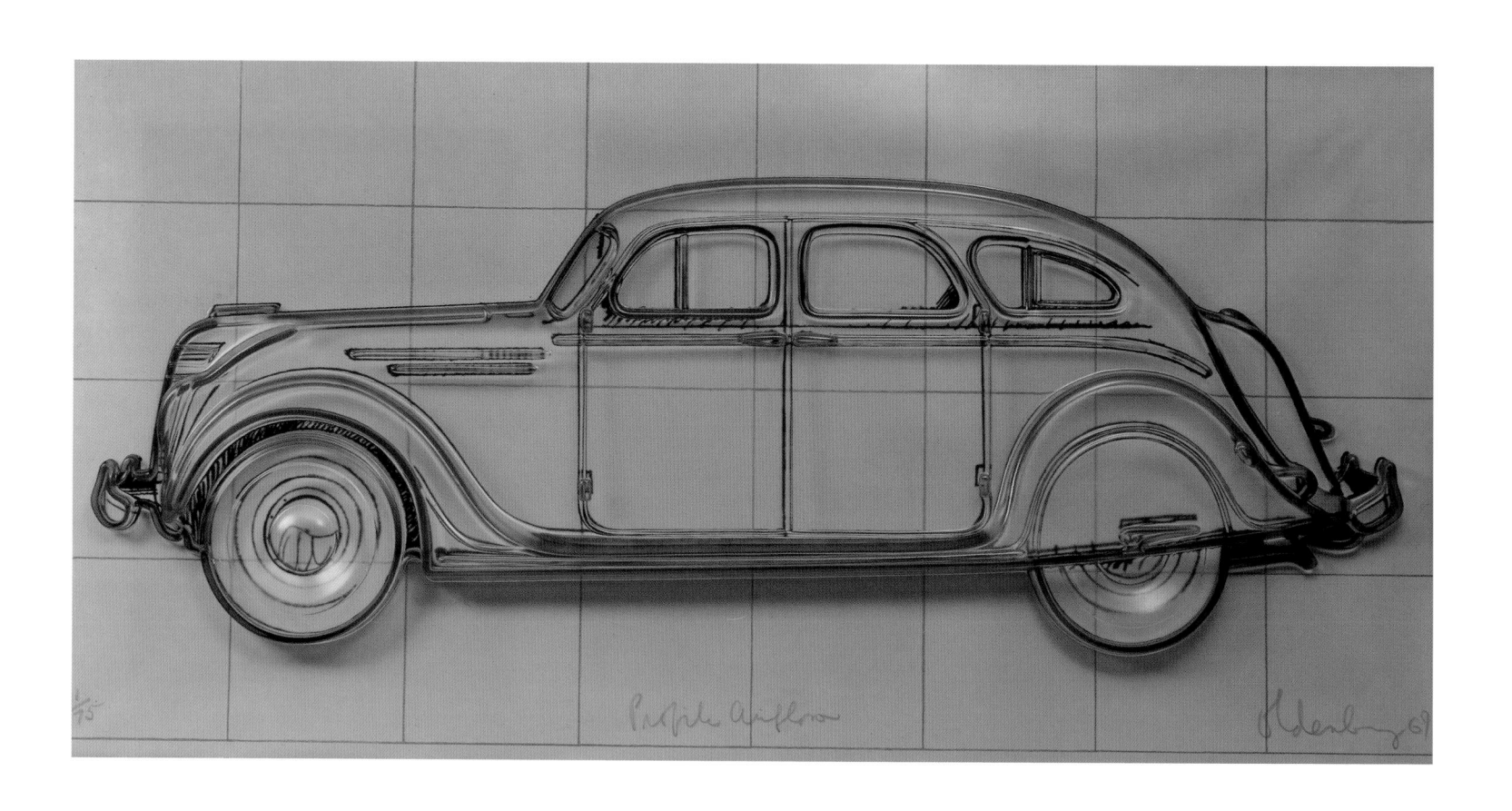

Claes Oldenburg
Profile Airflow, 1969
Molded polyurethane relief over two-color lithograph
33 1/2 x 66 5/8 in. (85.1 X 169.2 cm)
Promised gift of LWG Family Partners, L.P., Leonard A. Lauder, Partner P.2002.61

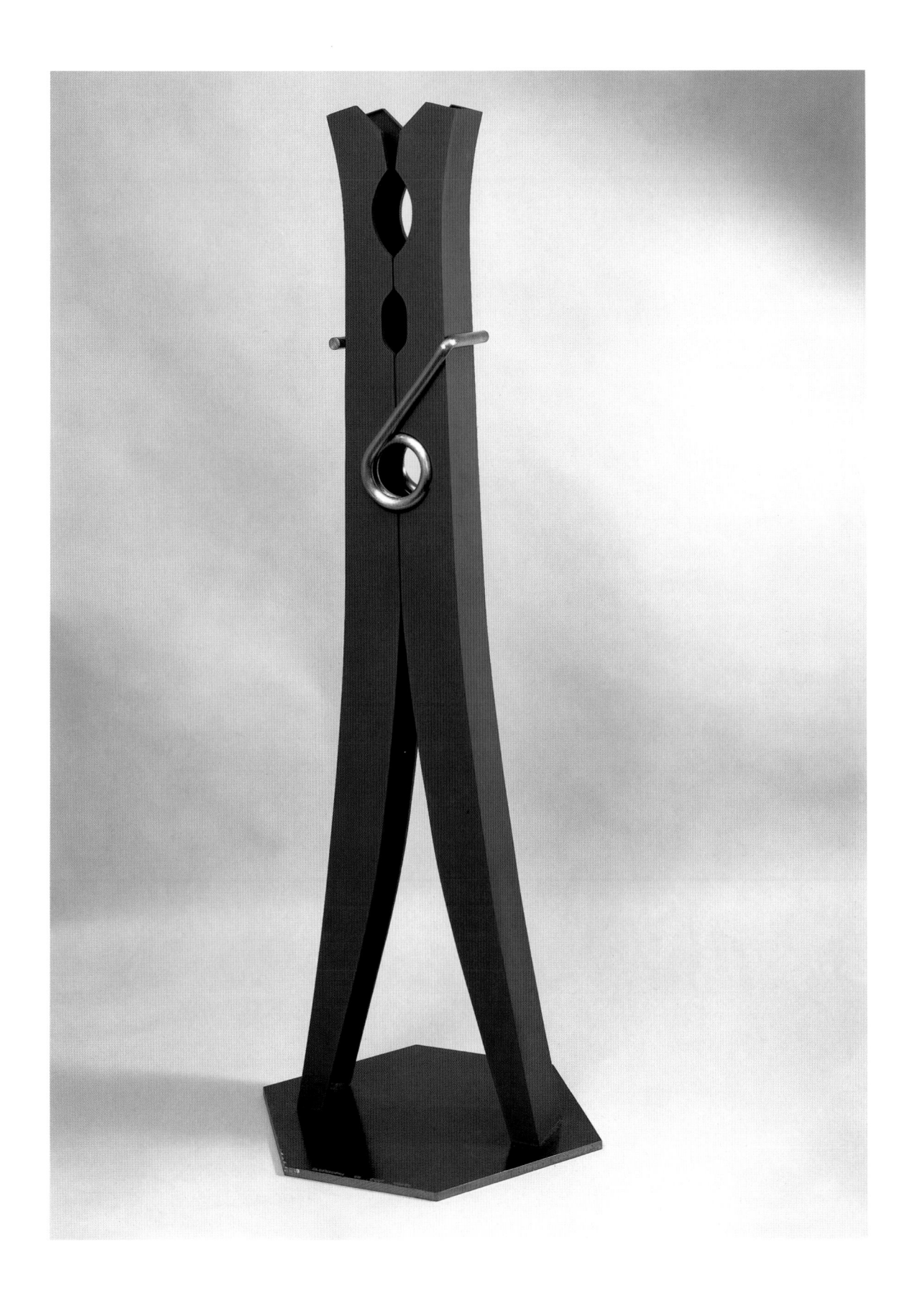

Claes Oldenburg
Clothespin—45-Foot Version, Model, 1976–79
Cor-ten and stainless steels
60 x 24 x 19 in. (152.4 x 61 x 48.3 cm)
Promised gift of Leonard and Evelyn Lauder P.2002.63

In 1965 Oldenburg began to conceive of common objects as fantastically scaled public sculpture. These "feasible" and "nonfeasible" monuments, brazen antidotes to historic, commemorative statues in city squares, were anti-heroic in content but ambitious in size. Typewriter erasers, which Oldenburg remembers playing with as a child in his father's consulate office in Chicago, grow obsolete over time, lose their utilitarian role and, an especially apt destiny for this tool, "vanish from daily use."

In 1970 Oldenburg proposed the eraser as a monument for New York City's 57th Street, imagining it as an object that "might fall out of an office building." He experimented with various positions for the sculpture, settling upon a dynamic composition with the brush sweeping upward, "like a wheel with a wing." Characteristically, Oldenburg executed the eraser in several scales. In 1976, he made the 7-foot *Typewriter Eraser*, a skillfully fabricated sculpture with a cement wheel and steel bristles. The 3-foot edition shown here was made the following year and, in 1999, he and van Bruggen oversaw the fabrication of a 19-foot version.

Oldenburg saw the potential of a simple wooden clothespin on an architectural scale in 1967 as he flew into Chicago and held one against the city's distinctive skyline, which is dominated by the slanted walls of the Hancock Building. The clothespin proved to be a procreative stimulant for the artist's associative thought process. In his first drawing of the subject, *Late Submission to the Chicago Tribune Architectural Competition of 1922: Clothespin—Version Two* (1967), Oldenburg fantasized the spring of the colossal monument as a sound-producing wind tunnel and a portion of the spring as a glass-enclosed restaurant.

In 1976 a 45-foot version, *Clothespin*, was erected in downtown Philadelphia, becoming the artist's first "feasible" monument to be built in an urban center. As with many of the Large-Scale Projects made since with van Bruggen, its graceful silhouette is a response both to the metaphorical possibilities of the city and to its physical environment. Oldenburg also developed smaller sculptures based on the clothespin, including a 4-foot edition in bronze and a 10-foot edition in Cor-ten and stainless steels. The Whitney's unique 5-foot version (p. 79), whose proportions differ from the editioned sculptures, is a precise scale model of the Philadelphia monument.

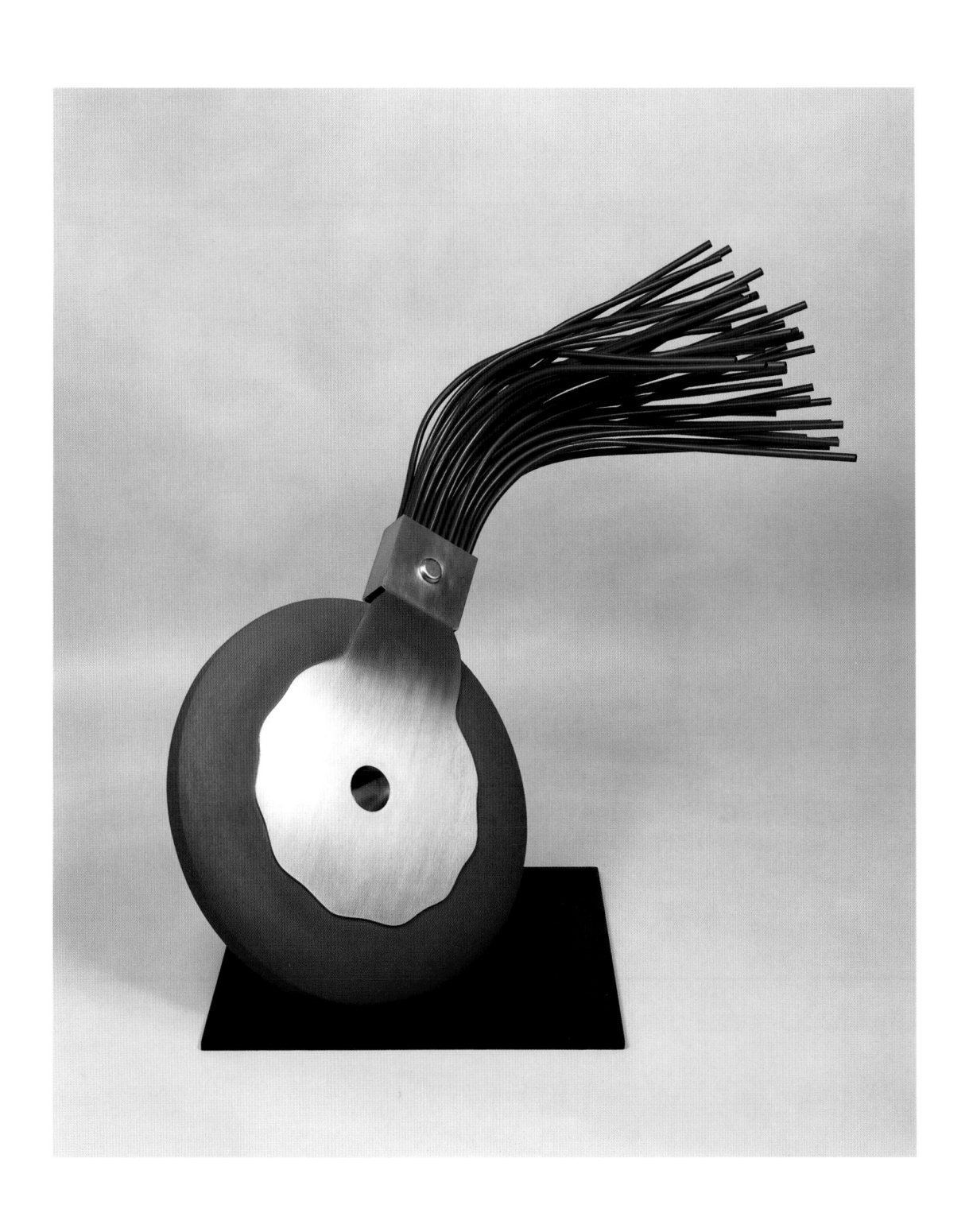

Claes Oldenburg
Typewriter Eraser, 1977
Aluminum, cement, and stainless steel
36 x 18 x 18 in. (91.4 x 45.7 x 45.7 cm)
Promised gift of LWG Family Partners, L.P., Leonard A. Lauder, Partner P.2002.62

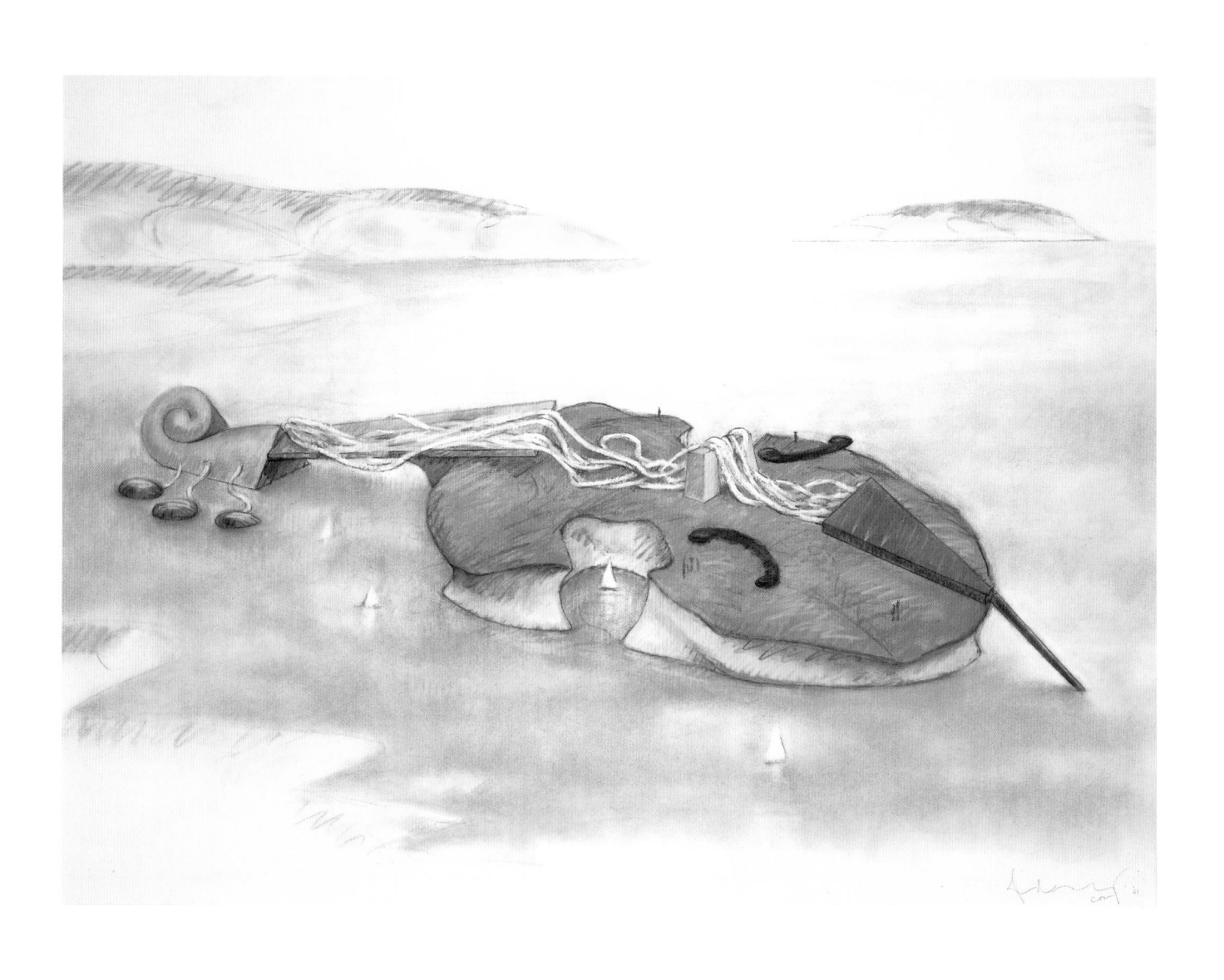

Claes Oldenburg and Coosje van Bruggen
Soft Viola Island, 2001
Charcoal and pastel on paper
34 x 46 1/2 in. (86.4 x 118.1 cm)
Gift of Robert J. Hurst and The American Contemporary Art Foundation, Inc. 2002.277

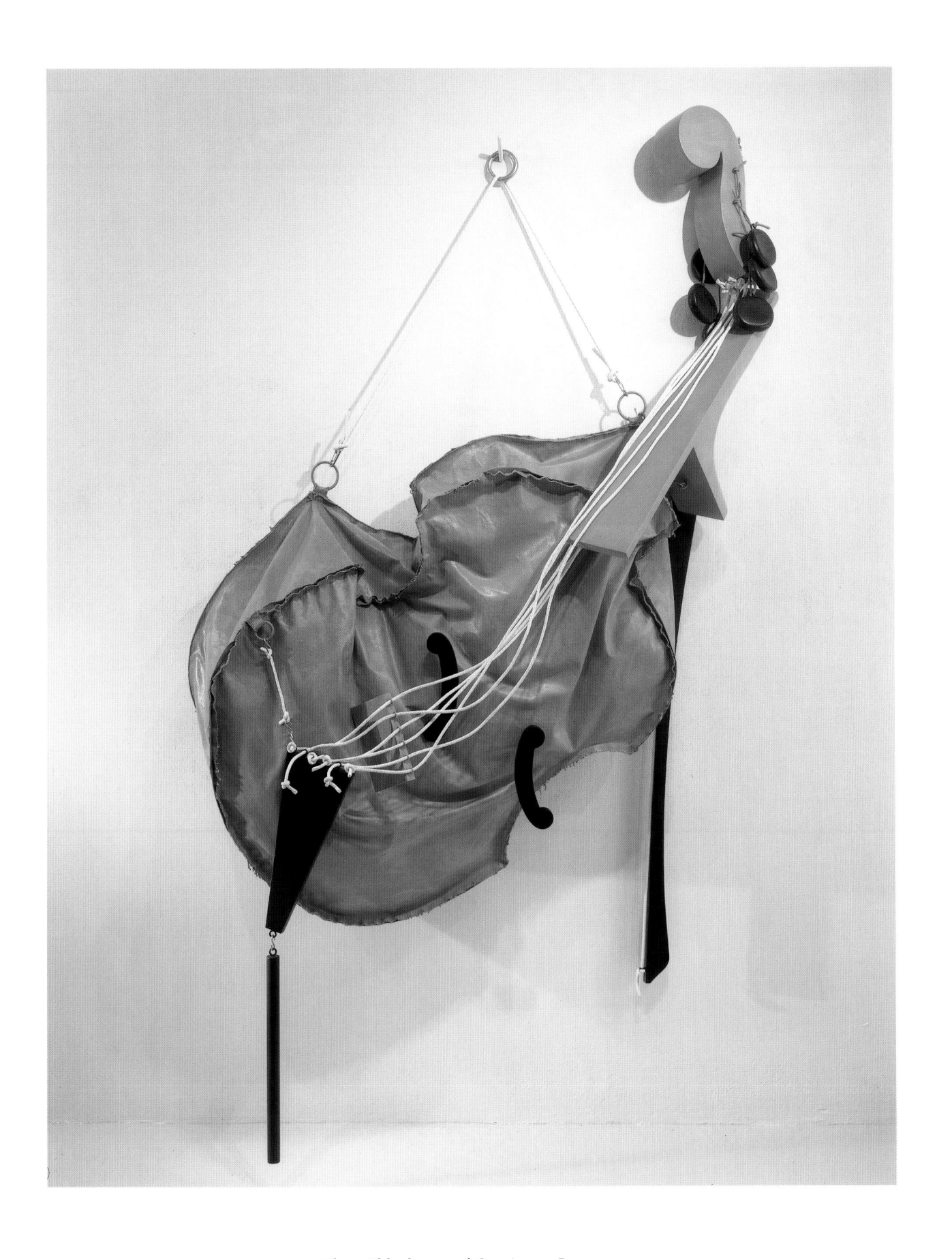

Claes Oldenburg and Coosje van Bruggen
Soft Viola, 2002
Canvas, resin, rope, metal, and latex paint
104 x 60 x 22 in. (264.2 x 152.4 x 55.9 cm)
Gift of The American Contemporary Art Foundation, Inc., Leonard A. Lauder, President 2002.257

Jackson Pollock

In 1951 and 1952 Jackson Pollock created a series of black enamel paintings, among them *Number 18, 1951*, which marked a shift from the colored "drip" paintings he made from 1947 to 1950. The allover composition of the drip paintings, such as the Whitney's *Number 27, 1950*, gave way to a monochrome calligraphy set against a white ground. Pollock worked on long strips of canvas placed on the floor and, in addition to his standard sticks and hardened brushes, used basting syringes to apply the enamel paint. Figural elements may be discerned at the center of *Number 18, 1951*, a typical aspect of Pollock's work of the period.

Given his innovative contribution to abstract painting, Pollock's return to figuration caused a stir within the art world. In a letter to fellow painter Alfonso Ossorio from June 1951, Pollock anticipated this reaction: "I've had a period of drawing on canvas in black—with some of my early images coming thru—think the non-objectivists will find them disturbing—and the kids who think it simple to splash a Pollock out." Yet the black enamel paintings did not mark as dramatic a shift in Pollock's work as many thought. Pollock's wife and fellow painter, Lee Krasner, explained, "I saw his paintings evolve: Many of them, many of the most abstract, began with more or less recognizable imagery—heads, parts of the body, fantastic creatures. Once I asked Jackson why he didn't stop the painting when a given image was exposed. He said, 'I choose to veil the imagery.' Well, that was that painting. With the black-and-whites he chose mostly to expose the imagery. I can't say why."

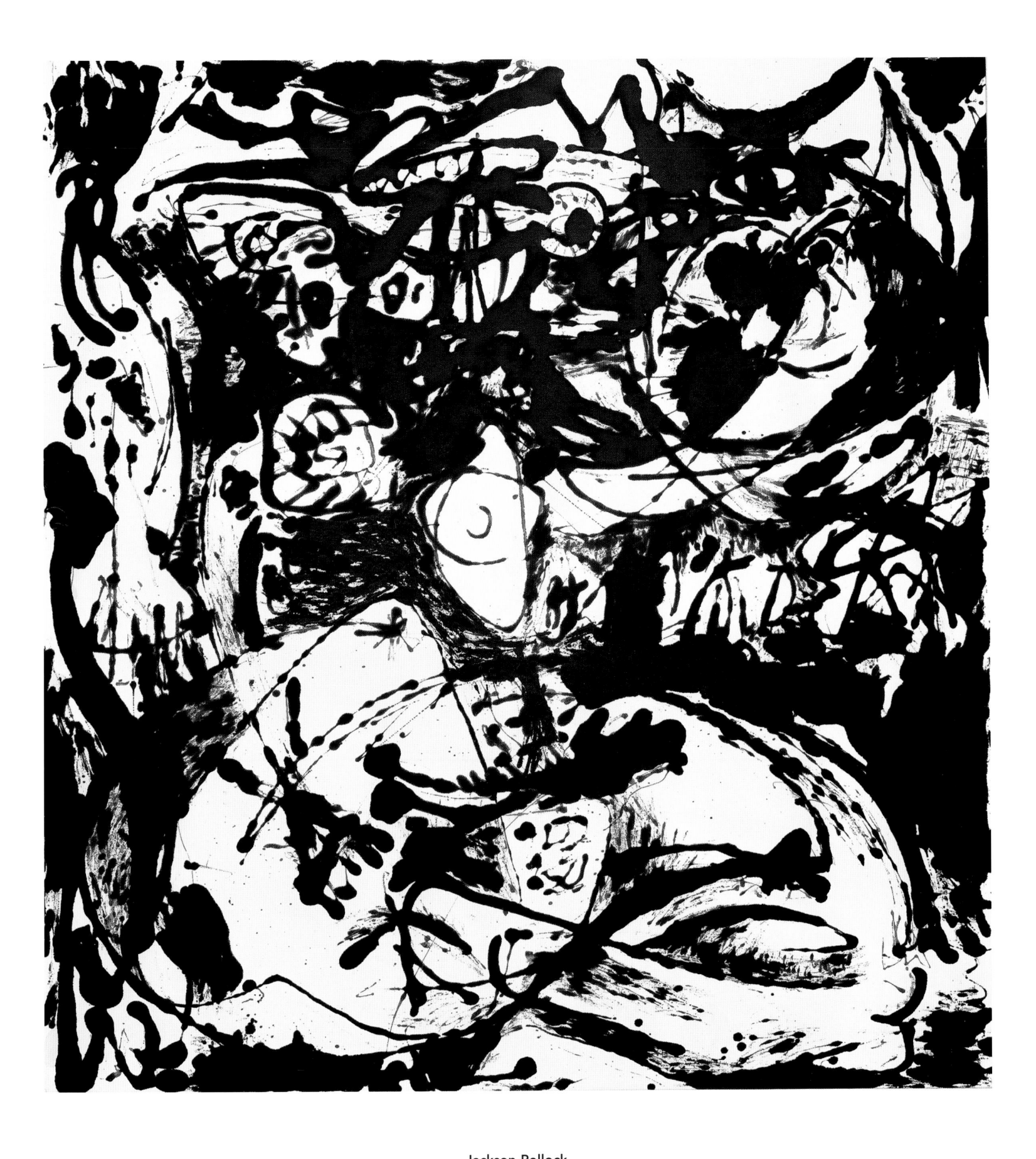

Jackson Pollock
Number 18, 1951, 1951
Enamel on canvas
58 3/4 x 55 1/2 in. (149.2 x 141 cm)
Gift of The American Contemporary Art Foundation, Inc., Leonard A. Lauder, President 2002.258

Robert Rauschenberg's *Untitled* belongs to a series of black paintings that he began in 1951, shortly after starting a group of white paintings. These monochromatic works were partly a response to the color theories of Josef Albers, with whom Rauschenberg studied in 1948 at Black Mountain College in North Carolina. Rauschenberg worked on the two series simultaneously, "so neither would be the answer."

Rauschenberg incorporated newspaper into areas of the black paintings, lending them a weathered, charred texture. When the works were first exhibited, critics wrote that the torn newspapers alluded to death, pain, and nihilism. Rauschenberg objected to such interpretations, explaining, "I began using newsprint in my work to activate a ground so that even the first stroke in a painting had its own unique position in a gray map of words." He composed the black paintings on variously sized panels, sometimes reused from earlier paintings. *Untitled* was originally composed of five panels, but the artist later removed one to inspect the panel's underlying layers. Rauschenberg has hung both the four- and five-panel versions of the work in varying sequences and orientations. His incorporation of newspaper in the black paintings presages the inclusive use of materials taken from everyday life that would characterize the next five decades of his career.

In the mid-1950s Rauschenberg created hybrids of painting and sculpture using scavenged materials from his environment, which he termed "combine paintings." As he explained, "After you recognize that the canvas you're painting on is simply another rag then it doesn't matter whether you use stuffed chickens or electric light bulbs or pure form." In *Blue Eagle* (p. 88), Rauschenberg affixed a T-shirt and a flattened can of Blue Eagle motor oil to the canvas along with an electric cord that attaches to a tin can on the floor. The blue bulb inside the can lights up when the cord is plugged in.

The Whitney already owns two of Rauschenberg's combine paintings, *Yoicks* (1953) and *Satellite* (1955), as well as more than forty-five prints and drawings. The Museum also has particularly strong holdings of the artist's later works, such as *Fusion* (1996), *Sphinx Atelier* (1998), and the fifty-two panel *Synapsis Shuffle* (1999).

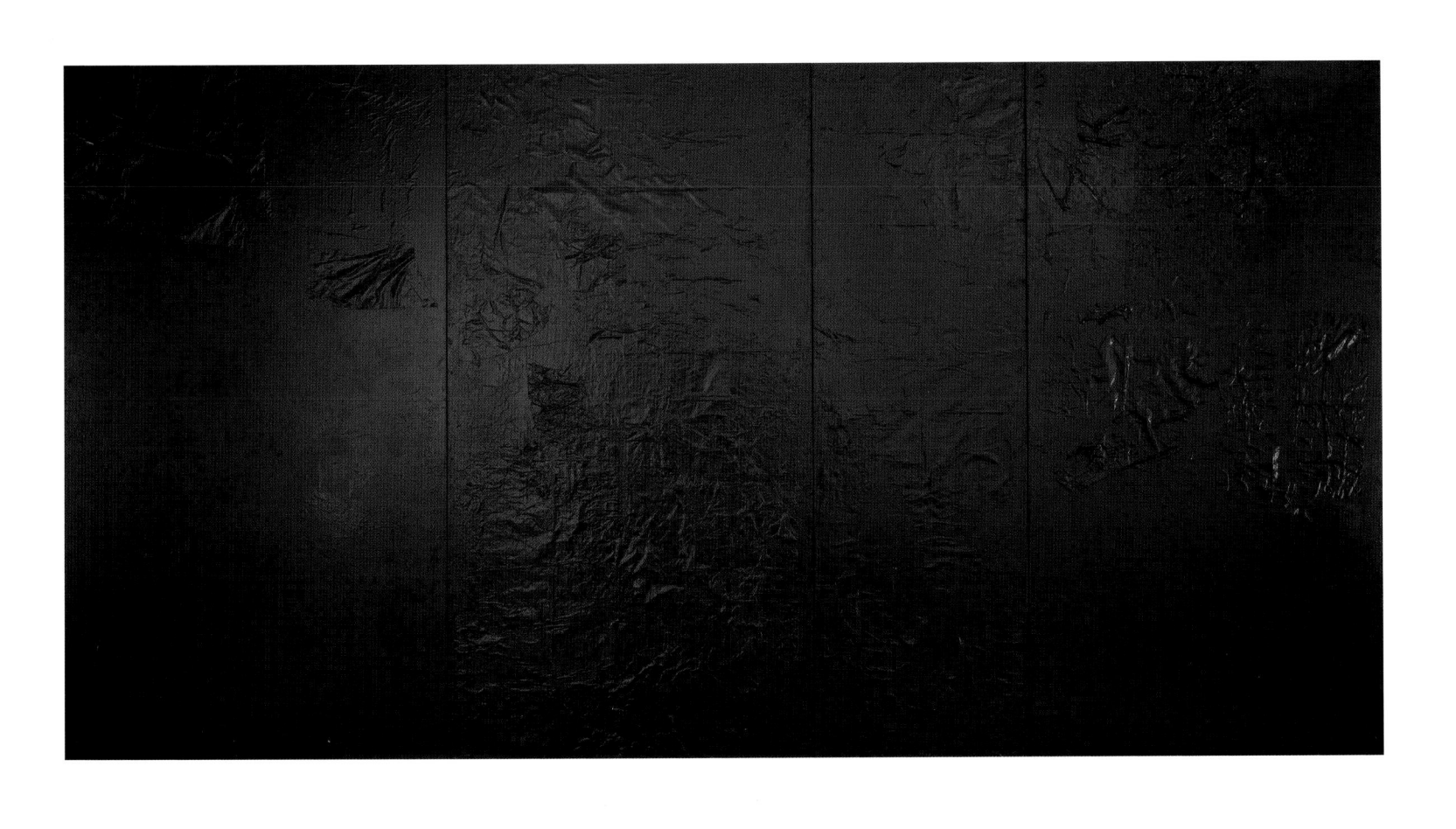

Robert Rauschenberg
Untitled, c. 1951
Oil and newspaper on canvas
Four panels, 87 x 171 in. (221 x 434.3 cm) overall
Gift of The American Contemporary Art Foundation, Inc., Leonard A. Lauder, President 2002.259

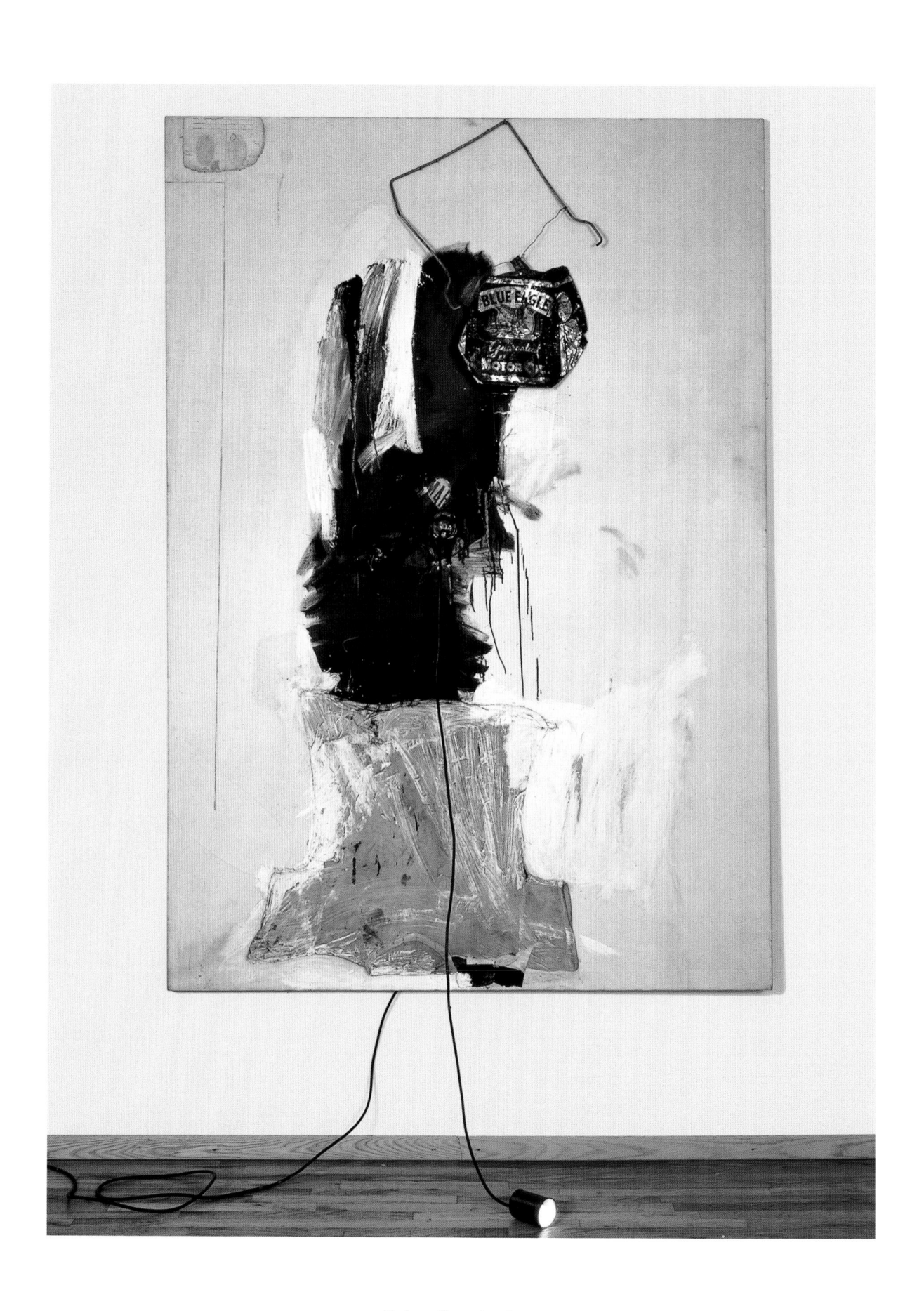

Robert Rauschenberg
Blue Eagle, 1961
Mixed media
84 x 60 x 5 in. (213.4 x 152.4 x 12.7 cm)
Gift of The American Contemporary Art Foundation, Inc., Leonard A. Lauder, President 2002.260

Mark Rothko

By 1950 Mark Rothko had begun painting classic abstractions of multicolored rectangles on and within contrasting fields of color. Upon viewing *Blue, Yellow, Green on Red*, one has an immediate impression of a serene, luminous presence, at once gentle and chromatically powerful. As they move forward and recede, Rothko's hovering, vaporous forms project an evanescent quality, enveloping the viewer with their almost respiratory movement.

A radiant lemon yellow square is centered on the canvas between horizontal bands, slightly varied in height. The yellow appears to float on a coral field, but this underlayer occurs only at the edges of the central form. In a similar fashion, the upper blue rectangle is brushed over yellow and, at the perimeter, coral washes. The bottom rectangle draws its nearly chartreuse hue from the yellow beneath it, and Rothko lightened its effect by adding a thin white line between it and the yellow square above.

While compositionally symmetrical, the work is not uniform in surface density. Rothko laboriously calibrated degrees of translucency and opacity with an initial coat of rabbitskin glue sizing and subsequent layers of thinned oil paint. His painterly application is visible in the multidirectional brushstrokes throughout and in the soft, feathered edges of each form. With these strokes he also manipulated the subtle shifts between matte and glossy surfaces. Multiple drips, especially visible along the lower left side, occurred in the painting process, and Rothko obviously reworked areas of color, especially with additions of yellow. The artist believed a sensitive viewer would perceive his paintings as timeless, complex dramas and experience spiritual and transcendent states of emotion before them. After 1957 Rothko's works project a more somber mood, exemplified by the Whitney's monumental canvas, *Four Darks in Red*, from 1958.

By 1964 Rothko had moved into what would be his last studio, located on 69th Street in New York City. Having achieved sufficient national recognition, the artist began a number of important commissions. Among these was the last and most significant of his career, a series of fourteen paintings installed in the Rothko Chapel in Houston, which opened in 1971, one year after his death.

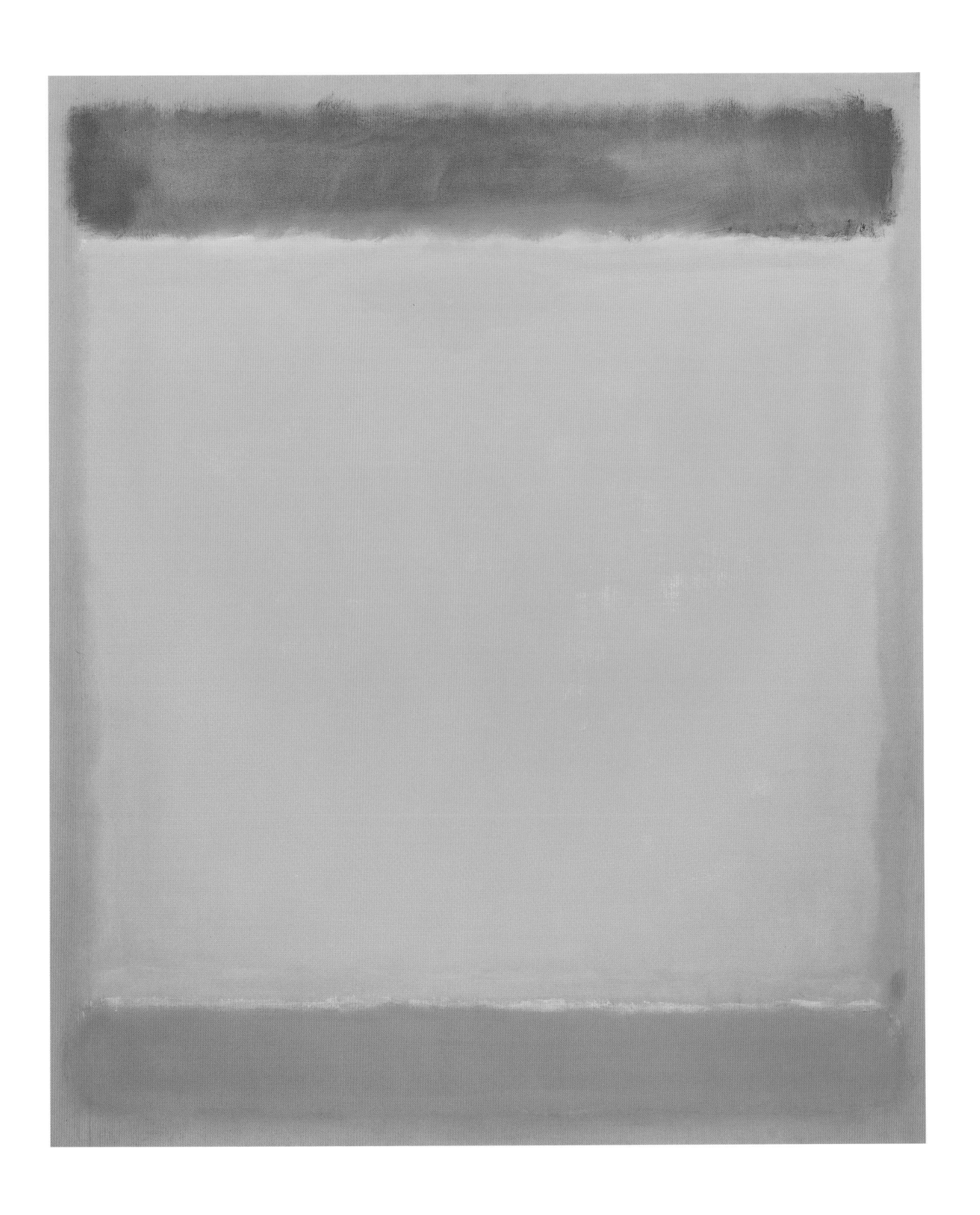

Mark Rothko
Blue, Yellow, Green on Red, 1954
Oil on canvas
77 3/4 x 65 1/2 in. (197.5 x 166.4 cm)
Gift of The American Contemporary Art Foundation, Inc., Leonard A. Lauder, President 2002.261

Edward Ruscha

In the mid 1950s Edward Ruscha studied fine art in Los Angeles, while also learning the lettering, layout, and illustration techniques of commercial art. Ruscha drew on his expertise in both areas when he began pursuing his career as an artist around 1961. A number of his earliest paintings synthesized language and image in large-scale, colorful compositions. Ruscha's works from the 1960s generally featured single words, sometimes paired with painted objects with which they may or may not have a relationship. Ruscha chose to incorporate words into his paintings in part because of his disillusionment with traditional subject matter. As he recalled, "When I first became attracted to the idea of being an artist, painting was the last method, it was an almost obsolete, archaic form of communication....I felt newspapers, magazines, books, words to be more meaningful than what some damn oil painter was doing."

In the 1970s Ruscha began using pairs of words in his works, which expanded in the 1980s to include phrases and epigrams. He often set his phrases against panoramic, cinematic landscapes, which were perhaps inspired by the filmmaking industry of Los Angeles, his home since 1956. Both of Ruscha's paintings currently in the Whitney's collection refer to the culture and geography of Los Angeles. *Large Trademark with Eight Spotlights* (1962) presents one of Hollywood's best-known logos. A more recent work, *Hollywood to Pico* (1998), belongs to a series of aerial landscapes based on Los Angeles streets and intersections.

The Act of Letting a Person into Your Home features a cloud-filled sky with the deep oranges and reds of a sunrise or sunset above a brown horizon. "Paintings of words can be clearer to see when there is an anonymous backdrop. I've always believed in anonymity as far as a backdrop goes—that's what I consider the ground or the landscape or whatever it is that's in a painting," the artist explained. "And so there's a landscape that's a background, but I don't see it. It's almost not there. It's just something to put the words on." The combination of language and the backdrop of sky creates a spatial ambiguity that is compounded by the unexplained phrase that hangs in midair. It is precisely this type of inscrutability that Ruscha is seeking: "The most that an artist can do is to start something and not give the whole story," he has said. "That's what makes mystery."

THE ACT

OF

LETTING

A

PERSON

INTO

YOUR HOME

Edward Ruscha
The Act of Letting a Person into Your Home, 1983
Oil on canvas
84 x 137 3/4 in. (213.4 x 350 cm)
Partial and promised gift of Emily Fisher Landau P.2002.60

Robert Ryman

For over forty years Robert Ryman has built a repertoire of paintings, prints, and drawings using predominantly white pigment. Among Ryman's earliest works are small, delicate paintings such as the 1958 example here, made on inexpensive, ragged-edged paper, with the date and his signature turned on their side included as prominent graphic motifs. Ryman has always preferred a square or nearly square format, for it provides, as he has explained, the "most perfect space," and downplays the need for "spatial composition." He gradually enlarged the scale of his work and in 1962 made a number of large paintings of roughly the same size, including *Untitled* (p. 96). The artist has said that despite his use of the color white, the works are not necessarily monochromatic, and with its brilliant inflections of color this work is anything but. Visible through the paint layers is the warm hue of the burlap-colored linen support, particularly where the paint trails off on each side and, most clearly, at the bottom edge. The opaque white strokes only partially obscure the gemlike colors embedded within the paint matrix—unmixed shades of blue, yellow, orange, and several hues of green.

The use of white enables Ryman to focus on the physical properties of his medium without the distraction and potential illusionism of color. By rigorously restricting his palette and controlling his distinctive facture, he stresses the material nature of the painting as object over any perceptions of the composition as figure against ground. The sensuous texture of *Untitled* comes from the viscous nature of the oil paint, which holds in high relief the stiff, thick ridges of Ryman's impasto. His gestures are not sweeping improvisations but wrist-size, comma-shaped marks approximately one inch wide. Hundreds of paint coils seem to writhe across the surface like teeming larvae. In a later painting in the Whitney's collection, *Carrier* (1979), Ryman eliminated patches of color but conveyed coloristic values through his rich surface textures.

Ryman approaches printmaking in a manner similar to his paintings, using aquatint plates, lithograph stones, silkscreens, paper, ink, and the variable pressure of the printing press to create subtle and varied surfaces. *Boundary Box 7* (p. 97) is a testimony to his investigation of the potentialities of printmaking for nearly a quarter century. The suite comprises forty-two unique works, with four impressions placed in each of ten wood boxes—with inset encaustic panels—that the artist considers integral to the work. The apparent simplicity of these sheets belies the complexity of their execution and the highly conceptual inception that one associates with the artist's paintings. The "boundaries" within each impression—points of contact between textures, edges, gestures, and surfaces—are subtly achieved in a multitude of ways using paper, printing techniques, and hand additions by the artist. For example, Ryman printed a deeply aquatinted plate on a fine Japanese mulberry paper in impression #12. Under the pressure of the press, the surface gains a reflective quality that is intensified by the dense white oilstick applied on top. For impression #10 Ryman used the same deeply aquatinted plate to emboss the paper surface and create a dappling of soft shadow.

Robert Ryman
Untitled, 1958
Casein, colored pencil, and charcoal on paper
10 x 10 1/16 in. (25.4 x 25.6 cm)
Gift of The American Contemporary Art Foundation, Inc., Leonard A. Lauder, President 2002.262

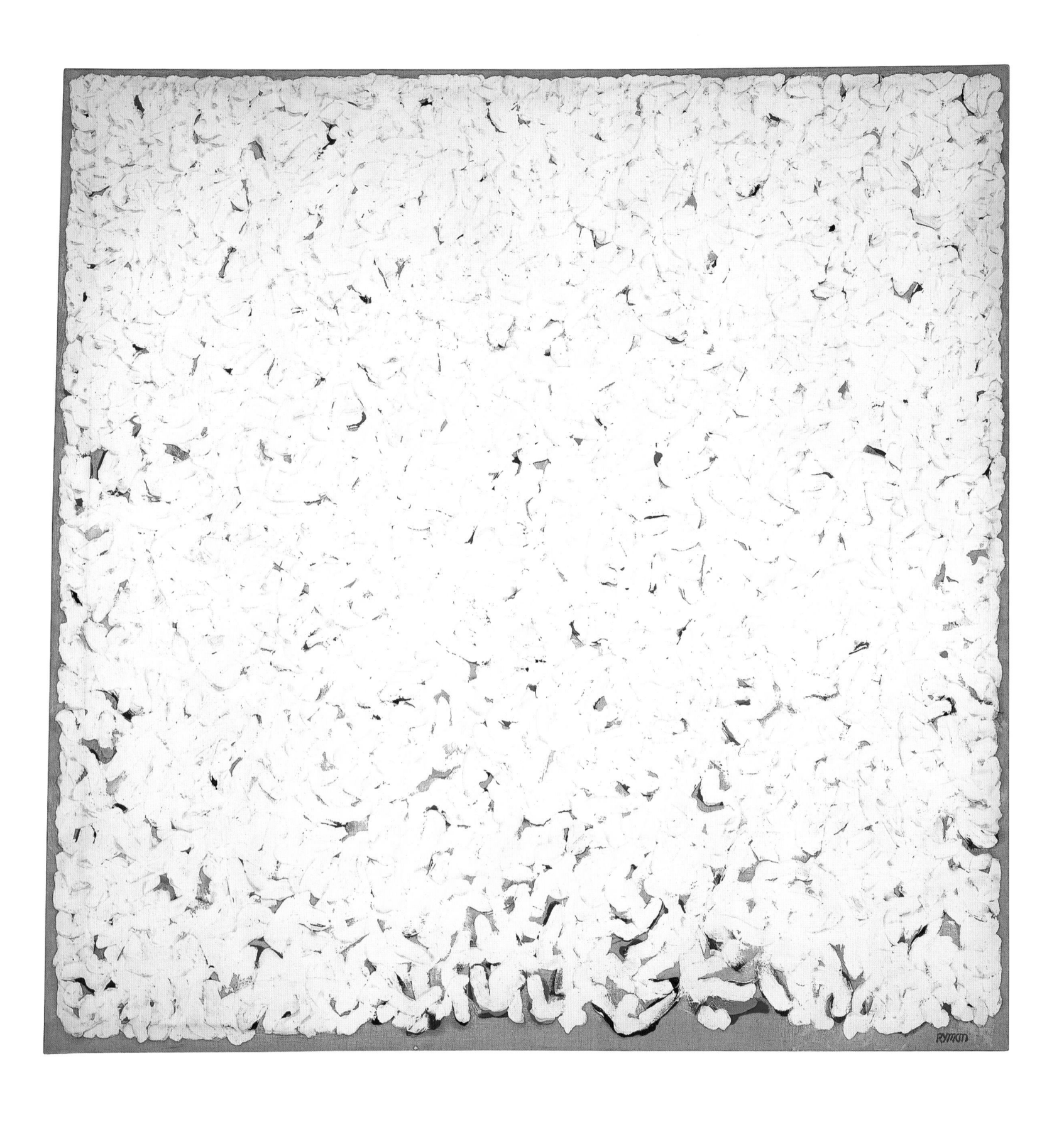

Robert Ryman
Untitled, 1962
Oil on linen
69 1/2 x 69 1/2 in. (176.5 x 176.5 cm)
Gift of The American Contemporary Art Foundation, Inc., Leonard A. Lauder, President 2002.263

Robert Ryman
Boundary Box 7, 1990
Aquatints with blind stamping, chine collé, graphite, ink, oil paint, oilstick,
and rubber stamp on handmade paper in black cherry wood box with encaustic
Four sheets, numbered 9 (illustrated), 10, 11, 12, approximately 20 x 19 1/4 in. (50.8 x 48.9 cm) each
Box, 22 1/4 x 21 3/4 x 2 3/4 in. (56.5 x 55.2 x 7 cm)
Gift of The American Contemporary Art Foundation, Inc., Leonard A. Lauder, President 2002.264

Lucas Samaras

Greek-born Lucas Samaras has long utilized his own image to investigate the charged subjects of sexuality, terror, and mortality, while experimenting with unconventional, often bizarre materials. Samaras has created thousands of self-images through photography, drawing, and multimedia sculptures, relentlessly exploiting his own body for his art. He has described his motivation as "discovering unknown territories of my surface self." With over one hundred sculptures, drawings, paintings, and photographs by Samaras in its collection, the Whitney holds more of his work than any other institution.

In the fall of 1966, Samaras made a series of drawings that far exceed in scale the small pastels that preceeded them. For *Extra Large Drawing #8*, a work of extreme detail, Samaras once again turned to the body for his inspiration. On the left is an image based on an X-ray of a large intestine. On the right he combines a drawing derived from an X-ray of his own skull with depictions of two X-rayed hands, one presented in vibrant color and the other as a kind of reversed shadow. The middle finger of the colored hand mysteriously seeps into the artist's jaw bone. The two halves of the composition vaguely mirror each other, almost appearing to gaze at one another. "Looking into a mirror to do a self-portrait was fine. Getting an X-ray of my skull was better," the artist has said. "It provided me with a fresh recognizable shape to work with."

Samaras bisected the drawing with hundreds of fine lines that converge at separate vanishing points and illuminate its center. With surgical precision, he etched white lines into the heavily worked graphite that covered much of the sheet, lending the whole a subtle, relief-like quality when viewed in raking light. Against this ground Samaras has placed the anatomical shapes, executed in ink and colored pencil, and reinforced their contours with brilliant hues that seem to irradiate the forms they circumscribe. He observed, "I had an X-ray made of my own skull taken to see the bone structure and I felt faint though I couldn't see my soul. I said I did it to see how the skeleton would look after my death and by this devious glimpse of death to diffuse its horror."

Lucas Samaras
Extra Large Drawing #8, 1966
Ink, graphite, and colored pencil on paper
23 x 29 in. (58.4 x 73.7 cm)
Gift of Anne and Joel Ehrenkranz 2001.44

Clyfford Still

Although Clyfford Still is considered one of the most prominent figures of the New York School, he resisted the label Abstract Expressionist and spent much of his early career on the West Coast and in Virginia, purposefully withdrawn from the avant-garde artistic community in New York. While living on the West Coast in the late 1930s and early 1940s, Still made paintings using a palette knife, applying thick layers of impasto to achieve a sensuous tactility. By 1944 he was using this method to create large-scale works featuring areas of accreted paint with serrated edges, often piercing them with jagged shapes in contrasting color. His imagery has been compared to lightning bolts or fissures in the earth, but Still cited immaterial sources: "I never wanted color to be color. I never wanted texture to be texture, or images to become shapes. I wanted them all to fuse into a living spirit." Still resisted identifying single explanations or interpretations of his paintings and avoided titling them. "I want no allusions to interfere with or assist the spectator," he declared. "Before [my paintings] I want him to be on his own, and if he finds in them an imagery unkind or unpleasant or evil, let him look to the state of his own soul."

From 1950 to 1961 Still lived in New York City, where he created this monumental work composed mostly of crimson, black, and white paint, and punctured by tiny crags of electric blue and deep yellow. In many of his paintings from the second half of the 1950s, including *Untitled*, Still expanded the works horizontally and left large areas of unpainted canvas.

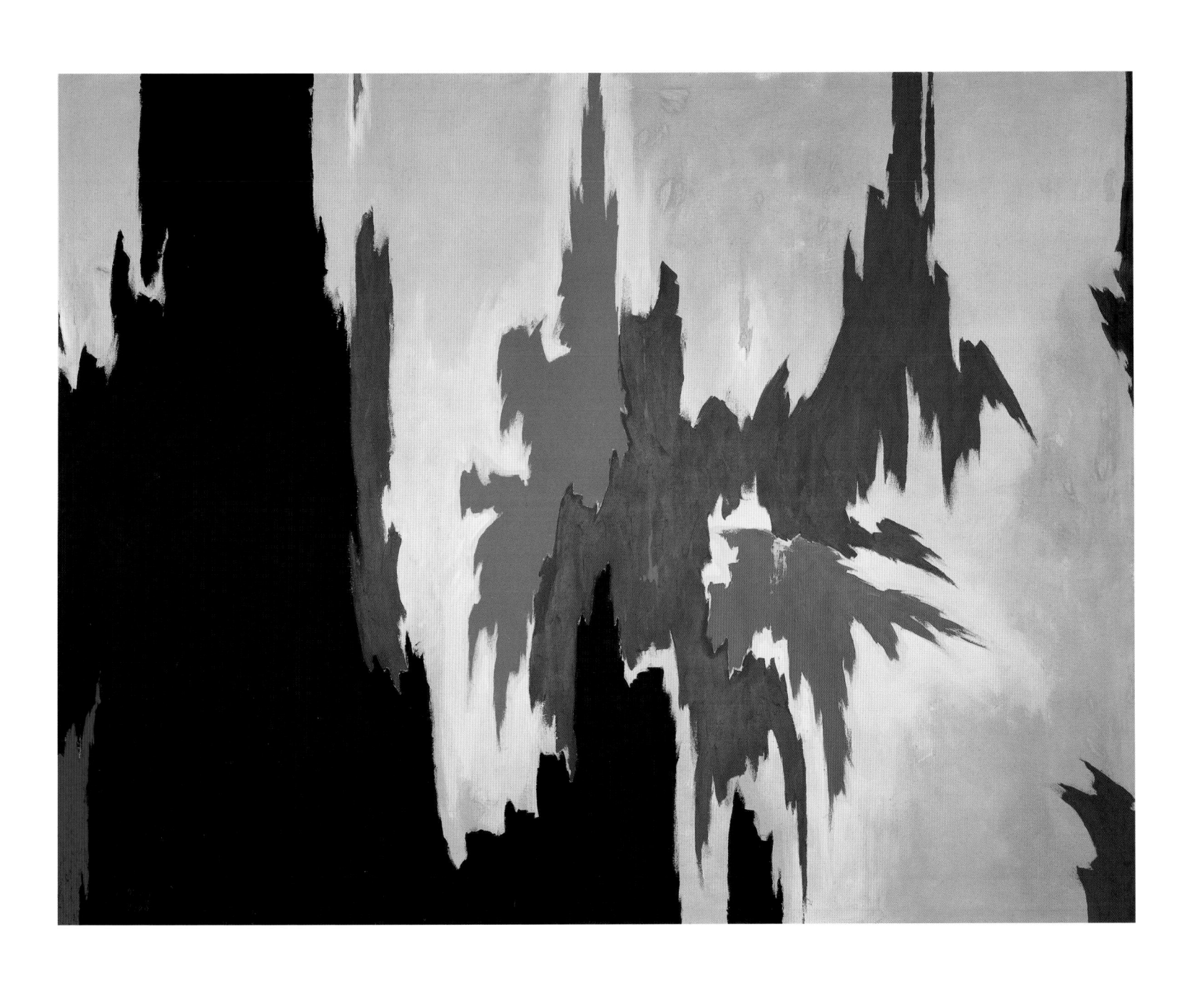

Clyfford Still
Untitled, 1956
Oil on canvas
113 1/4 x 147 3/8 in. (287.7 x 374.3 cm)
Gift of The American Contemporary Art Foundation, Inc., Leonard A. Lauder, President 2002.265

Cy Twombly

Since the mid-1940s Cy Twombly has occupied a singular position within the art world, making paintings and sculpture motivated more by historical events, ancient myth, and Renaissance art than by the tendencies of his contemporaries. Although Twombly maintains a studio in his hometown of Lexington, Virginia, he has lived in Rome since 1957 and also has a studio in Gaeta, southeast of the capital. Having begun this untitled painting in Rome in 1964, Twombly completed it twenty years later in Bassano, a medieval town north of Rome. During this long passage of time between campaigns, the artist seems to have subdued his earlier animated calligraphy, violent impasto, and graffiti-like forms in favor of an atmospheric mood reminiscent of Turner or late Monet. What has endured over time is Twombly's virtuoso execution and the impulsive energy he summons to smudge, slash, and erase his forms, often with his hands, and to partially bury snippets of words and phrases. Overall, the painting has an upward diagonal movement from left to right, like a cloudy, windswept seascape.

Although Twombly's paintings far exceed his sculptures in number, he has made three-dimensional works sporadically since 1946. His sculpture resides in only a few public collections and has not been as widely exhibited or studied as his paintings. One author paraphrased the artist's fondness for sculpture by saying that while a painting must be made "from scratch," found objects provide a sculpture with "an existence, objecthood, of its own." Made mostly in plaster and wood, Twombly's sculptures incorporate fragile materials such as paper, dried flowers, spoons, twine, and palm leaves. These assemblages are roughly constructed, with visible nails and rickety joints, and are usually painted white. "White paint is my marble," the artist has said.

Twombly began to make casts of his sculptures in 1977, first in synthetic resin and, beginning in 1979, in bronze. The 6-foot bronze *Untitled* (p. 105) was directly cast from a 1983 sculpture built of wood, plaster, nails, clay, glue, and white paint. When he cast the work in bronze in 1998, Twombly took great pains to achieve a patina that both recalls the character of his original painted wooden surface from 1983 and transforms it, creating a delicate, powdery finish that seems to have weathered through centuries of exposure. The midsection of a long diagonal stick juts out from a stepped rectangular base and is poised atop an upright element, forming a right triangle. A recurring configuration in Twombly's three-dimensional work, these refined, geometric shapes perform a precarious balancing act, as if the long stick could teeter and fall. Yet they could also allude to the human form, from an ancient discus thrower to a striding figure.

In 1983 Twombly made *Untitled* (p. 104) in both wood and cast bronze. The warm tonalities and crusty textures of this 1998 casting differ considerably from the matte, white coloration of his 1983 bronze. Twombly cast the cubic base from a cardboard box, contrasting this elemental geometric form with the organic clumps that surmount it, which were molded from plaster and cloth and, in the uppermost section, plastic tulips.

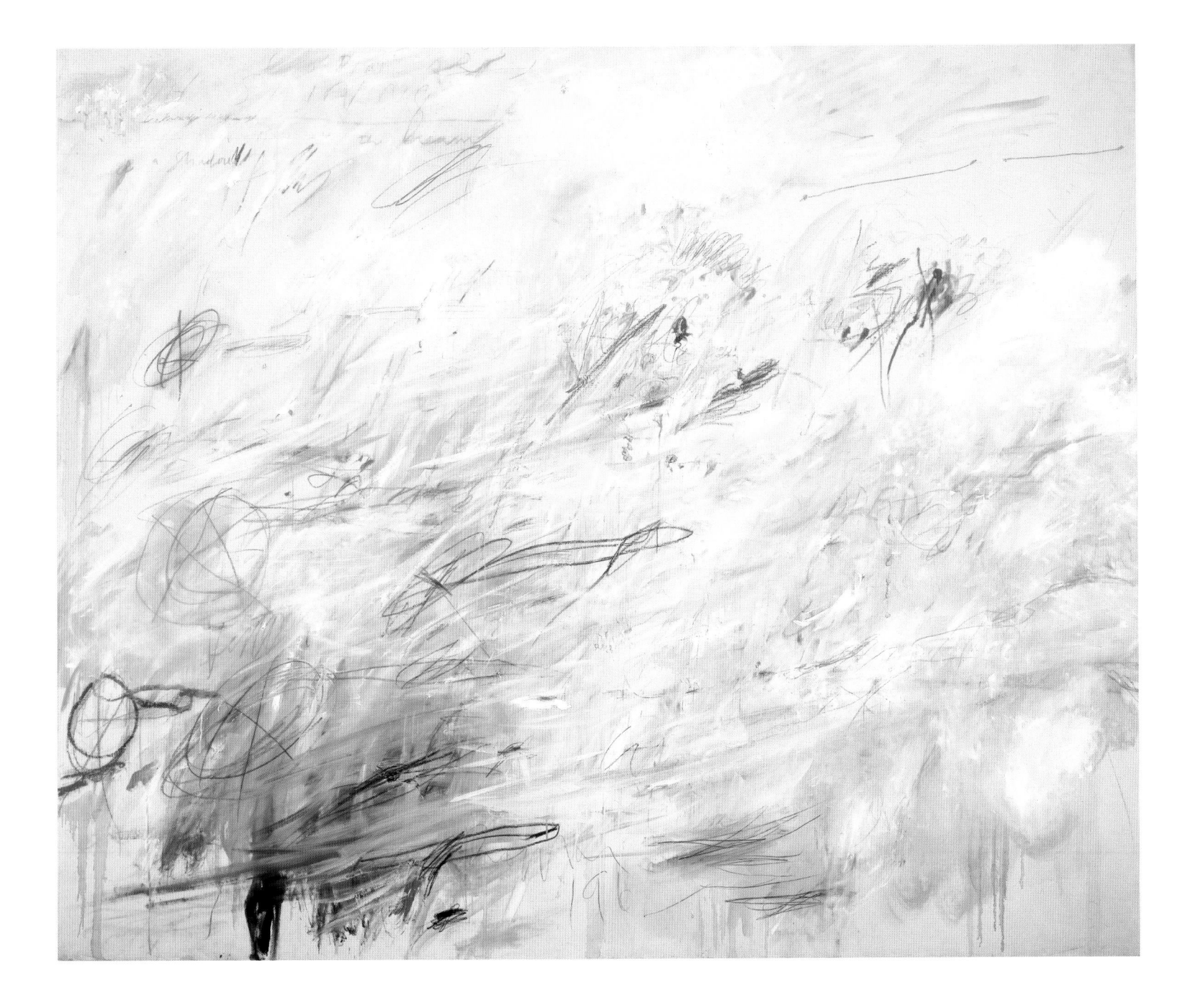

Cy Twombly
Untitled, 1964/1984
Oil paint stick, wax crayon, and graphite on canvas
80 3/8 x 98 1/4 in. (204.2 x 249.6 cm)
Partial and promised gift of Emily Fisher Landau 2002.280

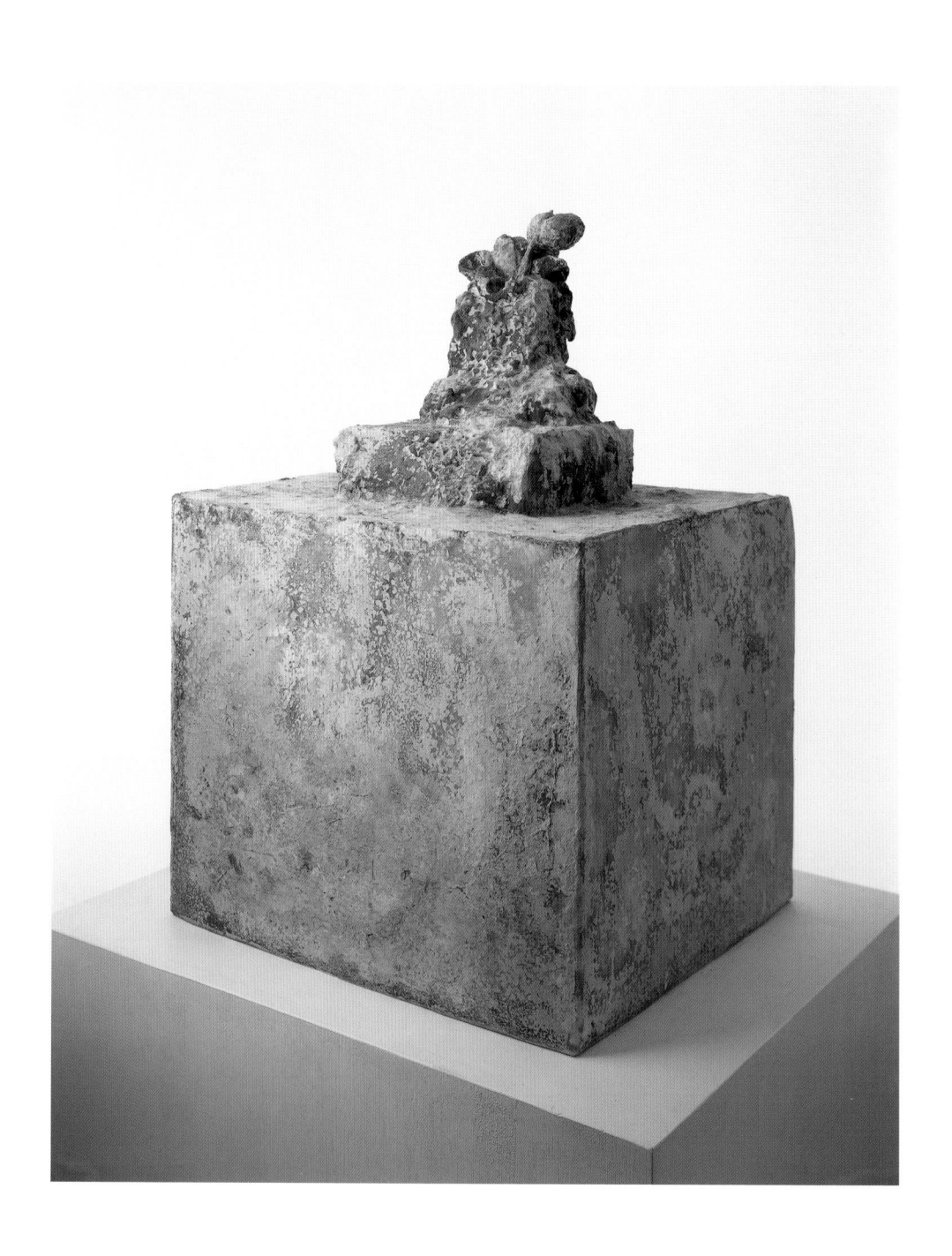

Cy Twombly
Untitled, 1983/1998
Bronze
32 1/4 x 22 x 20 1/2 in. (81.9 x 55.9 x 52.1 cm)
Gift of The American Contemporary Art Foundation, Inc., Leonard A. Lauder, President 2002.267

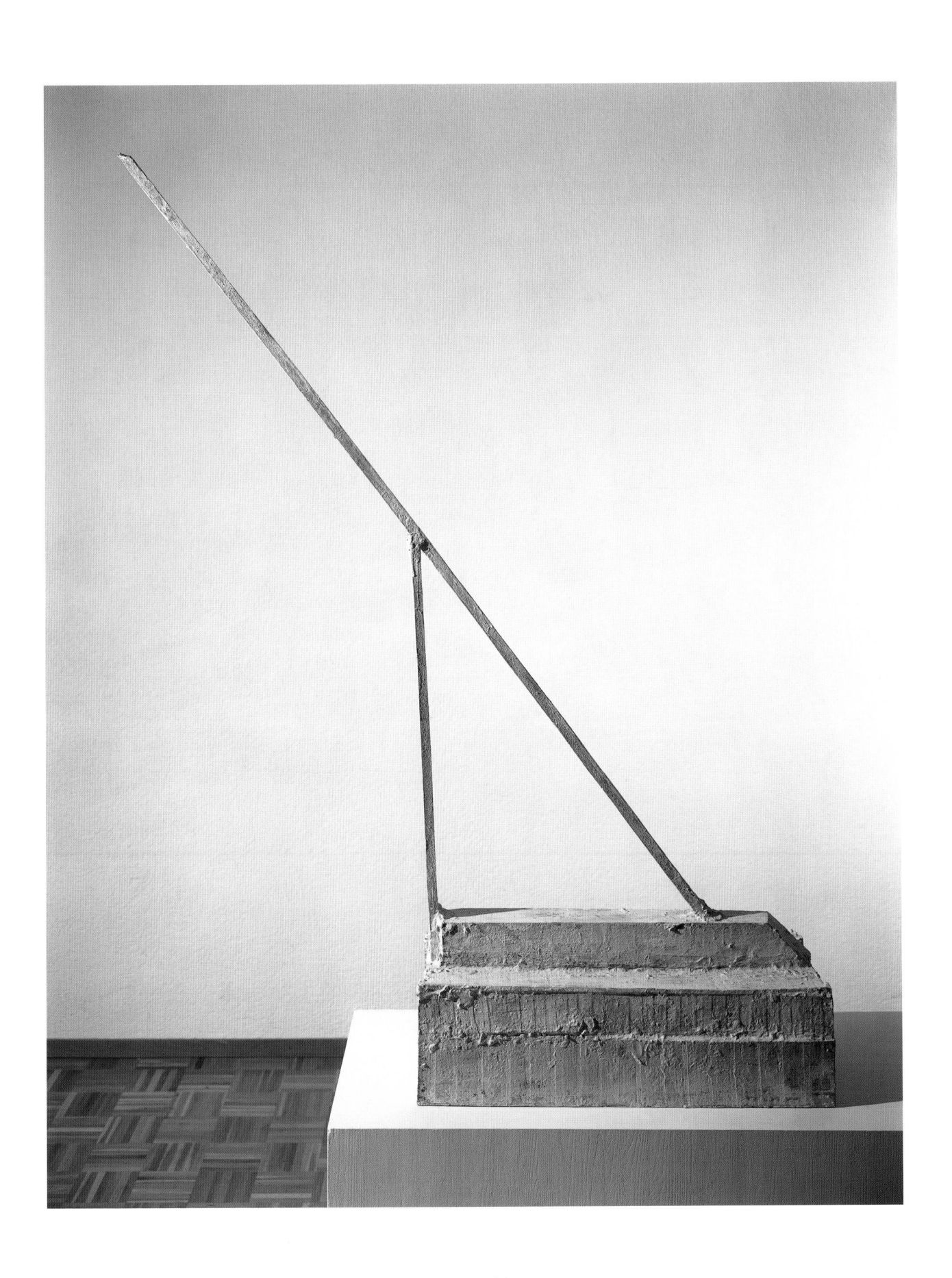

Cy Twombly
Untitled, 1983/1998
Bronze
73 1/8 x 63 x 13 3/4 in. (185.7 x 160 x 34.9 cm)
Gift of The American Contemporary Art Foundation, Inc., Leonard A. Lauder, President 2002.266

Andy Warhol, the figure most closely identified with Pop art, was born Andrew Warhola in Pittsburgh, Pennsylvania. He began his career in the 1950s as a commercial illustrator in New York City and, despite success in that field, turned to painting in 1960. The following year Warhol began a group of black-and-white paintings based on advertisements he gleaned from newspapers. *$199 Television* is derived from an ad in the April 27, 1961, issue of the *Pittsburgh Press*. Warhol did not duplicate commercial printing processes in this early painting, as he would by the following year. Instead the work is loosely structured in a collagelike composition and displays the paint drips and brushstrokes of hand application. Its black-and-white palette stands in marked contrast to the colorful paintings Warhol became known for in subsequent years. *$199 Television* is now the Whitney's earliest Warhol painting and joins *Before and After, 4* (1962), another advertisement-based painting in the collection.

Warhol took the image for another black-and-white work, *Dance Diagram, 5 (Fox Trot: "The Right Turn—Man")*, from an instructional dance book titled *Fox Trot Made Easy*, published by the Dance Guild in 1956. Warhol used this book and one other, *Lindy Made Easy (with Charleston)*, for a group of eight dance diagram paintings he made in 1962. He projected pages from the books onto canvases, tracing the contours in pencil and taping off some of the lines before adding the paint. Touches of pencil and masking tape remain throughout this work. Warhol exhibited his dance diagrams resting on low pedestals on the floor, though in subsequent years they have been exhibited by museums and galleries on the wall.

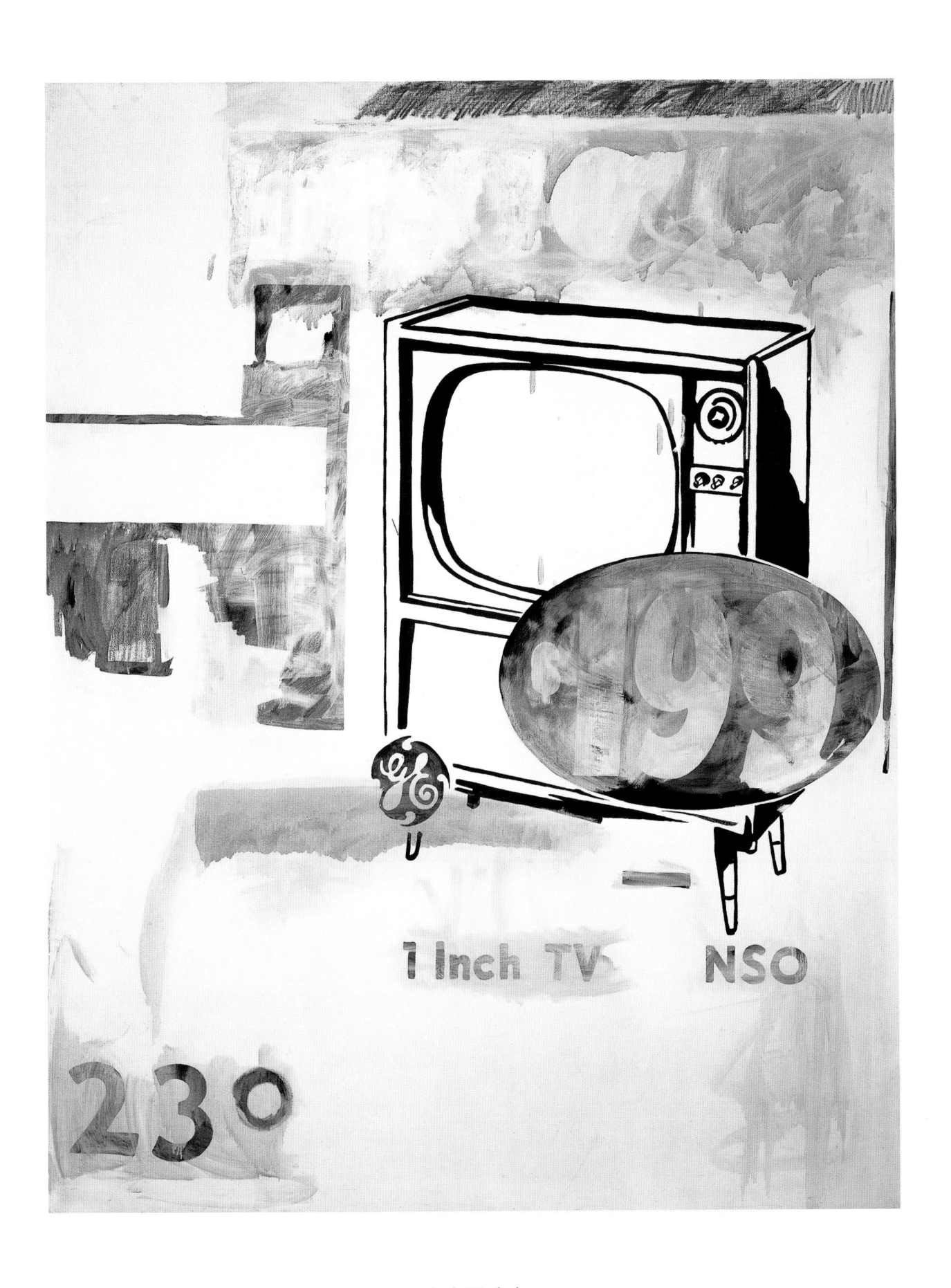

Andy Warhol
$199 Television, 1961
Casein, oil, and wax crayon on cotton
72 x 54 in. (182.9 x 137.2 cm)
Gift of The American Contemporary Art Foundation, Inc., Leonard A. Lauder, President 2002.268

Andy Warhol
Dance Diagram, 5 (Fox Trot: "The Right Turn—Man"), 1962
Casein and graphite on linen with masking tape
83 1/4 x 24 1/4 in. (211.5 x 61.6 cm)
Gift of The American Contemporary Art Foundation, Inc., Leonard A. Lauder, President 2002.274

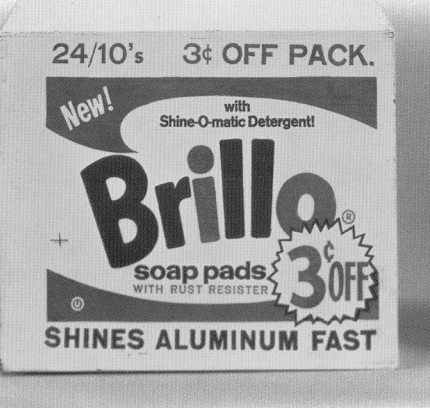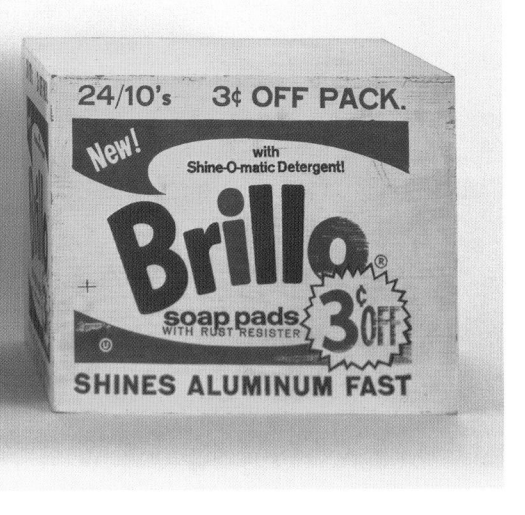

Andy Warhol
Brillo Box, 1963–64
Synthetic polymer and silkscreen ink on wood
13 x 16 x 11 1/2 in. (33 x 40.6 x 29.2 cm)
Gift of The American Contemporary Art Foundation, Inc., Leonard A. Lauder, President 2002.269

Brillo Box, 1963–64
Synthetic polymer and silkscreen ink on wood
13 x 16 x 11 1/2 in. (33 x 40.6 x 29.2 cm)
Gift of The American Contemporary Art Foundation, Inc., Leonard A. Lauder, President 2002.270

Brillo Box, 1963–64
Synthetic polymer and silkscreen ink on wood
13 x 16 x 11 1/2 in. (33 x 40.6 x 29.2 cm)
Gift of The American Contemporary Art Foundation, Inc., Leonard A. Lauder, President 2002.271

In 1964 Warhol appropriated newspaper photographs of Jacqueline Kennedy for a series of dramatic paintings in which he depicted the moments before and after the assassination of her husband, President John F. Kennedy. In the top row of *Nine Jackies* we see a smiling Jackie in the pillbox hat she wore that ill-fated day in Dallas. The President's face is barely visible at the left side of the panels. This image stands in juxtaposition to that in the row below, taken during the ceremony in which the flag-draped coffin was carried to the Capitol. A headline from the following day's *New York Times* read: "A Widow's Courage Catches at the Heart of a Nation as Kennedy Lies in State." The image in the bottom row was taken as the grief-stricken Jackie stood by Lyndon B. Johnson's side during his swearing-in ceremony.

Warhol used a total of eight different photographs for his Jackie paintings, photomechanically transferring the images onto silkscreens, which were then printed onto canvas. The works combine two of Warhol's familiar themes: celebrities and fatal disasters. Yet these voyeuristic newspaper pictures of Jackie differ from the glossy publicity stills that Warhol typically borrowed. The images of a bereft widow in the hours and days after her husband's death reveal emotions rarely seen in the public facade of celebrity. The three closely cropped images of Jackie's head repeated in *Nine Jackies* have appeared so often in the media they have become embedded in our national consciousness. Each image contains enough information for the viewer to place them in the familiar chronology of the days around the assassination. By using photographs from both before and after the event, Warhol created a modern history painting in which the murder of a president is unseen yet tragically present.

In his *Elvis 2 Times* (p. 112), Warhol repeated an image of Elvis Presley from a publicity still for the Western film *Flaming Star*. Warhol made numerous versions of this subject, silkscreening Elvis's image onto uncut rolls of linen. Many of the works were painted silver before the image was imprinted, possibly an allusion to the silver screen. Four faint images of Elvis appear in reverse on the back side of the painting, perhaps transferred when the work was rolled while the paint was still wet.

In 1962 Warhol's fascination with consumer goods took form in sculptural objects. The three examples of *Brillo Box* (p. 109) in this exhibition are among the first of the wooden boxes onto which Warhol silkscreened brand-name packaging.

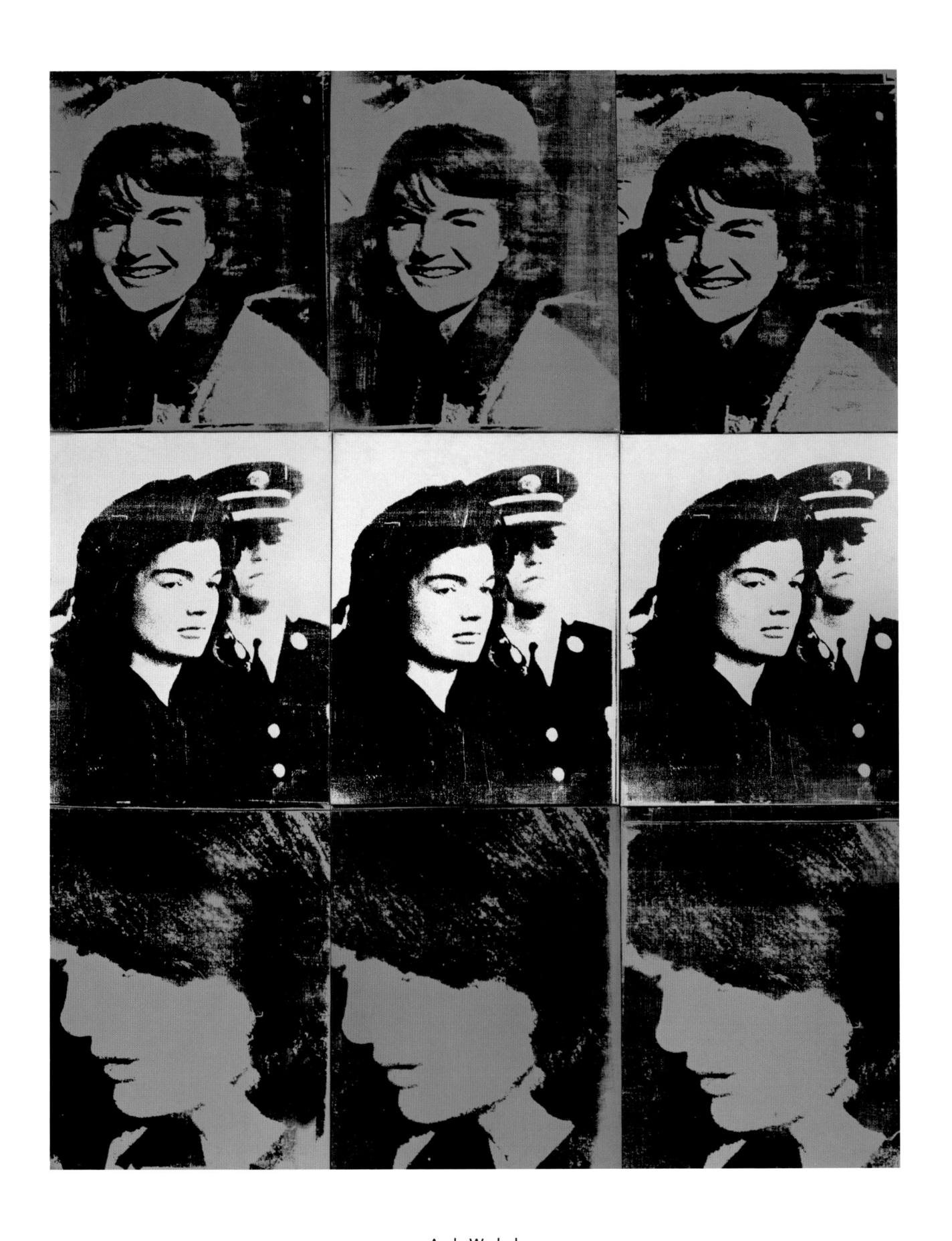

Andy Warhol
Nine Jackies, 1964
Synthetic polymer and silkscreen ink on canvas
60 1/2 x 48 1/4 in. (153.7 x 122.6 cm)
Gift of The American Contemporary Art Foundation, Inc., Leonard A. Lauder, President 2002.273

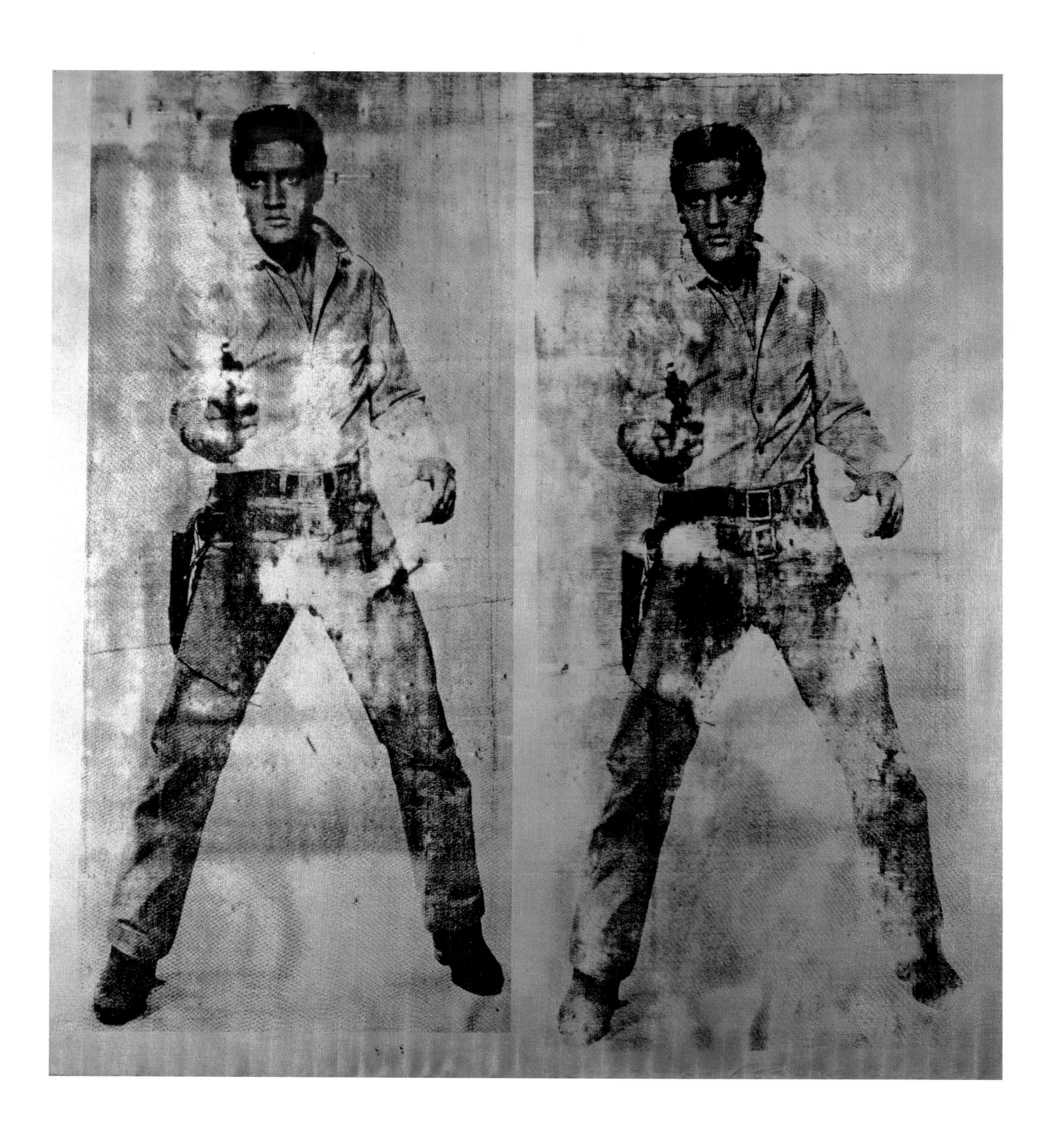

Andy Warhol
Elvis 2 Times, 1963
Silkscreen ink and paint on linen
82 3/4 x 80 3/4 in. (210.2 x 205.1 cm)
Gift of The American Contemporary Art Foundation, Inc., Leonard A. Lauder, President 2002.272

ARTIST BIOGRAPHIES

Chuck Close
b. 1940

Born in Monroe, Washington, Chuck Close studied art at Everett Junior College and the University of Washington before attending Yale University School of Art and Architecture, where he received a BFA in 1963 and an MFA in 1964. Among Close's classmates were Nancy Graves, Brice Marden, and Richard Serra. After Yale, Close received a Fulbright grant to study the work of Gustav Klimt and Egon Schiele at the Akademie der Bildenden Künste in Vienna. Returning to the United States in 1965, Close taught art at the University of Massachusetts, Amherst, before moving in 1967 to New York, where he has worked prolifically for more than three decades.

Close's early work was in the Abstract Expressionist style, influenced in particular by Willem de Kooning. In the mid-1960s he shifted away from abstraction when he began employing found photographs, and then his own portrait photographs, as the basis for paintings. Close transferred the information from his source photographs to the canvas by means of grids plotted on both surfaces, transposing and enlarging the image square by square. Close has explored a variety of materials and methods in his photo-based portraits over the course of the last thirty years, including drawings composed of thumbprints and collages of pulp paper. In 1988 Close suffered from incomplete quadriplegia, which left him partially paralyzed. With the aid of physical therapy and innovative studio equipment, Close began painting again the following year.

Storr, Robert. *Chuck Close.* Exhibition catalogue. New York: Harry N. Abrams in association with the Museum of Modern Art, 1998.

The Portraits Speak: Chuck Close in Conversation with Twenty-Seven of His Subjects. New York: Art Resources Transfer, 1997.

Jay DeFeo
1929–1989

Jay DeFeo was born Mary Joan DeFeo in Hanover, New Hampshire, and spent most of her youth in California, with extended trips to see family in Colorado. DeFeo received a BA in 1950 and an MA in 1951, both from the University of California, Berkeley. Awarded a fellowship in 1951, DeFeo traveled through Europe and spent a number of months painting in Florence. Upon her return to the United States she settled in San Francisco, where she became part of a vibrant scene of artists and literary figures, including the painter Wally Hedrick, whom she married in 1954.

DeFeo's work of the 1950s was influenced by the reigning Abstract Expressionist movement but she soon began experimenting with unorthodox materials and, in 1958, started work on *The Rose,* a monumental painting that weighed over a ton upon its completion. DeFeo worked on *The Rose* until 1966 and then stopped painting for four years. During this hiatus she taught at various colleges and continued to teach for the duration of her career, eventually becoming a tenured professor at Mills College in Oakland. Her work of the 1970s and 1980s includes photographs, collages, drawings, and paintings, typically in black and white though sometimes featuring vibrant jewel tones. DeFeo died from cancer at the age of 60.

Jay DeFeo: Ingredients of Alchemy, Before and After The Rose. Exhibition catalogue. Essay by Carter Ratcliff. New York: Michael Rosenfeld Gallery, 2002.

Jay DeFeo: Selected Works, Past and Present. Exhibition catalogue. Essay by David S. Rubin. San Francisco: San Francisco Art Institute, 1984.

Jay DeFeo: Selected Works 1952–1989. Exhibition catalogue. Essay by Constance Lewallen. Philadelphia: Goldie Paley Gallery, Moore College of Art and Design, 1996.

Jim Dine
b. 1935

Jim Dine was born in Cincinnati, Ohio, in 1935, and raised by his grandparents. He began his formal artistic training as a senior in high school, when he enrolled in evening art classes at the Art Academy of Cincinnati. After studying at various art schools in Ohio, he received his MFA from Ohio University in Athens.

In the late 1950s, Dine moved to New York and quickly became an important participant in Happenings—unconventional theatrical performances—along with artists such as Allan Kaprow, Claes Oldenburg, and Lucas Samaras. At the same time, Dine began to affix worn articles of clothing and other commonplace objects onto his canvases. This led critics to dub him a Pop artist, though Dine maintains that his images of ordinary objects, such as tools, bathrobes, and painting palettes, are deeply personal and autobiographical. He associates tools, for example, with his grandfather's hardware store. Dine devoted himself to printmaking and drawing after moving to London in the late 1960s. In 1970 the Whitney honored him with a retrospective. The artist currently lives and works in New York and Paris.

Celant, Germano, and Clare Bell. *Jim Dine: Walking Memory, 1959–1969.* Exhibition catalogue. New York: Solomon R. Guggenheim Museum, 1999.

Livingstone, Marco. *Jim Dine: The Alchemy of Images.* Commentary by Jim Dine. New York: Monacelli Press, 1998.

Helen Frankenthaler
b. 1928

Helen Frankenthaler was born in New York City and studied painting at Bennington College in Vermont and at New York's Art Students League. In 1952 she developed a method of applying paint directly onto unprimed canvas laid flat on the floor. Frankenthaler's innovations placed her among the ranks of so-called second-generation Abstract Expressionists. In the 1950s Frankenthaler met the prominent art critic Clement Greenberg, who introduced her to first-generation Abstract Expressionists such as Jackson Pollock, Lee Krasner, and Willem and Elaine de Kooning. Frankenthaler was also married for a time to fellow artist Robert Motherwell. Greenberg championed Frankenthaler's stained canvases as paragons of modernist painting for their integration of foreground and background. The artist's first solo exhibition was held at the Tibor de Nagy Gallery in 1951. Nine years later, she was given her first museum exhibition at The Jewish Museum in New York, and the Whitney organized a midcareer retrospective of her work in 1969. For the last three decades Frankenthaler has lived and worked in New York, though she has frequently taught as a visiting professor at schools throughout the country. Since the 1980s she has expanded her oeuvre to include drawing, set and costume design, and printmaking. Frankenthaler has apprenticed with a master woodblock maker in Japan and continues to experiment with a wide variety of printing techniques.

Carmean, E.A., Jr. *Helen Frankenthaler: A Paintings Retrospective.* Exhibition catalogue. Fort Worth: Modern Art Museum of Fort Worth, 1989.

Rose, Barbara. *Frankenthaler.* New York: Harry N. Abrams, 1971.

Ellen Page Wilson, *Portrait of Chuck Close, May 1999,* 1999

Wallace Berman and Jay DeFeo, *Untitled,* 1959 (from the series *Portraits of Jay DeFeo*) Whitney Museum of American Art, New York; gift of the Lannan Foundation 96.243.2

Hans Namuth, *Jim Dine,* 1977 Hans Namuth Archive; Center for Creative Photography

Arnold Newman, *Helen Frankenthaler, New York City,* 1963

Jasper Johns
b. 1930

Jasper Johns was born in Augusta, Georgia, and grew up in South Carolina, spending much of his youth with his grandparents in the town of Allendale. Johns received his first art training at the University of South Carolina at Columbia in 1947 and 1948. He spent the next two years stationed in Japan in the United States Army. By 1952 Johns had settled in New York City, where he supported himself with odd jobs, including designing window displays for department stores. In 1954 Johns destroyed virtually all of his prior work, determined from that point on to purge it of any resemblance to the works of other artists. He then began to base his compositions on familiar symbols, enriching these banal subjects with distinctive brushwork in oil and encaustic. Johns's first one-artist exhibition at New York's Leo Castelli Gallery in 1958 generated immediate critical and commercial success. Since then Johns has expanded his appropriation of images to include objects in his studio, home, and particular works by artists such as Barnett Newman and Pablo Picasso. His first important museum exhibition took place in 1964 at The Jewish Museum in New York, and a survey of his work was organized by the Whitney in 1977. A comprehensive retrospective was organized by the Museum of Modern Art in 1996. Today Johns maintains studios in Sharon, Connecticut, and St. Martin, in the French West Indies.

Crichton, Michael. *Jasper Johns*. Exhibition catalogue. New York: Harry N. Abrams in association with the Whitney Museum of American Art, 1977.

Rosenthal, Nan, and Ruth E. Fine, with Marla Prather and Amy Mizrahi Zorn. *The Drawings of Jasper Johns*. Exhibition catalogue. Washington, D.C.: National Gallery of Art, 1990.

Varnedoe, Kirk. *Jasper Johns: A Retrospective*. Exhibition catalogue. Essay by Roberta Bernstein. New York: The Museum of Modern Art, 1996.

Donald Judd
1928–1994

Donald Judd was born in Excelsior Springs, Missouri, and raised in Nebraska and New Jersey. After high school Judd served in the United States Army in Korea, from 1946 to 1947. In 1948 he studied at the Art Students League in New York and at the College of William and Mary in Virginia the following year. Judd returned to the Art Students League from 1949 to 1953, when he also studied at Columbia University. He received his BS in 1953 and his MA in 1962 from Columbia.

During the 1950s and early 1960s Judd worked as a reviewer and editor for various publications in New York, including *Art News* and *Arts Magazine*. His writing from the 1960s, particularly his pivotal 1965 essay "Specific Objects," helped to define the burgeoning Minimalist movement. By the early 1960s, Judd was working almost exclusively in three-dimensional forms. He discarded the pedestal of traditional sculpture and created free-standing or wall-mounted works from industrial materials, often in repeated sequences with regular intervals. The spare forms and pristine surfaces of Judd's untitled sculptures became hallmarks of Minimalism, even though the artist resisted this classification. In the late 1970s Judd settled in Marfa, Texas, where he worked, primarily on large-scale outdoor sculpture, for the remainder of his career.

Judd, Donald. "Specific Objects." *Arts Yearbook* 8 (1965), pp. 74–82.

Smith, Brydon. *Donald Judd*. Exhibition catalogue. Ottawa: National Gallery of Canada, 1975.

Ellsworth Kelly
b. 1923

Ellsworth Kelly was born in Newburgh, New York, and attended the Pratt Institute in Brooklyn from 1941 to 1942 before serving in the United States Army during World War II. After the war, Kelly studied for two years at the School of the Museum of Fine Arts in Boston and then traveled to Paris. There he enrolled at the École des Beaux-Arts on the G.I. Bill and studied Romanesque art and architecture. He also taught for a time at the American School in Paris and submerged himself in the artistic community there, gaining exposure to the work of avant-garde European artists such as Jean Arp. While in Europe, Kelly made his first paintings and wood reliefs in spare compositions. The works were responses to forms, such as shadows and architectural details, that the artist observed in his environment. Kelly returned to the United States in 1954, settling in New York City. Over the course of the last five decades, he has maintained a consistency of vision, exploring the distillation of forms in various scales and color combinations and in a wide variety of media, including painting, sculpture, drawing, and printmaking. *Ellsworth Kelly: Sculpture* opened at the Whitney in 1983. He has lived in Spencertown in upstate New York since 1970.

Ellsworth Kelly: The Years in France, 1948–1954. Exhibition catalogue. Essays by Yve-Alain Bois, Jack Cowart, and Alfred Pacquement. Washington, D.C.: National Gallery of Art, 1992.

Goosen, E.C. *Ellsworth Kelly*. Exhibition catalogue. New York: The Museum of Modern Art, 1973.

Waldman, Diane. *Ellsworth Kelly: A Retrospective*. Exhibition catalogue. New York: Solomon R. Guggenheim Foundation, 1996.

Franz Kline
1910–1962

Born in Wilkes-Barre, a coal-mining town in eastern Pennsylvania, Kline studied painting at Boston Art Students League, Boston University, and Heatherly's School in London. He returned to the United States in 1938, finally settling in New York City. Unlike many of his peers, he resisted abstract painting throughout the 1940s, instead painting urban views of New York with an Expressionist tinge. In 1949 he turned to abstraction when, projecting one of his drawings onto a wall, he recognized the graphic power and immediacy of his line when magnified to large scale. Although the slashing brushstrokes of his black-and-white—and later multicolor—abstractions appear spontaneous, many are based on preparatory drawings. Kline had his first one-artist exhibition in 1950 at the Egan Gallery, then the usual showcase of the "downtown" group of Abstract Expressionists. His calligraphic images in black and white were well received, and after 1951 his reputation grew rapidly.

Anfam, David. *Franz Kline: Black and White, 1950–1961*. Exhibition catalogue. Houston: Menil Collection, 1994.

Franz Kline: Art and the Structure of Identity. Exhibition catalogue. Barcelona: Fundació Antoni Tàpies, 1994.

Gaugh, Harry F. *The Vital Gesture: Franz Kline*. Exhibition catalogue. Cincinnati: Cincinnati Art Museum, 1985.

Sol LeWitt
b. 1928

Born in Hartford, Connecticut, Sol LeWitt received his BFA from Syracuse University in 1949 and served in the United States Army during the Korean War. LeWitt moved to New York in 1953, at the height of Abstract Expressionism, and his early work reflects the influence of that movement. He attended the Cartoonists and Illustrator's School while working various jobs to support himself, including as the night receptionist at the Museum of Modern Art and a graphic designer for the architect I.M. Pei.

In the early 1960s LeWitt began making geometric reliefs and then free-standing sculptures based on an open cube unit, which he termed "structures." In 1967 LeWitt wrote "Paragraphs on Conceptual Art," an essay that helped to define the Conceptual art movement. The following year he made his first wall drawing at the Paula Cooper Gallery in New York. LeWitt continues to make structures, including monumental outdoor works, and has conceived of more than one thousand wall drawings, which have been executed by others according to his instructions and diagrams. LeWitt continues to work prolifically, and since 1980 has divided his time between Italy and Connecticut.

Garrels, Gary. *Sol LeWitt: A Retrospective.* Exhibition catalogue. Essays by Martin Freidman et al. San Francisco: San Francisco Museum of Modern Art, 2000.

LeWitt, Sol. "Paragraphs on Conceptual Art," *Artforum* 5, no. 10 (June 1967), pp. 79–83.

Sol LeWitt: Twenty-Five Years of Wall Drawings, 1968–1993. Exhibition catalogue. Andover, Massachusetts: Addison Gallery of American Art, 1993.

Roy Lichtenstein
1923–1997

Roy Lichtenstein's paintings based on comic strips are synonymous with Pop art. In the late 1950s Lichtenstein had made abstract paintings in a gestural mode but suddenly, in 1961, he introduced the cartoon as subject, enlarging banal images culled from newspapers and comic books. He restricted himself to simple black contours and primary colors (based on those used in commercial printing), and even mimicked the Benday dot patterns of halftone printing, first painting them by hand and, later, employing a metal stencil.

Lichtenstein completed his undergraduate degree in 1946 and a graduate degree in 1949, both at Ohio State University. His first one-artist show at Leo Castelli Gallery in 1962 launched his career along with his inclusion the same year in the groundbreaking show *The New Realists* at Sidney Janis Gallery. His well-known cartoon paintings drew upon popular, cheaply produced romance and war comic books such as *Girls' Romance* and *Our Army at Work*. His images are visually arresting by virtue of their large scale, and Lichtenstein enhanced their sense of drama and irony by reproducing the word balloons.

In his later work, Lichtenstein tended to work in series, adopting new subject matter—brushstrokes, landscapes, domestic interiors—while retaining his signature style.

Alloway, Lawrence. *Roy Lichtenstein.* New York: Abbeville Press, 1983.

Waldman, Diane. *Roy Lichtenstein.* Exhibition catalogue. New York: Solomon R. Guggenheim Museum, 1993.

———. *Roy Lichtenstein: Riflessi / Reflections.* Exhibition catalogue. Milan: Electa, 1999.

Barnett Newman
1905–1970

Barnett Newman was born on the Lower East Side of New York City to immigrant parents who had arrived in the United States from Poland five years earlier. During high school Newman took drawing classes at the Art Students League and regularly visited local museums. From 1923 to 1927 he attended City College of New York, where he was a philosophy major. After graduating, the artist joined his family's garment business, while also teaching public school and taking further classes at the Art Students League. During the late 1920s and early 1930s Newman developed close friendships with fellow artists Adolph Gottlieb, Milton Avery, and Mark Rothko.

The biomorphic forms in Newman's paintings of the mid-1940s reflect his interest in plant and animal life—he even took classes at the American Museum of Natural History. Newman experimented with various forms of abstraction, attempting to purge his art of narrative and representation without eliminating its meaning. He reached a breakthrough in 1948 with the painting *Onement I.* The work featured a maroon ground divided vertically by a band of orange. Newman would continue to explore variations on this format in different scales, hues, orientations, and proportions for the duration of his career. The stripes, which Newman termed "zips," have become a hallmark of his paintings.

Barnett Newman: Selected Writings and Interviews. Edited by John P. O'Neill. New York: Alfred A. Knopf, 1990.

Temkin, Ann. *Barnett Newman.* Exhibition catalogue. Philadelphia: Philadelphia Museum of Art in association with Yale University Press, 2002.

Kenneth Noland
b. 1924

Born and raised in Asheville, North Carolina, Kenneth Noland served in the United States Air Force as a glider pilot and cryptographer from 1942 to 1946, including assignments in Egypt and Turkey. Noland returned to Asheville to attend Black Mountain College on the G.I. Bill from 1946 to 1948 and again during the summer of 1950. He studied there under Ilya Bolotowsky and Josef Albers and, in 1948, traveled to Paris to study sculpture. While in Europe, Noland gained exposure to the work of European artists such as Matisse, Picasso, and Miró.

Noland settled in Washington, D.C., in 1949 and taught at the Institute of Contemporary Arts and, beginning in 1951, at Catholic University, where he remained on staff for nine years. Noland's paintings from the late 1940s and early 1950s were characterized by the thick paint application and allover composition typical of Abstract Expressionism. At the suggestion of critic Clement Greenberg, Noland and fellow artist Morris Louis visited Helen Frankenthaler's New York studio in the spring of 1953. Noland was profoundly influenced by Frankenthaler's innovative method of pouring thinned paint on unprimed canvas. Noland adopted this method and, over the course of the next five decades, using both oil and acrylic paints, created a wide variety of stained canvases, most taking the form of concentric circles, stripes, or chevrons.

Agee, William C. *Kenneth Noland: The Circle Paintings 1956–1963.* Exhibition catalogue. Houston: Museum of Fine Arts, Houston, 1993.

Moffett, Kenworth. *Kenneth Noland.* New York: Harry N. Abrams, 1977.

Waldman, Diane. *Kenneth Noland: A Retrospective.* Exhibition catalogue. New York: Solomon R. Guggenheim Museum in collaboration with Harry N. Abrams, 1977.

Claes Oldenburg
b. 1929

Claes Oldenburg was born in Stockholm but spent most of his childhood in the United States. After studies at Yale University and the Art Institute of Chicago, he moved to New York City in 1956, where he established himself in the early 1960s with a series of installations and performances influenced by his surroundings on the Lower East Side.

Oldenburg's initial interest in constructing environments such as *The Street* (1960), *The Store* (1961), and *Bedroom Ensemble* (1963) soon evolved into a concentration on single sculptures. Using ordinary, everyday objects as his form of expression, he went on to develop "soft" sculpture and fantastic proposals for civic monuments. In 1969, Oldenburg took up fabrication on a large scale with *Lipstick (Ascending) on Caterpillar Tracks*, which became a controversial focus for student protest when it was installed on the Yale campus, followed in 1976 by *Clothespin* for downtown Philadelphia. Since 1976 he has worked in partnership with the art historian and writer Coosje van Bruggen. The couple, married in 1977, has executed over forty Large-Scale Projects, which have been inserted into various urban surroundings in Europe, Asia, and the United States. Their most recent work is the 144-foot-long, 64-foot-high *Cupid's Span* for Rincon Park on the Embarcadero in San Francisco.

Celant, Germano. *Claes Oldenburg: An Anthology*. Exhibition catalogue. Essays by Germano Celant, Dieter Koepplin, and Mark Rosenthal. New York: Solomon R. Guggenheim Museum; Washington, D.C.: National Gallery of Art, 1995.

Rose, Barbara. *Claes Oldenburg*. Exhibition catalogue. New York: Museum of Modern Art, 1970.

Jackson Pollock
1912–1956

Born in Wyoming, Jackson Pollock grew up in rural areas of Arizona and California and began his formal studies in art in 1928 at the Manual Arts High School in Los Angeles. Two years later he moved to New York City, settled in Greenwich Village, and enrolled at the Art Students League. There he studied drawing and painting with American Regionalist painter Thomas Hart Benton and sculpture with Robert Laurens.

In the late 1930s Pollock worked for the Easel Division of the Federal Art Project, a part of the Works Progress Administration (WPA). He also spent time in the workshop of Mexican muralist David Alfaro Siqueiros. Pollock's first one-artist exhibition took place at Peggy Guggenheim's Art of This Century Gallery in New York in 1942. His paintings from the 1940s usually involved some degree of actual or implied figuration. Coarse and heavy, and suggestive of Picasso, they were charged with a nervous, brutal energy.

In 1945, Pollock married artist Lee Krasner and moved to The Springs, on New York's Long Island. By 1947 his mature, radically innovative painting style had emerged. The paint appeared to extend beyond the limits of the canvas, with complex linear patterns evoking the energetic movements of the artist's body. Pollock's mature work constitutes one of the most influential achievements in American painting.

Solomon, Deborah. *Jackson Pollock: A Biography*. New York: Simon & Schuster, 1987.

Varnedoe, Kirk, with Pepe Karmel. *Jackson Pollock*. Exhibition catalogue. New York: Museum of Modern Art, 1999.

Robert Rauschenberg
b. 1925

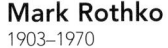

Born in Port Arthur, Texas, Robert Rauschenberg studied at the Kansas City Art Institute and School of Design, the Académie Julian in Paris, and with Joseph Albers at Black Mountain College in North Carolina. His work defies traditional categories by combining painting, sculpture, printmaking, photography, performance, and music.

As a way of embracing the quotidian world Rauschenberg began in the 1950s to include fabric, newspaper, and found objects in his work, creating what he called "combine paintings." These hybrid painting-sculptures joined the improvisatory energy of Abstract Expressionism with an exuberant proliferation of collaged elements. In the early 1960s he experimented with various transfer techniques, such as photo-silkscreen printing, which allowed him to incorporate found images. More recently he has drawn imagery from the vast archive of his own photographs. Rauschenberg has consistently valued inclusivity, multiplicity, and constant experimentation. He famously remarked, "Painting relates to both art and life. Neither can be made. (I try to act in that gap between the two)."

Hopps, Walter, and Susan Davidson. *Robert Rauschenberg: A Retrospective*. Exhibition catalogue. Essays by Trisha Brown et al. New York: Solomon R. Guggenheim Museum, 1997.

Robert Rauschenberg. Exhibition catalogue. Washington, D.C.: National Collection of Fine Arts, Smithsonian Institution, 1976.

Mark Rothko
1903–1970

One of the key figures of The New York School, Mark Rothko was born Marcus Rothkowitz in Dvinsk, Russia. His family moved to Oregon in 1913. Before settling in New York City in the mid-1920s, Rothko attended Yale University but left during his second year of study. In New York Rothko studied at the Art Students League, under George Bridgeman and Max Weber. In 1935, he formed an independent artists' group with Adolph Gottlieb called The Ten. In the 1940s Rothko made biomorphic, Surrealist-inspired paintings informed by his interest in ancient myths. His work became increasingly abstract during the 1940s, until, at the end of the decade, his biomorphic forms dissolved into clouds of color. For the next twenty years he explored abstraction through subtly defined expanses of luminous color. He believed these paintings could elicit from an attentive viewer profound human emotions, including "tragedy, ecstasy, and doom." Rothko suffered from various physical ailments in the 1960s, and in early 1970, he committed suicide.

Selz, Peter. *Mark Rothko*. Exhibition catalogue. New York: Museum of Modern Art, 1961.

Waldman, Diane. *Mark Rothko in New York*. New York: Solomon R. Guggenheim Museum, 1994.

Weiss, Jeffrey. *Mark Rothko*. Exhibition catalogue. Contributions by John Gage, et al. Washington, D.C.: National Gallery of Art, 1998.

Edward Ruscha
b. 1937

Edward Ruscha was born in Omaha, Nebraska, and raised in Oklahoma City. In 1956 he moved to Los Angeles with the intention of becoming a graphic artist and studied both fine art and commercial art at the Chouinard Art Institute until 1960. Ruscha worked as a freelance sign painter and graphic designer to support himself during school and for several advertising agencies after graduating.

Ruscha has consistently found inspiration in the urban environment of Los Angeles; the parking lots, apartment buildings, and billboard signs of his surroundings—"idioms peculiar to America," as he put it—feature prominently in his work. Ruscha's first solo exhibition was held at the progressive Ferus Gallery in Los Angeles in 1963, the same year he published his first book, *Twentysix Gasoline Stations*. Books have been an important part of Ruscha's oeuvre and he has made more than a dozen since 1963, incorporating photographs, drawings, and paintings into their pages. Ruscha has also experimented with unorthodox materials, using gunpowder, blueberry juice, and spinach, among other things, in his drawings.

Benezra, Neal, and Kerry Brougher. *Ed Ruscha.* Exhibition catalogue. Washington, D.C.: Hirshhorn Museum and Sculpture Garden, Smithsonian Institution and the Museum of Modern Art, Oxford, England, 2000.

The Works of Edward Ruscha. Exhibition catalogue. Essays by Dave Hickey and Peter Plagens. Introduction by Anne Livet. New York: Hudson Hills Press, in association with San Francisco Museum of Modern Art, 1982.

Robert Ryman
b. 1930

Robert Ryman grew up in Nashville, Tennessee, and moved to New York City in 1952, hoping to become a jazz musician. The following year, he began working as a guard at the Museum of Modern Art—a position he ultimately held for seven years. That same year, he also made his first paintings. While working at MoMA, he became friends with many artists who also worked at the museum—among them Al Held, Dan Flavin, Sol LeWitt, and the future art critic Lucy Lippard (who became his first wife in 1961). Ryman has built a rich body of work while stringently working within the narrow confines of largely white abstract paintings and works on paper. The artist once explained his longstanding interest in the hue by saying, "It's a neutral color that allows for a clarification of nuances in painting. It makes other aspects of painting visible that would not be so clear with the use of other colors."

Sandback, Mary. *Robert Ryman Prints, 1969–1993.* New York: Parasol Press, 1993.

Storr, Robert. *Robert Ryman.* Exhibition catalogue. London: Tate Gallery; New York: Museum of Modern Art, 1993.

Waldman, Diane. *Robert Ryman.* Exhibition catalogue. New York: Solomon R. Guggenheim Museum, 1972.

Lucas Samaras
b. 1936

Lucas Samaras was born in Macedonia, Greece, and grew up in the midst of World War II and the Greek civil war. He was deeply affected by the devastation he witnessed: his home was damaged and several of his relatives were injured or killed. Emigrating to the United States with his family in 1948, Samaras studied art at Rutgers University and Columbia University with such artists and scholars as George Segal, Allan Kaprow, and Meyer Shapiro. Echoes of his traumatic childhood may be found in his works, many of which emphasize physical and psychological metamorphosis, incorporating uncommon and often bizarre media. Samaras used domestic materials, such as yarn and pins, to make his inventive and sometimes threatening sculptures, including his well-known box assemblages and *Chair Transformations.* His photography from the 1970s and 1980s includes self-portraits with distortions created by reworking the soft surfaces of Polaroids. While he has always stood outside the mainstream, Samaras's work has influenced younger artists. The Whitney held a retrospective of his work in 1972 and plans another exhibition for the year 2003.

Cooke, Lynne. *Lucas Samaras.* Exhibition catalogue. London: Waddington Galleries, 1990.

Lucas Samaras: Objects and Subjects, 1969–1986. Exhibition catalogue. Essays by Thomas McEvilley, Donald Kuspit, and Roberta Smith. New York: Abbeville Press in association with the Denver Art Museum, 1988.

Samaras, Lucas. *Lucas Samaras.* Exhibition catalogue. New York: Whitney Museum of American Art, 1972.

Clyfford Still
1904–1980

Clyfford Still was born in Grandin, North Dakota, and raised in Spokane, Washington, and on a homestead in Alberta, Canada. Still entered the Art Students League in New York in 1926 but withdrew after one day. He returned to Washington, where he received his BA from Spokane University in 1933 and studied art, philosophy, and literary criticism at Washington State College, completing his MA in 1935 and teaching there until 1941. Still helped with the war effort in the early 1940s, working in the shipbuilding and aircraft industries around San Francisco. His first solo exhibition was held at the San Francisco Museum of Art in 1943. After teaching in Richmond, Virginia, for two years, Still moved to New York City in 1945. There he founded the Subjects of the Artist teaching group, along with Mark Rothko and Robert Motherwell. In 1946 Still went back to San Francisco, returning to New York in 1950. He stayed in New York until 1961, when he moved to Maryland. Still's mature work began in the mid-1940s when he began making paintings characterized by large expanses of thickly applied color, edged with jagged contours. Throughout his career Still resisted being classified as an Abstract Expressionist and he remained distant from galleries and museums.

Clyfford Still. Exhibition catalogue. San Francisco: San Francisco Museum of Modern Art, 1976.

Clyfford Still: The Buffalo and San Francisco Collections. Exhibition catalogue. Contributions by Michael Auping, Thomas Kellein, Susan Landauer, and Patricia Still. Munich: Prestel-Verlag, 1992.

Demetrion, James T. *Clyfford Still: Paintings 1944–1960.* Exhibition catalogue. Essays by David Anfam, Neal Benezra, and Brooks Adams. Washington, D.C.: Hirshhorn Museum and Sculpture Garden, Smithsonian Institution in association with Yale University Press, 2001.

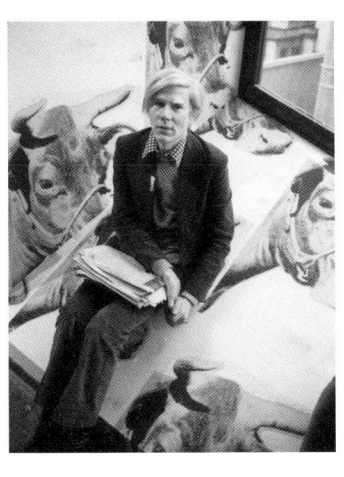

Cy Twombly
b. 1928

Cy Twombly was born in 1928 in Lexington, Virginia. He studied at the School of the Museum of Fine Arts in Boston, Washington and Lee University in Lexington, Virginia, and the Art Students League in New York City. From 1951 to 1952, at the encouragement of Robert Rauschenberg, Twombly attended Black Mountain College, an avant-garde art school in North Carolina. While at the school, he studied with Franz Kline, Robert Motherwell, and Ben Shahn. Throughout the early 1950s he traveled extensively in Europe and North Africa.

In 1957 Twombly moved to Rome, where he has maintained a studio. He also works in Gaeta, south of Rome, and in his hometown of Lexington. After moving to Italy Twombly created some of his best-known works—airy, white paintings with frenzied, layered passages of dark pencil, crayon lines, and house paint. He combined these animated marks with words and numbers, and his titles often allude to ancient poetry and mythology. Over the course of his career, Twombly has also made sculpture incorporating wood, cloth, and floral motifs, which he has occasionally cast in bronze.

Cy Twombly: Paintings and Drawings, 1954–1977. Exhibition catalogue. New York: Whitney Museum of American Art, 1979.

Schmidt, Katharina. *Cy Twombly: Die Skulptur/The Sculpture.* Exhibition catalogue. Ostfildern-Ruit, Germany: Hate Cants in association with the Kunstmuseum Basel, 2000.

Varnedoe, Kirk. *Cy Twombly: A Retrospective.* Exhibition catalogue. New York: Museum of Modern Art, 1994.

Coosje van Bruggen
b. 1942

Born in Groningen, the Netherlands, Coosje van Bruggen received a master's degree in art history from the University of Groningen. From 1967 to 1971 she worked in the curatorial department of the Stedelijk Museum in Amsterdam and was coeditor of the catalogue of *Sonsbeek 71,* an exhibition of contemporary sculpture held in Park Sonsbeek, Arnhem, and other sites in the Netherlands. Van Bruggen was a member of the selection committee for *Documenta 7* in Kassel, Germany (1982); a contributor to *Artforum* (1983–88); and senior critic in the Department of Sculpture at Yale University School of Art (1996–97). She has also authored books on Claes Oldenburg's early work and on John Baldessari, Hanne Darboven, Bruce Nauman, and the architect Frank O. Gehry, among others. Van Bruggen's first collaboration with Claes Oldenburg was in 1976, when *Trowel I,* originally shown at *Sonsbeek 71,* was rebuilt and relocated in the sculpture garden of the Kröller-Müller Museum in Ötterlo, the Netherlands. In 1978 van Bruggen moved to New York, where she and Oldenburg worked to reach a wider audience by creating large-scale, site-specific works in urban settings. Their collaboration has extended to include smaller-scale park and garden sculptures, as well as indoor installations.

Celant, Germano. *Claes Oldenburg, Coosje van Bruggen.* Exhibition catalogue. Milan: Skira editore, 1999.

Lee, Janie C. *Claes Oldenburg: Drawings, 1959–1977/Claes Oldenburg with Coosje van Bruggen: Drawings, 1992–1998, in the Whitney Museum of American Art.* New York: Whitney Museum of American Art, 2002.

Andy Warhol
1928–1987

Born Andrew Warhola and raised in Pittsburgh, Pennsylvania, Andy Warhol attended the Carnegie Institute of Technology and received his BFA in 1949. That year he moved to New York, where he became a highly successful commercial artist and designed window displays for department stores. In the early 1960s, he decided to concentrate on painting and used images from comic strips, advertisements, and commercial products such as Coca-Cola bottles and Campbell's Soup cans. His first paintings were done freehand, but by 1962 he had adopted a silkscreen process that transformed photographs of subjects, ranging from celebrities and flowers to disasters such as car crashes and riots, into some of the most emblematic images of the Pop era. Warhol appropriated his subjects from mass-produced printed sources and composed them in a serial manner, accentuating their banality and underscoring his own detachment from the subject. In the mid-1960s, he began making films in his New York studio, The Factory. Toward the end of his career he worked primarily as a society portraitist, making brightly colored silkscreen paintings of friends, art world figures, celebrities, and himself.

Frei, Georg, and Neil Prinz. *The Andy Warhol Catalogue Raisonné: Paintings and Sculpture, 1961–1963.* London: Phaidon Press, 2002.

McShine, Kynaston, ed. *Andy Warhol: A Retrospective.* Essays by Kynaston McShine, Robert Rosenblum, Benjamin H. D. Buchloh, and Marco Livingstone. New York: Museum of Modern Art, 1989.

Warhol, Andy, and Pat Hackett. *POPism: The Warhol '60s.* New York: Harper & Row, 1983.

Andy Warhol at the Whitney, April 29, 1971, 1971 (photographer unknown). Warhol seated in front of his cow wallpaper, at a press conference for his exhibition at the Whitney.

David Seidner, *Cy Twombly,* 1994 (detail)

Vera Isler, *Coosje van Bruggen,* 1992 (detail)

Faith G. Linden joined the Board in 1982. She currently serves as chair of the Drawing Committee, where her guidance perpetuates the Whitney's dedication to collecting major examples of this important aspect of American art. Mrs. Linden chaired the Sol LeWitt retrospective at the Whitney in 2001. It is LeWitt's work that she has parted with, donating a richly colored wall drawing, which has been executed in the exhibition, and the preparatory drawing for the work.

Adriana and Robert Mnuchin have committed one of Barnett Newman's defining works from 1949. This landmark acquisition, a tribute to the impeccable quality of the couple's collecting habits, richly enhances the Whitney's commitment to the New York School. The two have also endowed a gallery on the Museum's fifth floor. Mrs. Mnuchin has been a wise voice at the Board table since 1986, serving on numerous committees over the years and as vice president from 1990 to 1998 and since 2000. She also founded the Whitney Abroad International Travel Program in 1988.

Brooke Garber Neidich, who has chaired the Museum's Print Committee since becoming a Trustee in 1999, has, along with her husband, Daniel Miller Neidich, contributed a seminal series of prints by Donald Judd. During her stewardship of the Print Committee, the Whitney has greatly strengthened its commitment to a number of key American artists. She has also been instrumental in the Committee purchases of Judd's early woodcuts, and with this gift has ensured that the Museum's holdings of Judd's prints are the most comprehensive among American public collections.

Laurie Tisch Sussman joined the Whitney's Board in 1996. An active voice in support of museum education, she also was founding cochair of the American Fellows, the Whitney's patron group that supports programs dealing with early modern art. In addition to endowing a gallery on the Whitney's fifth floor, Ms. Sussman serves as secretary of the Board and is a consistent champion of art of the first half of the twentieth century. Her very generous gift of two oils from the 1960s by Kenneth Noland doubles the Museum's holdings of this major artist.

Each of these individuals was inspired to join this collective enterprise by the example of one person: our chairman, Leonard A. Lauder. The lion's share of the works in this exhibition are his contributions, in the form of gifts from The American Contemporary Art Foundation, Inc., Leonard A. Lauder, President, and LWG Family Partners, L.P. Together with his wife, Evelyn, Mr. Lauder began his involvement with the Museum over thirty-five years ago and joined the Board in 1977. The Lauders were founding members of the Museum's National Committee in 1980. Beginning in the mid-1990s, they led the effort to create the Whitney's fifth-floor galleries, endowing a space dedicated to showing selections from the prewar collection. After serving in various executive capacities since 1979, Mr. Lauder served as president from 1990 to 1994 and has been chairman since 1994. There is virtually no Museum committee that has not benefited from his membership and guidance.

In 1980 Mr. Lauder led the effort to acquire *Three Flags* by Jasper Johns, at the time the most highly valued artwork by a living artist. From his unparalleled support of the Museum's financial needs to his endless enthusiasm in support of our mission, he has set an example for trustees and benefactors of museums around the world. Appropriately, in 1999 Mr. Lauder was the first recipient of the prestigious Duncan Phillips Award, honoring a dedication to collecting and cultural philanthropy.

For this project Mr. Lauder strategically and expertly set out to strengthen the Museum's substantial holdings by artists whose careers came to broad public attention during the 1950s and 1960s. The roster of artists whose work he has secured work reads like a select history of postwar art. Leonard Lauder has made history with this gift, by advancing the Whitney's collection in ways that would otherwise take decades to realize. Rather than making one acquisition at a time, he harnessed the generosity of his peers by example. The Board, staff, and volunteers of the Whitney join me in thanking him for his unprecedented gesture, which will inspire museums for generations to come.

Maxwell L. Anderson
Alice Pratt Brown Director

ACKNOWLEDGMENTS

Many people worked to accomplish this exhibition, but none more than Marla Prather, curator of postwar art. Her skills as a connoisseur aided Whitney Chairman Leonard A. Lauder at turns, and her sensitive installation of these masterworks harnessed the evidence of compound acts of generosity into an exquisite display. She was ably assisted by Dana Miller, assistant curator of postwar art, who coauthored the publications for the exhibition, and Kenneth Fernandez, senior curatorial assistant/researcher, both of whom Prather considers indispensable colleagues in the furtherance of the Whitney's collection of postwar art. The curators are grateful for the research help provided by curatorial interns Anna Bohichik and Jennifer Goldstein. Thanks also to Janie C. Lee, adjunct curator of drawings, and David Kiehl, curator of prints. Carol Mancusi-Ungaro, director of conservation, was essential throughout the project, and her expertise will ensure the preservation of these works for future generations.

I would also like to thank Garrett White and Rachel Wixom in the Department of Publications and New Media for conceiving this book. Their expert staff who worked on the project includes Anita Duquette, manager, rights and reproductions; Jennifer Belt, photographs and permissions coordinator; Libby Hruska, assistant editor; Makiko Ushiba, senior graphic designer; Christine Knorr, graphic designer; and Vickie Leung, production manager.

Christy Putnam, associate director for exhibitions and collections management, and Suzanne Quigley, head registrar, have contributed their energies to this complicated project. Thanks go especially to members of their staff: Barbi Spieler, senior registrar; Joelle LaFerrara, assistant registrar; Kelley Loftus, assistant paper preparator; Joshua Rosenblatt, head preparator; and Mark Steigelman, manager, design and construction.

Led by Barbara Bantivoglio, associate director for external affairs, Betsy Jacks, director of marketing, and Terri Coppersmith, director of corporate partnerships, have overseen the marketing, advertising, and fundraising efforts for this exhibition.

Lastly, we are most grateful for the generous support we have received from HSBC Bank USA and WNYC New York Public Radio to help make this exhibition possible.

All of us welcome these works to the permanent collection with abiding gratitude, and words fail us in thanking our chairman and our trustees for this singular leap forward.

Maxwell L. Anderson
Alice Pratt Brown Director

PHOTOGRAPH AND REPRODUCTION CREDITS

CATALOGUE
COPYRIGHT CREDITS

PHOTOGRAPH CREDITS

ARTIST BIOGRAPHIES
COPYRIGHT CREDITS

This publication was produced by the Publications and New Media Department at the Whitney Museum of American Art:

Director: Garrett White
Editorial: Rachel Wixom, Managing Editor; Thea Hetzner, Assistant Editor; Libby Hruska, Assistant Editor
Design: Makiko Ushiba, Senior Graphic Designer; Christine Knorr, Graphic Designer
Production: Vickie Leung, Production Manager
Rights and Reproductions: Anita Duquette, Manager, Rights and Reproductions; Jennifer Belt, Photographs and Permissions Coordinator
Assistant: Carolyn Ramo

Text editor: Libby Hruska
Proofreader: Julia Corcoran

Catalogue design: Makiko Ushiba and Christine Knorr

Printing and binding: Butler and Tanner Ltd, Frome, London, and New York
Color separations: Radstock Reproductions, England

Printed and bound in England